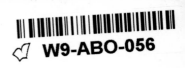
The

Many

Faces

of

Mata

Ortiz

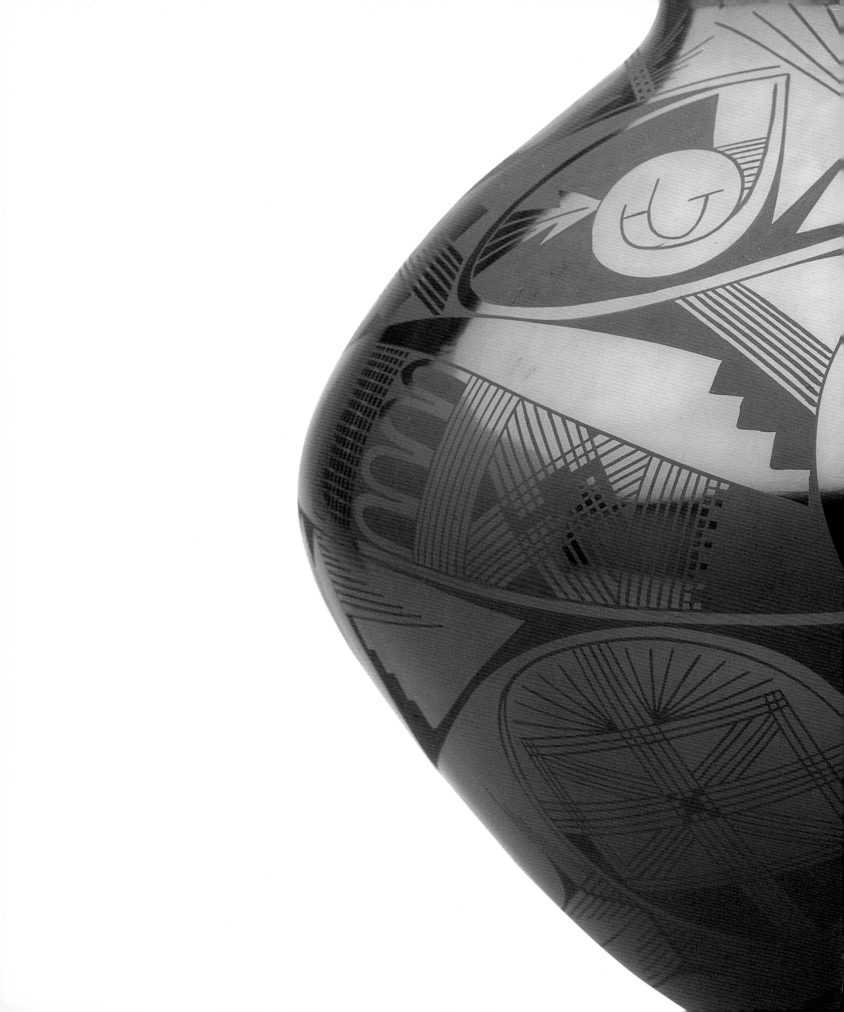

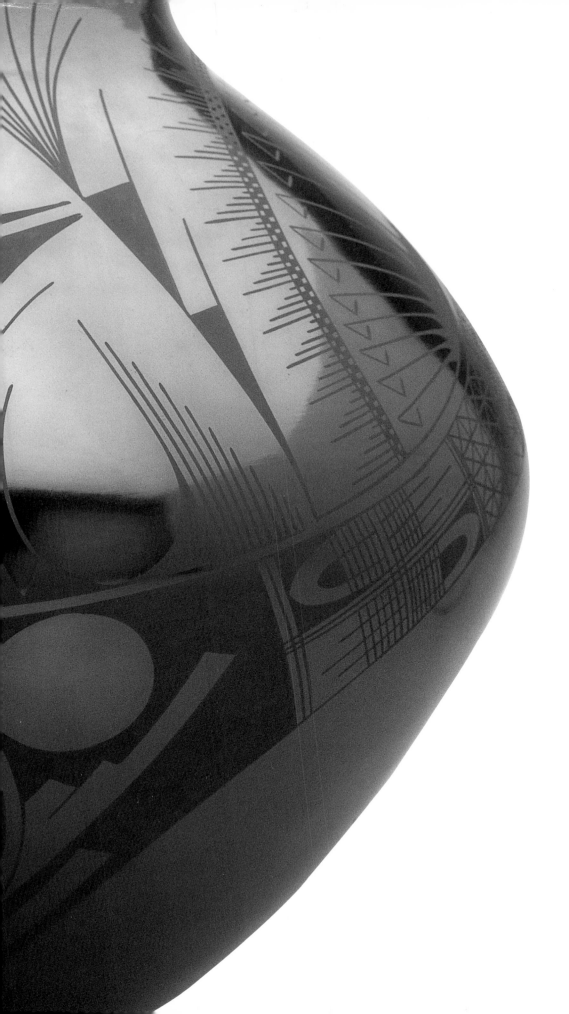

The Many Faces of Mata Ortiz

CONTRIBUTORS
Susan Lowell
Jim Hills
Jorge Quintana Rodríguez
Walter Parks
Michael Wisner

PHOTOGRAPHY
W. Ross Humphreys
Robin Stancliff

Treasure Chest Books
Tucson, Arizona

Treasure Chest Books
P. O. Box 5250
Tucson, AZ 85703-0250
(520) 623-9558

ISBN 1-887896-08-2 Paperback edition
ISBN 1-887896-18-X Hardcover edition

This book is set in Stone Serif and Stone Sans with Stone Informal display.
Front cover: Noé Quezada, *Olla*, 11½ x 11½ inches, 1997
Title page: Lydia Quezada, *Olla*, 9½ x 8 inches, 1997
Back cover: Tomás Osuna working in his studio

Editor: Linnea Gentry
Editorial assistant: Natsuki Yokokura
Designer: David Skolkin

Printed in Korea

Contents

Foreword

by

Walter Parks

THE ROUGH CATTLE COUNTRY of northern Chihuahua in Mexico seems hardly the place to find an artistic movement. Yet a few dozen miles south of the rugged San Luis Mountains, the residents of a small village produce a thin-walled, finely painted ceramic ware rivaling any handmade pottery in the world. Its originator, Juan Quezada, was discovered in 1976. With a few notable exceptions, most of the potters are young. In fact, this pottery is so new that there is no agreement as to what it should be called. Some use the name "Casas Grandes" after those who occupied the area hundreds of years ago. Others call it "New Casas Grandes" to distinguish the new pottery from prehistoric pieces found in the Casas Grandes ruins. Still others prefer to call it "Mata Ortiz" pottery after the village where it originated. That is probably as good a designation as any, except that the village was named in honor of an old Apache fighter, Juan Mata Ortiz, who was hardly an artistic type.

Whatever the name, the pottery originates in a dusty little village, only three streets wide, which straggles for over a mile between a branch of the Casas Grande river and the Chihuahua Al Pacifico railroad tracks. Mata Ortiz boomed briefly as a lumber town after the turn of the century, processing logs hauled down from the Sierra Madre. The Mexican Revolution disrupted operations, however, and the mill closed sometime after 1910. Those families that remained subsisted on small farms or ran a few cattle on the plains. They found intermittent work repairing the railroad tracks or in the apple orchards near the only large town in the area, Nuevo Casas Grandes.

Most families in the village trace their roots to other places. Juan Quezada arrived as a baby. He grew up as a country boy with little formal schooling. At age twelve, he began long trips into the mountains alone with

opposite
Olla, 7 ½ x 8 inches, **Arturo Ledezma**

7

the family burro to collect firewood. There he taught himself how to collect wild honey and where to find the most tender agave shoots and the sweetest prickly pear cactus fruit. These he brought back along with the firewood to sell in the village.

As he crossed the plains to the mountains, he entertained himself by collecting the beautifully painted pottery sherds from the prehistoric mounds. No one knew anything about the people who had made the pottery, but everyone knew about the ruins of the great city called Paquimé, which lay to the north about fifteen miles, the center of the Casas Grandes culture that had flourished between about 1000 and 1400. The mounds on the plains were the remains of outlying communities that spread for miles around Paquimé.

In the mountains, huddled before a fire under a yucca blanket, the boy would pull the sherds from his pockets and examine the precise geometric decorations. Sometimes he could recognize a figure in the design, usually a bird. He wondered about the ancient people and how they made such objects. When he had time at home, he dug clay in the arroyos, soaked it, and tried to make pots. They all cracked. He kept trying. Eventually, after studying the broken edges of the sherds, he realized that the clay needed a little sand or other material in the mix to prevent cracking. He figured out how to make the round bottoms similar to the prehistoric pots by using a little mold. When he found such molds in the mounds later, he knew he was on the right track. Gradually, step by step, he mastered the process. By the time he was a young man, he was making and decorating credible pots for his own amusement. Without any instruction, he had recreated the entire ceramic technology from clay preparation to firing, using only the sherds to guide him.

Yet he could only work at this diversion in his spare time. By now he was married and had to support his own family from whatever jobs he could find—as a cowboy, in the fields, on the railroad, and a few times across the border, legally as a *bracero* and illegally as a *mojado*. Pottery kept enticing him, however, and sometime around 1974 (exact dates get lost in the rhythm of life in Chihuahua) he decided to concentrate on making pots. He had begun to sell enough to local traders to risk leaving his work on the railroad. Repairing track earned the equivalent of a few dollars a day, whereas the sale of just one pot equaled one day's wages and sometimes more. Juan's modest success attracted the interest of his brothers and sisters, so he began to show them the rudiments of what he had learned. Eventually Nicolás, Reynaldo, and Lydia became superb potters, followed by Consolación, Reynalda, Rosa, Jesús, and Genoveva. The Quezada siblings in turn had chil-

dren who grew up with their hands in the clay. Thus this extended family, plus a few neighbors, became the core of the pottery movement in Mata Ortiz.

An important digression from the main Quezada-inspired movement occurred not long after Juan began to devote his full attention to pottery. A man named Félix Ortiz, who lived in a neighborhood called Barrio Porvenir at the extreme south end of the village, became interested. How much he actually learned from Juan will never be known, but by the late 1970s he was producing pottery using Juan's techniques but in his own style, with sweeping, unstructured designs considerably different from Juan's carefully crafted symmetry. Influenced by Félix Ortiz and less directly by Juan Quezada, individuals and family groups began making pottery, mostly of a lower quality than that produced in the center of the village by those closer to Juan. Some good work came from Porvenir, particularly from another Ortiz family: brothers Nicolás, Macario, and Eduardo, not directly related to Félix. For the first decade or so after it reached the U.S. markets, Mata Ortiz pottery fell into two broad categories—the finely made pieces from the main part of the village and the cruder version from Porvenir. The distinction has diminished considerably since then.

In 1976 an American trained in anthropology and art history, Spencer MacCallum, discovered three of Juan's pots in a junk store just north of the border in Deming, New Mexico. He had no idea what they were, but their artistic integrity came across so powerfully that he knew he had made an important discovery. He began a search for the potter who had made them, a search which led him to Mata Ortiz and Juan Quezada's little adobe house along the river. As he examined more of Juan's pots, MacCallum was struck by the fact that he was seeing an original art form. He was so taken with the discovery that he returned again and again, ultimately spending most of his time and money over the next eight years working with Juan and a growing number of other potters in the village.

This meeting between Juan Quezada and Spencer MacCallum was a defining moment. Before they met, only a few potters worked intermittently; sales were sporadic even for Juan. Spencer's contacts, salesmanship, and perseverance found the all-important markets essential to the potters' survival. He showed pieces to museum curators, academicians, gallery owners, and whoever else would look, until he convinced an important segment of the ceramic establishment that this Mata Ortiz pottery movement was an original and significant phenomenon worthy of attention. His efforts culminated in an exhibition on Juan Quezada and the pottery that traveled to five prestigious galleries in Arizona, New Mexico, and California in 1979 and 1980. *Juan Quezada and the New Tradition* featured Juan's work plus pieces by

Nicolás Quezada, Reynaldo Quezada, Lydia Quezada, Félix Ortiz, and Taurina Baca. MacCallum kept the collection intact during succeeding years and turned it over in its entirety to the Museum of Man in San Diego, California, in 1997.

This exhibit helped to establish Mata Ortiz pottery as a legitimate art movement which continued to gain momentum during the 1980s. More and more U.S. traders discovered the village and brought the pottery north across the border to an expanding market. The path of least resistance led to American Indian galleries, virtually the only outlets for high-quality ethnic pottery. Even in these locations, dealers had to overcome prejudice against "Mexican" versus "authentic Indian" pottery. This unusual ware showed so well, however, that it was accepted and sold.

Gradual market acceptance in the 1980s was followed by an unprecedented flowering of Mata Ortiz styles and skills in the 1990s, a development which even the most ardent admirers had failed to predict. The first sign of the new burst of activity lay in the large number of young people who began potting in the late 1980s and early 1990s. It was almost as though an entire generation, upon reaching adulthood, chose Juan Quezada as an occupational inspiration. Some of these newcomers had grown up in established potting families, but many did not. The list of new potting families grew dramatically, adding the names of López, Rodríguez, Ledezma, Gallegos, Martínez, Domínguez, and Cota. And the list continues to expand. Traders now regularly report some unknown youngster doing fantastic work, newly discovered on their last buying trip.

Experimentation and innovation have always characterized the approach in Mata Ortiz, beginning with Juan Quezada's first fumbling attempts to form a vessel from wet sticky clay. No artificial barriers restrict fledgling potters—neither tradition, caste, or even gender—in their development. Dozens of young potters look first to Juan and the other Quezadas and then proceed to do their own distinct thing. There is no cultural pattern that must be followed. In fact, there is no pattern at all in the way potters have learned the craft and developed their styles. The following pages show that the variety is endless: father teaching son, son teaching father; wife teaching husband, husband teaching wife; traditional use of old designs, abstract use of old designs, complete departure from old designs; symmetry, asymmetry; new clays, new paints; and more.

A few years ago some admirers worried that Mata Ortiz pottery might degenerate into repetitious ware of low quality, as so many traditional folkart movements have in the past. From the first, however, Juan Quezada and Spencer MacCallum emphasized quality, and newer traders for the most part have picked up the theme and purchased only the best examples. Even in

Porvenir, their products have improved significantly. Now traders keep "discovering" good potters there who, in fact, have been working for years.

Rarely do we see an artistic movement expanding and flowering before our eyes. Usually, the prime period of an art movement which we admire happened in the past or, if in our own era, was over before we recognized it. The ceramic art spilling out of the plains of northern Chihuahua moves today through its prime period, and we can watch it happen. Juan Quezada, the originator and prime mover, continues to experiment and innovate. Dozens of potters pride themselves on following his general style, and dozens more measure their success against how far they can depart from his style and still produce credible work. This book tells their story. No one knows where their art movement is going, but it is clear that the culmination is still ahead.

Who Is Included

THIS BOOK was in the making for three years. During that time, the number of potters active in Mata Ortiz has exploded. Many new fine potters have surely been missed as our list developed. We apologize to each of them for our inability to keep up with the new developments. And we advise our readers not to overlook the work of many good potters not listed here.

The selection of potters featured in this book is a cross section of the community of potters in age, skill, and reputation. Of course Juan Quezada, the acknowledged master of Mata Ortiz pottery, is included. But so are many potters who were less well known as this book went to press. Skill levels advance very rapidly in this community, and potters described in these pages as beginners may be experts by the time you read this.

How to Understand Spanish Names

In the biographies of featured potters in Part II and in the Potters Index at the end of the book, each person is listed with his complete formal name: first name, father's surname, and mother's surname. For example: Roberto Bañuelos Guerrero. After the potter has been introduced in the text once, only the first name and the father's surname is used—Roberto Bañuelos—as people are less formally known in Mexico.

Married women use their father's surname followed by the preposition "de" and then their husband's surname. For example: Graciela Martínez de Gallegos. Graciela is known in the pottery community as Graciela Gallegos

because of the teamwork in the family pottery. After the first use of her formal name, she is referred to here as her community does: Graciela Gallegos.

There are a number of exceptions. One example is Oscar Gonzáles Quezada, who is known as Oscar Quezada in the pottery community. "Oscar Quezada" will be found in the Potters Index with "Gonzáles Quezada" in parentheses: Oscar Quezada (Gonzáles Quezada).

Another exception involves nicknames. Only the most common nicknames are identified here. For example, Gabriela "Gaby" Almeida de Domínguez is widely known as Gaby Domínguez. In the Potters Index she is referred to as Gabriela "Gaby" Domínguez (Almeida Domínguez). Nicknames used only among close friends and family are not included.

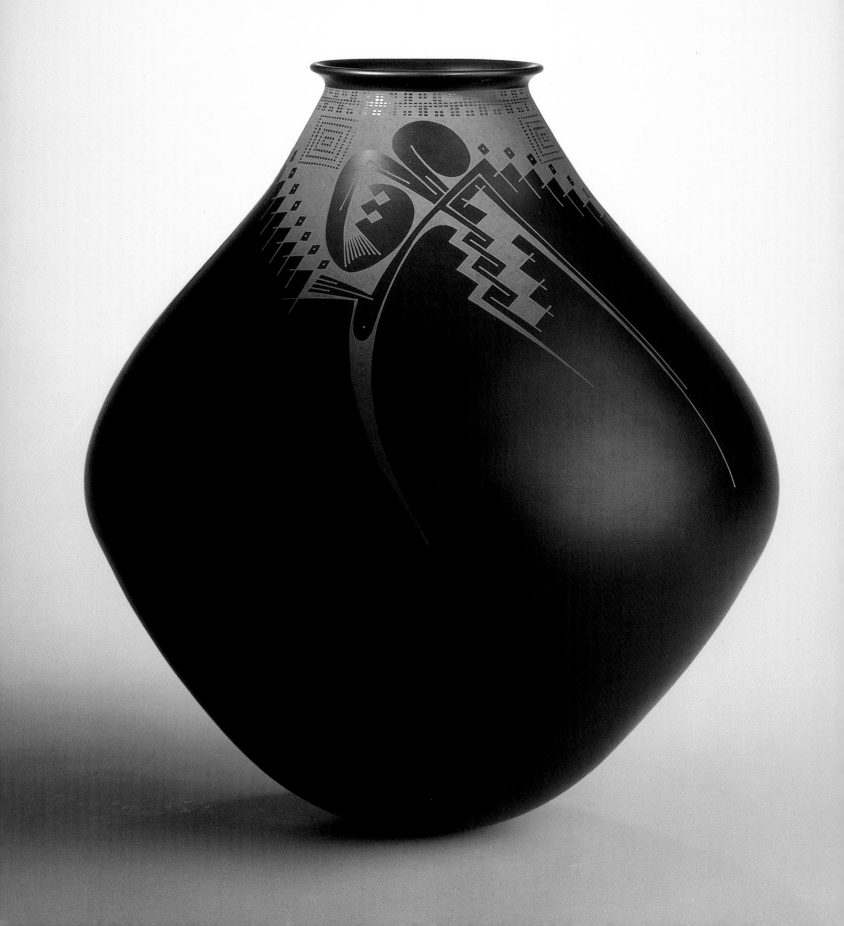

Objects

*They live alongside us
we do not know them,
they do not know us.
But sometimes they speak to us.*

— OCTAVIO PAZ
from "Object Lesson"

The Many Faces of Mata Ortiz

by Susan Lowell

IN A SMALL VILLAGE at the end of a long dirt road, magic happens every day. It is an earthly magic, worked by men, women, and children at kitchen tables and in backyards all over town, and its elements are very simple.

A handful of mud.

A few sticks and stones and human hairs.

A pile of cow manure or sometimes cottonwood bark, a splash of kerosene, a quick fire.

But out of the smoke and ashes comes something greater than the sum of these homely parts: beautiful pottery. Seventy-five miles due south of the "boot heel" jog in the New Mexico border, in the heart of the Casas Grandes region of the Mexican state of Chihuahua, the master potters of Mata Ortiz turn dirt into art.

One of these magicians, Nicolás Ortiz, is a tall man of few words, but his large hands contain a double jar . . . and a tragic drama with two characters. The two hollow, shining black hemispheres are connected by the body of a rattlesnake, life-like and life-size, its jointed tail poised along one rim. Its fanged jaws yawn into the cavity of the other pot, where a tiny black mouse is cowering.

Eighteen-year-old Laura Bugarini cradles her work in a clean cloth. "It's not finished yet," she apologizes, flashing a big smile. Her green eyes sparkle and her curly hair springs wildly in all directions. Dozens of narrow horizontal bands encircle the pot from lip to base, each band containing a repeating pattern of hundreds of tiny dots, lines, and arrows painted in tones of olive green and burnt sienna. It is a ceramic tapestry, half-woven. By the time the piece is done, she will have lavished ten thousand brush strokes on it.

opposite
Olla, 17 x 12 inches, Juan Quezada, 1996

15

One tall, slim jar silently dominates the room where it stands. Technically, it is a piece of black-on-black ware with a narrow band of decoration curved asymmetrically around its neck and shoulders. But what makes it so elegant? Why does it seem, ever so subtly, to luminesce? Why does it look pre-Columbian and postmodern at the same time? The easiest answer is: Juan Quezada made it. The ceramics of Juan Quezada Celado, the acknowledged *maestro* of Mata Ortiz, can be found in museums and private collections throughout North America and as far abroad as the Vatican and Japan.

But the phenomenon that has been called "the miracle of Mata Ortiz" is broader than the achievements of Juan Quezada himself, although much of the credit for this artistic and economic miracle does belong to him. In Spanish the word *maestro* means "teacher" as well as "master of an art or skill," and Juan, whose example has inspired two generations of potters with a third quickly rising, is a magisterial figure in every way, except perhaps in person. (Because so many Mata Ortiz potters share last names, it is customary

Double *olla*, 6 ¼ x 12 inches, Nicolás Ortiz, 1994

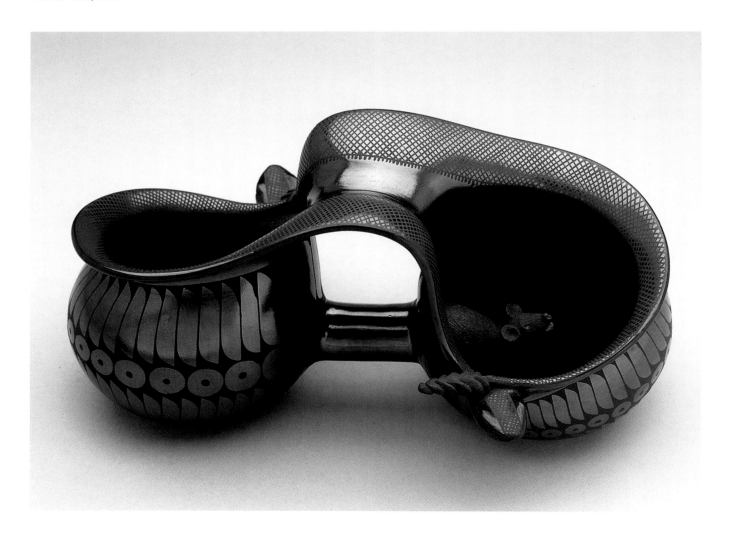

to refer to them by their first names.) Straightforward, unpretentious, active as a teenager, Juan continues to experiment with the various clays that he digs from the open country around the village, constantly pushing his work in new directions.

The history of Mata Ortiz pottery begins in the early 1950s, when Juan left school as a boy and went to work with a burro, gathering firewood in the hills. It was a traditional job, fit for a hero of folklore: the young Pancho Villa also collected kindling on a burro. But poverty and hard labor are facts of life in Mata Ortiz and significant factors in its true story. As the sixth of eleven children in a family hard-pressed to survive, Juan never had quite enough to eat, so he also foraged for wild foods, such as honey, acorns, rattlesnake meat, and edible succulents. What he did not eat, he sold. (Resourcefulness is another important factor in this story.) And scattered through the countryside he also found prehistoric potsherds, often elaborately painted in red and black.

Diamonds, stepped figures, checkerboards, and X's marched along in decorative bands. Bold triangles alternated with fine straight parallel lines; figures spiraled and interlocked and broke off tantalizingly in mid-design. Sometimes a lizard, a parrot, or a human face peeked back at him. Sometimes he could fit a few puzzle pieces together to reveal the movement of the designs around the original curved shape. On rare occasions a complete, unbroken pot turned up.

To a boy who covered his schoolwork with doodles, who even painted his bedroom wall with pictures (later erasing them with kerosene and starting over), and who secretly dreamed of being an artist, this was fascinating. Who created these objects? How? And if they did it long ago, in this very

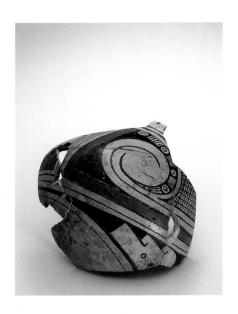

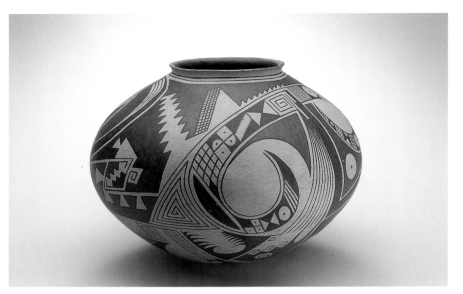

Partial Casas Grandes jar, reconstructed, 7 x 5 inches, San Diego Museum of Man Cat. No. 1997-2-170

right
One of four pots inspired by Casas Grandes jar fragment to the left, collected by Spencer MacCallum. 9x7 inches, Juan Quezada, February 1978, San Diego Museum of Man Cat. No. 1997-2-91.

From Spencer MacCallum's notes: "On my (12-19-77) trip, a neighbor of Juan had brought this sherd to me. Juan admired it, so I left it with him, to pick up on my next visit. It was the direct inspiration [for several pots in the San Diego Museum of Man collection]. I had not suggested that he do anything like this and was surprised and pleased."

place, why couldn't he do it now? He could see beds of clay near the potsherds. But there was no one to teach him, for no pottery tradition existed at all in Mata Ortiz, although they persist in other Mexican villages, as well as among the Tarahumara Indians living in the Sierra Madre to the south. But Juan had no contact with those potters. During his spare time, year after year, he taught himself.

By trial and error he discovered every step in the process of making ceramics: how to prepare the clay, adding coarser material such as sand to temper or strengthen it; and how to form a pot (*una olla*) from a flat circle of clay (*la tortilla*) topped with one or more fat sausage-like coils (*los chorizos*). The result was essentially a pinch pot. He achieved a rounded base by molding the *tortilla* in a shallow dish. He discovered how to grind specific minerals and mix paint, and he constructed his own fine brushes from his children's hair. To make his designs more permanent, he learned to burnish the painted pot with a polishing device before firing. And after much experimentation he settled on a method of firing each pot individually in a simple kiln (*el quemador*) in his yard; the most satisfactory fuel for the fire turned out to be dry grass-fed cow manure. Every material and every tool was free and close at hand in Mata Ortiz. To this day, potters' techniques and technical vocabulary remain thoroughly homespun. By 1971, while supporting his large family as a railroad laborer, he finally succeeded in producing polychrome pots very much like the ones left behind by *los antepasados*, the ancestors.

Between then and now, a revolution has rocked Mata Ortiz. But it is a revolution of mud, not blood. Constructive and creative rather than violent, the revolution has transformed more than three hundred of the villagers into potters, amounting perhaps to one person in six. Tens of thousands of clay

objects have come from their hands. And as their technical mastery has improved, so has the market for their work, bringing much-needed income into Mata Ortiz. Potters range from blind grandmothers to little boys. The elderly Irene Luján de Heras once patted out corn tortillas for a living; now she pats out *ollas*. First the potters turned clay into food; then into coats and cowboy hats, refrigerators and sofas; followed by running water, new rooms for their houses, indoor plumbing, cows and horses, pickup trucks, and education for their children.

"*Querer es poder*," says seventeen-year-old Reyna Patricia Rodríguez. "Desire is power."

"Learning took a lot of work," says Luz Elva Ramírez Carbajal, a fortyish housewife. "Also tenacity, temper tantrums, insistence, et cetera! But now I can do it all, from preparing the clay to firing my little pots, and I keep on struggling to improve. I have a lot of faith in the potter of potters, God, who gives me the patience and wisdom to work."

In many cases, too, people who once considered themselves plain as dust have become artists.

Thin as bone china, painted with exquisite precision, the best Mata Ortiz pots—whether in a potter's kitchen or a dealer's showroom—seem to float above a shelf like ceramic balloons. They are all individually hand-built, without the use of a potter's wheel, by a method somewhat different from the one used by Pueblo Indian potters to the north. Mata Ortiz pots range in size from one-inch miniatures to massive three-foot vessels; in price from one dollar to several thousand; and in color from metallic black to frosty white, and through all the earth tones from cream to yellow to chocolate brown and chile-pepper red. (Recently a few potters have begun to experiment with subtle green and blue paints, manufactured like the other pigments by hand from local minerals.) Each *olla* is unique. They glisten, they gleam, they swell with life, displaying mathematical ingenuity side by side with sly humor, as geometric zigzags melt into stylized animal designs. Besides hours or perhaps even months of work, each pot represents a personal history: a story of survival and growth, of victory in *la lucha del barro*, or the fight with the clay, as the potters call their work in Mata Ortiz. Behind each pot is a person—frequently a team of two—shaping, polishing, and painting the clay entirely by hand at a muddy table in a modest family house. And often a potter rises from the table, washes up, and takes on another identity as a farmer, a schoolgirl, a housewife, a cowboy, a religious dancer, or a celebrity on tour.

One recent winter evening Damián Quezada, one of Juan's young nephews, gets up out of bed to display his newest pots to a roomful of apologetic visitors. Although it is barely eight o'clock, he and his wife, Elvira, had

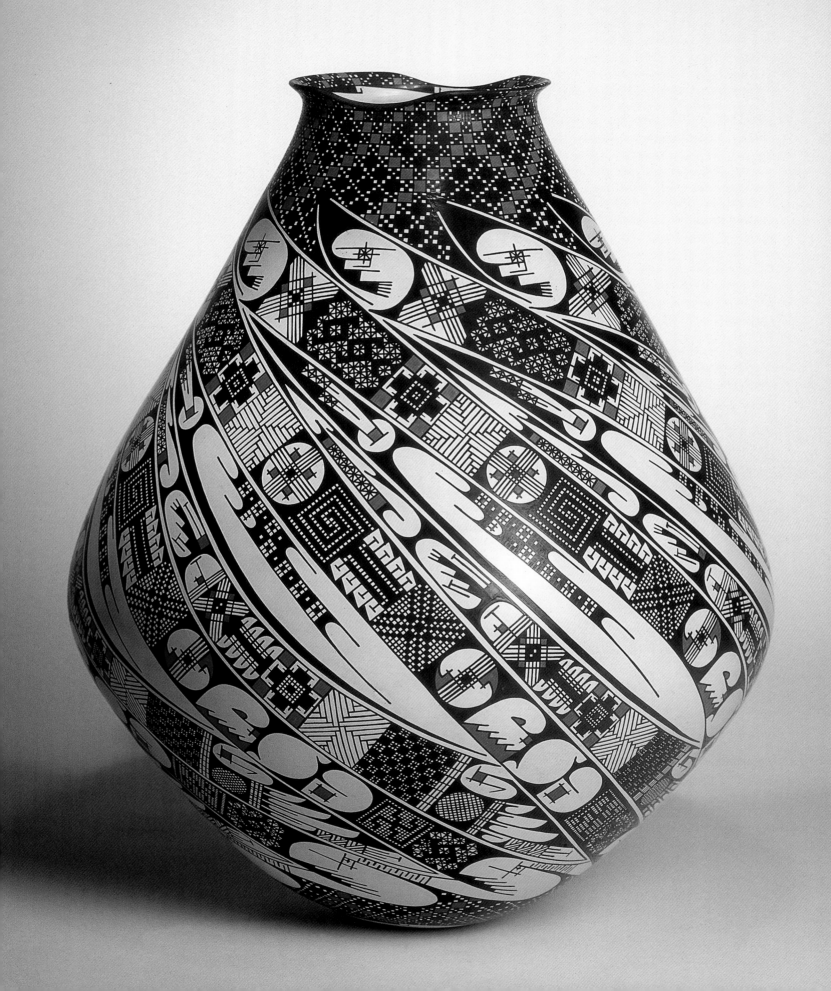

already taken cover from the biting cold of a December night on the high plains of Chihuahua. Now, hastily dressed, they are standing in their sparkling, recently remodeled kitchen, and Damián is grinning as he unwinds the protective rags from a big white jar with a narrow, fluted neck. Elvira's artistry created the pot itself and Damián painted it.

"Ah!" The visitors' heads swivel and their mouths fall open.

An eight-part design radiates sideways around the pot like the whorled patterns of a flower (or maybe an octopus). It strikes a fine balance between symmetry and asymmetry, between complex pattern and blank eggshell-white clay. Tiny red squares jump out like jewels set into the filigree of the main design, which Damián has painted in shining black. It has the exuberance of Mexico's splendid baroque art, as well as the precise geometry of its Native American decorative tradition.

This is not a flowerpot. Nor is it a replica or an imitation of either ancient or modern Pueblo ceramics. Instead, a fresh, exciting revival of an old regional craft is underway in northern Chihuahua. As in Renaissance Italy, examples of classic art from the distant past have been dug up, dusted off, rethought, remade, and frequently surpassed. Several cultural influences have helped to shape this clay, including the pre-Columbian ceramics of the Casas Grandes and Mimbres cultures, as well as the work of contemporary potters from both sides of the border. In fact, Mata Ortiz pottery serves as a strong reminder that the boundary lines on a modern map of North America are recent, political, and often unimportant: for most of human history the American Southwest and the Mexican Northwest were one and the same. Geographically and in many ways culturally, this is still true.

And yet the art of Mata Ortiz is also a local phenomenon. It is a creative response as uniquely Mexican as the dances of the *matachines* who celebrate Catholic holidays in Mata Ortiz, as they do across Mexico, with a vibrant, spectacular combination of Native American and European spirituality. It is proudly *mestizo*, Indian and Spanish "mixed," like the majority of Mexicans themselves.

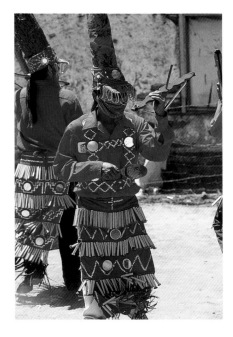

On May 15, young men and women from the village costumed as *matachines* celebrate the feast day of San Isidro, patron saint of farmers, from dawn until after dark in a series of dances outside of the church in Barrio Porvenir.

Olla, 14 x 11 inches,
Damián Quezada, 1997

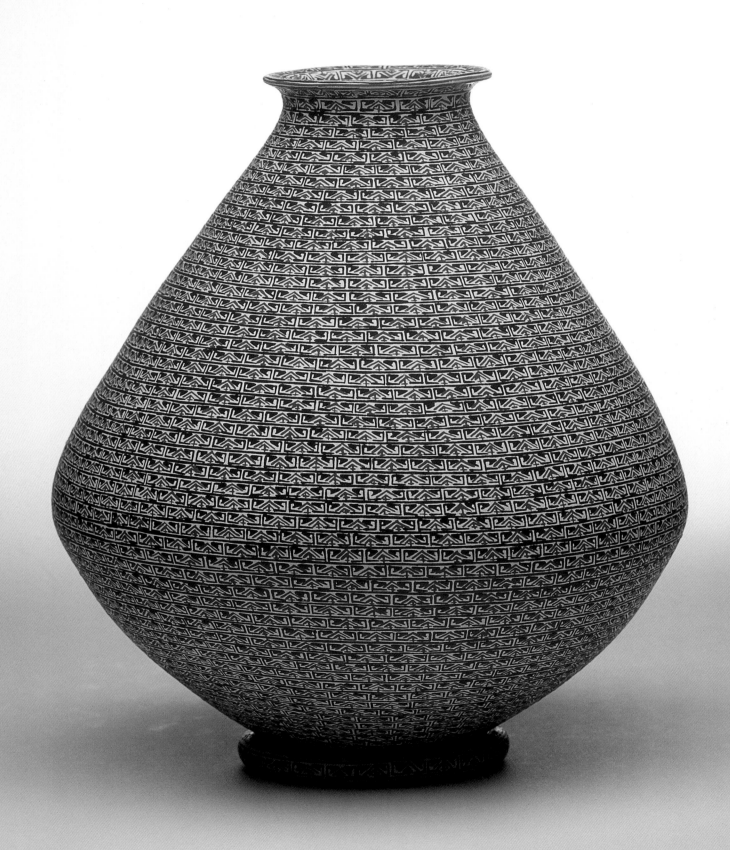

2.

THE ROAD TO MATA ORTIZ travels through many zones: of climate and culture, time and space. These transitions are never neat and tidy. During a six-hour trip, travelers find themselves whisked from the Sonoran Desert to an icy mountaintop, and from the Stone Age to the turn of the twenty-first century, with brief stops along the way at an outpost of the high civilization of the Gran Chichimeca (circa A.D. 1200), as well as Reformation Germany, nineteenth-century Utah, and the battlegrounds of the Apache wars and the Mexican Revolution of 1910. Empty as these vast tracts of land may seem to be, wave after wave of earlier travelers have left traces here—some their bones, some their potsherds, some their blown-out tires.

Through the deeper understanding it gives of Mexico past and present, the trip itself helps to explain the phenomenon of the pottery. The only practical way to reach Mata Ortiz is to drive, and most visitors will set out from one of the three closest major urban areas. Tucson, Arizona, lies approximately 250 miles northwest of the village; the twin cities of El Paso, Texas, and Ciudad Juárez, Chihuahua, straddle the border about 200 miles to the northeast; and Chihuahua, Chihuahua, the capital city of the state, is located about 200 miles southeast of Mata Ortiz. In each case, a traveler quickly leaves urban congestion and superhighways behind, for this is a trip to the country.

If the journey begins in Arizona, the exit from Interstate 10 in Benson is the jumping-off place to another universe, one of small towns, narrow roads, blue skies, pickup trucks, ranches, cattle, horses, stark peaks, small oases, mesquite trees, ravens, jackrabbits, coyotes, and dust. It is the universe of the

opposite
Olla, **10 x 8 inches, Laura Bugarini, 1997**

trip, containing its own set of smaller worlds. And every trip to Mata Ortiz is an adventure. Besides the fascination of the scenery and the people and a certain eerie sense of time travel, there's the thrill of a treasure hunt. What surprising new invention will turn up this time? Blue paint? Square pots? Has the weather in Mata Ortiz been good for firing—not too wet or windy? Has Manolo Rodríguez finished those three extraordinary Escher-like designs he promised?

The journey is very easy compared to the treks of the prehistoric Asian hunters, or Paleo-Indians, who were probably the first human beings to venture across North America. They left the earliest definite signs of human habitation in the greater Southwest about 12,000 years ago, around the end of the last Ice Age. Then about 10,500 years ago a different way of life developed, known as the Desert Archaic culture, which thrived side by side with the Paleo-Indian one. But Desert Archaic people ate a much more varied diet, foraging for plants as well as hunting and fishing, and about 3,000 years ago they achieved a great technological breakthrough: they became the first farmers in North America. To tend their crops, they settled in villages of slightly subterranean structures called pit houses. To process the many seeds they ate, they crafted a variety of stone tools, and then eventually, about 800 B.C. they produced the first Southwestern pottery.

By the time the Spanish *conquistadores* arrived in the sixteenth century, the current states of Arizona, New Mexico, Sonora, and Chihuahua had been settled for hundreds of generations. Some of the inhabitants were still nomadic, but most of them lived in villages near sources of water, raised corn, beans, squash, and other crops, and made ceramics. In other ways their cultures varied enough over time and from place to place to warrant many different archaeological names, including Mogollon, Anasazi, Mimbres, Hohokam, and Casas Grandes. To the Aztecs, the region was *Chichimecatlalli*, or the Gran Chichimeca (greater Chichimeca-land), a term some scholars prefer to long lists of modern states. In the Florentine Codex, one of the few surviving accounts of Mexico at the time of the Conquest, Fray Bernardino de Sahagún (a pioneering Franciscan friar who is generally regarded as the first ethnologist of the New World) recorded a big-city Aztec opinion of life in the desert hinterlands. "On this dwell the Chichimeca," his informant began, and then croaked out a dire warning: "It is a place of misery, pain, suffering, fatigue, poverty, torment. It is a place of dry rocks, of failure; a place of lamentations; a place of death from thirst; a place of starvation. It is a place of much hunger, of much death. It is to the north." Many cultural influences, including religion, advanced technology, and political domination, seem to have flowed from the wet south to the dry north. Nowadays perhaps the flow has reversed direction.

The route from Arizona to Mata Ortiz follows the San Pedro river valley, where, as always in the Western deserts, massive cottonwood trees are a certain sign of dependable water. Prehistoric farmers lived here. Their organic artifacts, such as baskets, have rarely survived them, but the simple pots that they used for cooking and seed storage have. Today the Mormon farming town of St. David nestles along the San Pedro riverbanks, complete with steepled church and red-brick schoolhouse, home to the industrious Latter-day Saints as well as a small Catholic monastery. Viewed at thirty miles an hour, St. David seems a little green refuge. But high above it all, catching the sunlight in a cloudless sky, a blimp surveys the area for drug smugglers.

Drugs are nothing new to the Gran Chichimeca. Tobacco (sometimes of hallucinogenic potency) was a prehistoric crop, and it was only one drug of many in widespread use. Psychoactive substances probably often played a part in ancient religious rites, as they sometimes still do for native peoples. Pre-Columbian drug paraphernalia has been found throughout the Americas and was probably traded along with the drugs, precious stones, seashells, brilliant feathers, seeds, jewelry, and fine pottery that traveled this trade route for thousands of years, very likely packed in burden baskets on the backs of runners who covered hundreds of miles barefoot, like the modern Tarahumara. But today's multibillion-dollar, multinational, illicit drug industry is different and dangerous. On a trip to Mata Ortiz, it can be very important to draw a clear distinction, verbal and otherwise, between "pot" meaning a clay vessel and "pot" in any other sense.

Roadblock! Be polite, cooperate, and move on. On this trip, armed persons in the middle of nowhere may be agents of the U.S. Border Patrol, the Mexican federal police, or several other branches of law enforcement in the borderlands; or they may be running from the law. In many ways this area remains the Wild West, both north and south of the border. Prudent travelers in these remote areas always carry water and a spare tire, and they avoid driving at night. Fortunately bandits and smugglers, like rattlesnakes, usually prefer not to be seen. So move on. Head straight for Tombstone (motto: "the town too tough to die"), where the road runs east of Boot Hill, west of the O.K. Corral, and then barrels toward the border crossing at Douglas, Arizona. A minor crossing with shorter hours also operates at Columbus, New Mexico, the scene of Pancho Villa's 1916 raid, the only military invasion of the United States by a foreign power since the War of 1812. Except, perhaps, for the Apaches. . . .

The road dips through an underpass dedicated to the memory of Cochise (1815–1870), the great chief who maintained his stronghold high in the Chiricahua Mountains to the northeast. Straight ahead looms *la frontera*, the Mexican-American border, as impressive as steel fences, patrolling police

dogs, and automatic weapons can make it. The line is all-important here. People die trying to cross it. Who can do so without emotion? Nevertheless, half a second carries you from faded Douglas to larger, livelier Agua Prieta, Sonora. At the line, as at the Pearly Gates perhaps, a wayfaring stranger shrinks down to a bare minimum of words (*escritora, casada, nacida en Chihuahua*—writer, married, born in Chihuahua) and a terrible sense of uncertainty: "Why go to Mata Ortiz anyway? What pots?" Such questions have their uses, for the answers are stunningly clear. Go to Mata Ortiz because it's like walking into someone else's dream. And it's a hopeful dream, a kind of nativity. The pots are symbolic. They stand for something bigger and brighter than a handful of dust, something that the journey may perhaps reveal.

So documents are presented, fees paid, tourist cards signed with the pen that the courteous Mexican immigration official has taped to a white plastic fork to prevent tourists from stealing it. Just then, something moves in the alcove behind the official. It is an unkempt blond youth who sits on the other side of a glass door and holds up a crudely lettered sign beginning with the word "HELP—"

Three graphite blackware pots by Macario Ortiz beginning to cool after being fired by the reduction method, 1996

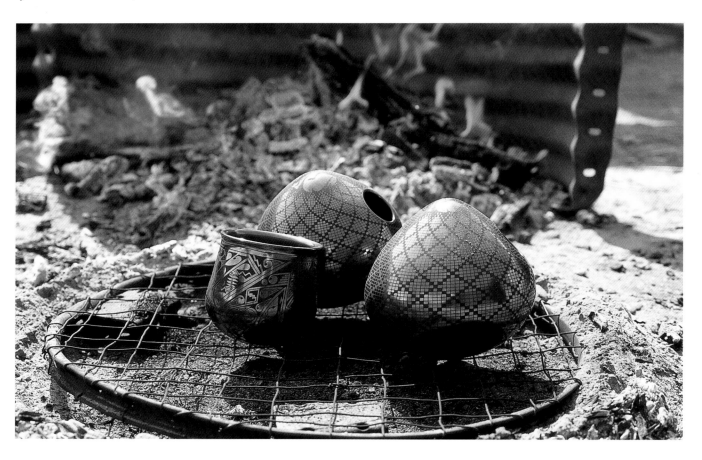

"Next," says the official, retrieving his fork in complete tranquility.

Passing tourists do not rate explanations. Prudent travelers also recognize that while in Mexico they are subject to Mexican law and the Mexican political system. Move on, move on. Outside, the stucco cityscape of Agua Prieta pulses with color: flaming orange, chrome yellow, pistachio green, cochineal pink walls decorated with three-dimensional six-foot chessmen. How can guidebooks claim there's nothing to see here? And there in a craft shop sits a row of small but unmistakable Mata Ortiz pots, their texture a lustrous metallic black. This finish, like the paint on the stucco, is highly characteristic of Mexican art: a daring, even jarring use of color in an unexpected place.

Macario Ortiz

On the pots, it is often achieved by coating the green vessels with a slip containing powdered graphite; the heat of the fire fuses the metallic particles to the clay. But the history of the graphite process is also characteristic. It all began with something as utterly common as pencils (a potter noticed that silvery pencil signatures on pots survived firing), followed by a flash of brilliance (why not turn the whole pot silver?) The glittering finish, first made by laboriously grinding pencil leads into powder but now quickly and pragmatically produced with toner from copy machines, instantly identifies these pots as products from potters with ties to one particular neighborhood, Barrio Porvenir on the west side of Mata Ortiz.

"Ah, yes, the graphite was a great invention," says Macario Ortiz, reminiscing about the late 1980s, when he created the technique. Along with his brothers Nicolás and Eduardo (nicknamed Chevo) Ortiz, Macario is one of the most accomplished potters in Porvenir. His many students learn by observation rather than formal instruction, as is usual in Mata Ortiz. ("We look and we learn," explains Edmundo López, who makes excellent graphite ware himself now.) And creativity moves fast in Mata Ortiz; so graphite, either plain or combined with a multiplicity of other paints, textures, and designs, is almost traditional now. But even very modest Porvenir pots are as enticingly shiny as Christmas tree balls or costume jewelry, and they beckon the treasure hunter onward, toward the source.

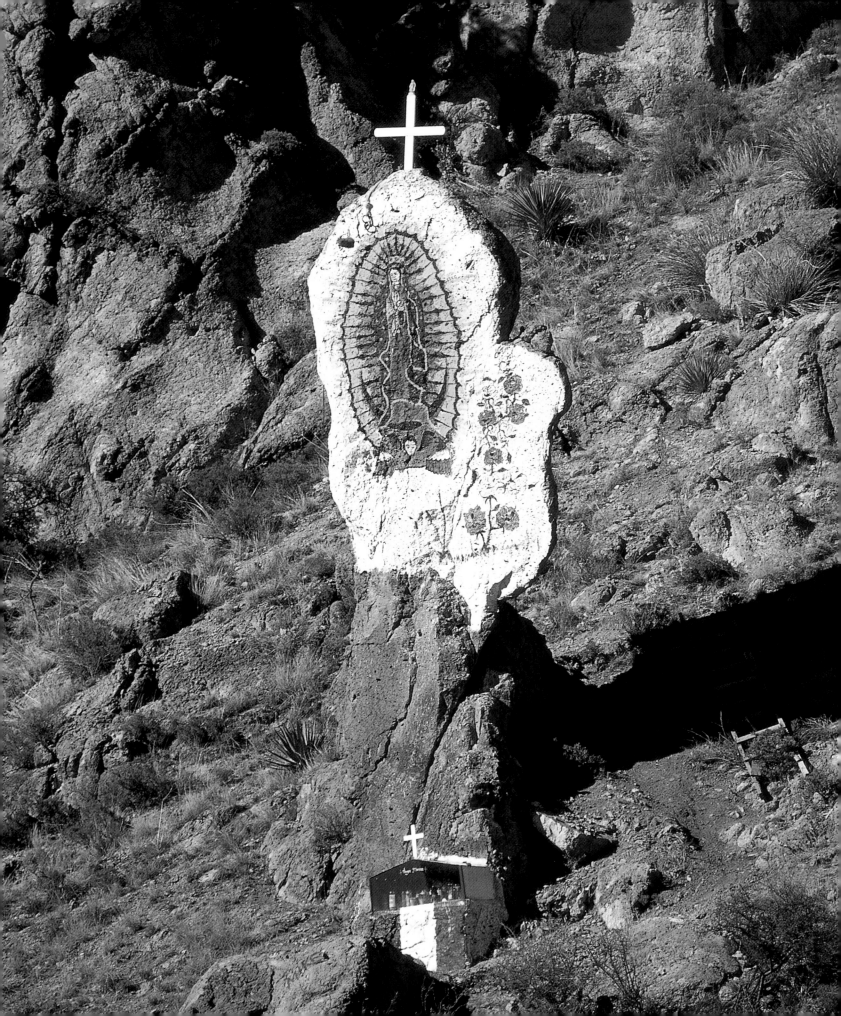

3.

FROM AGUA PRIETA, the route follows Mexican Highway 2 for about ninety miles eastward, parallel to the border and often within sight of the row of monuments built by the Bartlett Expedition that surveyed the international line for the Gadsden Purchase in 1852. Much of the scenery sketched by Bartlett's artist has hardly changed in one hundred fifty years, including the rugged peaks of the Sierra Madre Occidental rising in the distance. They represent the final extension of the great North American mountain chain that begins in Alaska and runs south through the Rockies, continuing deep into Mexico. To reach Mata Ortiz, you must cross the Sierra Madre. Alive.

Two-lane, narrow-shouldered Highway 2 is not a road to drive in the dark. Thundering buses and trucks seem taller than the road is wide. Some hazards are marked: a black *toro* on a yellow sign means open range, while *Curvas Peligrosas* means "Dangerous Curves." Other warnings, such as the hundreds of roadside crosses, memorial shrines (from elaborate miniature chapels to the most rudimentary of crosses), and heaps of shattered glass, are implicit. As the highway climbs the mountains, trucks slow down to a crawl, and passing on blind curves on the edge of cliffs is hard. Ice in winter adds another risk. Painted high on a cliff just before the steepest section, a brilliant image of the Virgin of Guadalupe presides over blue jays, piñon pines, running streams, struggling traffic, and an occasional ascending spirit.

Once, the Apaches were the much-dreaded masters of these mountains. From high vista points they launched raids on all their neighbors—Indian, Spanish, Mexican, and American—and here Geronimo and his band evaded two armies until his final surrender in 1886. In fact, large parts of the Sierra Madre Occidental are still impenetrable except on foot or horseback. At the

opposite
The Virgin of Guadalupe, San Luis Pass

Traveling east out of Agua Prieta, Mexican Highway 2 crosses the Sierra Madre in San Luis Pass just a few hundred feet south of the U.S. border.

top of the mountains, San Luis Pass is more of a dark crevasse than a roadway blasted through rock that seems poised to fall at any minute, but daredevils have autographed the narrow corridor nonetheless.

"Mexican death is the mirror of Mexican life," wrote Octavio Paz, Mexico's Nobel laureate poet and critic, in *The Labyrinth of Solitude*, his classic study of the national character. "Our songs, proverbs, fiestas and popular beliefs show very clearly that the reason death cannot frighten us is that 'life has cured us of fear.'" This is a nation that has risen above brutal conquest and revolution, that celebrates the Day of the Dead by eating candy skulls and crying bitter tears. "The Mexican," continued Paz, "is familiar with death, jokes about it, caresses it, sleeps with it, celebrates it; it is one of his favorite toys and his most steadfast love." Something of this attitude can be seen in Nicolás Ortiz's black rattlesnake-and-mouse pot, which artfully mixes the macabre with the deeply serious. The pot also demonstrates another characteristic of Mexican art: the use of animal designs stretched past realism into something mythological, grotesque, or funny.

And here ends the state of Sonora in a burst of light and a sign, which reads in Spanish: "Welcome to Chihuahua, the largest state in the Republic of Mexico."

Place is all-important. The story of Juan Quezada and the potters of Mata Ortiz is set in *el norte*, the North of Mexico, a very different place from teeming Mexico City or the tropical South. Chihuahua, Sonora, and the other thinly populated states of the North make up a region much more like the American West than anywhere else. According to the stereotype, which must, of course, be taken with many grains of salt, Northerners (*norteños*) wear cowboy hats and boots rather than flat sombreros and sandals; they eat flour, rather than corn, tortillas; they are miners, ranchers, and wheat farmers; they walk tall, work hard, and stand on their own two feet. Historically the North has had a closer relationship, for good and ill, with the United States than the South has, and long before the North American Free Trade Agreement was signed, the border economies were inextricably entwined. (This has helped Mata Ortiz pottery find an international market.)

Chihuahua is sometimes called "the Texas of Mexico," which might make sense geographically if Texas had towering mountains, a cloud forest, and a network of canyons substantially deeper and four times larger than the Grand Canyon. Closer to Wyoming in size, Chihuahua does share a long border and some desert scenery with Texas—and it shares something of an attitude. (Actually, the ubiquitous cowboy hats are known as *tejanos*, or Texans, in local slang.) Chihuahuans are known for being tough, ornery, independent, and *muy valientes*, very brave.

The biggest state of Mexico has a long history of support for nonconformity and rebellion: it gave refuge in 1811 to Padre Hidalgo, Mexico's Father of Independence, and it often served as center stage during the 1910 Revolution. Currently Chihuahua is a hotbed of new political parties challenging the P.R.I., the Institutional Revolutionary Party that controlled Mexico for much of the twentieth century. Yet Chihuahua's own special culture looks back as well as forward, and it contains human as well as geographic diversity. The Ice Age hunters and gatherers were only the first of many different immigrants to the area. When Chihuahua produces art, that also comes on Chihuahua's own strong-minded, multicultural terms. A traveler returning to Mata Ortiz cannot help but think ahead, trying to perceive connections between this huge, stark landscape, the people who live in it, their history, and their art. Visions of pots and potters begin to arise, vibrant and personal against the vast open spaces.

For example, a Mata Ortiz nativity scene by Manolo Rodríguez depicts the Holy Family as pre-Columbian figures adorned with jaguar skin loincloths and magnificent body paint. The Wise Men bring corn. In Mata Ortiz,

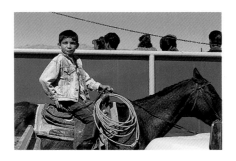

This young rider was one of hundreds of spectators attending a *jaripeo*, or rodeo, at the Hacienda San Diego outside of Mata Ortiz.

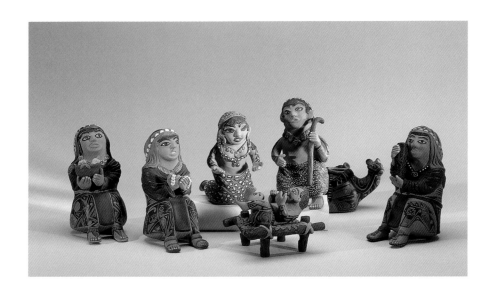

Typical of Manolo Rodríguez's early effigy figures, this nativity was made over a series of years for trader Steve Rose. Each figure is approximately 5 inches tall.

as in the little *ranchos* along the highway, there are no sheep at all, so there are none in Manolo's nativity scene. In other Mata Ortiz pots, the local color is completely literal: ferric red and manganese black paint from the rocks of the Sierra Madre, buff-colored clay from the foothills. Does landscape influence design? Does it help explain the potters' bold hand with black, and their strong sense of the power of positive versus negative space? Or is this more a matter of history and style? What gives them this passion to be potters?

"Necessity," says Roberto Bañuelos frankly. The only job he had had before he learned to make pottery was agricultural work at a few dollars a day, which is still the standard job and wage for non-potters in Mata Ortiz, as it is across rural Chihuahua. He lifts a bowl to display the fantastic reptile painted on the side. "No, it's not an iguana," he jokes. "Be careful! It's a *chupacabras*—a supernatural goatsucker!"

"Why make pots?" muses Humberto Ponce, lifting his long, thin paintbrush between one *cuadrito*, or tiny square, and the next. His work clothes are a New York Yankees cap and a red sweatshirt. A second-grade teacher, he becomes a potter in his spare time, painting "to relax" at the family dining table, where legions of *cuadritos* march off his brush and onto white jars. "I do it to grow," he explains. "The best part is doing the work better each time. As I paint I always search for something new, not just to earn a higher price, but to surpass myself. What's the point of doing the same thing?"

As the patterns of squares slide over the cheeks of his pot, they transform themselves from rectilinear to curvilinear forms. Humberto is painting this graphic essay on lines versus curves upon a pot made by his exuberant, outspoken wife, Blanca Almeida, who also does the painstaking work of polishing.

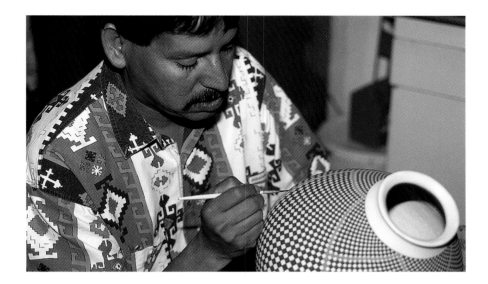

After his day job as an elementary school teacher in Nuevo Casas Grandes, Humberto Ponce spends most of his evenings painting.

"I forget the rest of the world when I'm polishing," Blanca says. "It takes all my attention. Making pottery is tiring . . . but not boring!"

Her sister Gaby laughs, "Me, when I make pots, I put on some music, and I work a little, and then I get up and dance a little, and then I work again. It's beautiful! Very beautiful work!" Gaby also specializes in shaping and polishing the pots that her husband, César Domínguez, paints. Like Humberto, he is a full-time elementary schoolteacher as well as a skillful and productive potter.

Mata Ortiz is about the same size as the little town of Janos, where Highway 2 reaches a junction with Highway 10, the route south to Nuevo Casas Grandes and eventually Mata Ortiz. (How many of these two thousand people would show artistic gifts if they got the chance? Perhaps any little town, or even any person, has undiscovered potential.) Each settlement along this route has evolved unique tactics to survive in such a rugged environment, where the great enemies are isolation, poverty, drought, and altitude. Clasped between the two motherly mountain range arms of the Sierra Madre Occidental and the Sierra Madre Oriental, the Altiplano, or high plains of northern Mexico, is the third highest inhabited plateau in the world, after those of Tibet and Bolivia. The altitude of the Altiplano averages about 4,000 feet in the north and twice that in the south, near San Luis Potosí. In the 1990s Janos seems mainly occupied in selling services to travelers, especially fixing their flat tires at its many *desponchados de llantas*, or tire repair shops, but a restaurant named "El Apache" gives an ironic clue to its past.

Compared to Mata Ortiz, Janos is an important crossroads with a long history. For well over two hundred years, this lonely town lived under siege. In fact, the last recorded battle ever fought between Mexicans and Apaches

took place in Janos . . . in 1928. And legends persist that renegade Apaches are hiding in the Sierra Madre to this day. The rococo wedding-cake towers of not one but two Spanish colonial churches rise above the flat adobe rooflines of Janos. Here only twenty years ago researchers discovered and transcribed a Spanish pastoral play that had been preserved in local oral tradition perhaps since the seventeenth century. "Both our Spanish and our Indian heritages have influenced our fondness for ceremony, formulas, and order," wrote Octavio Paz, finding a parallel between the excellence of Mexico's baroque art and the great geometric power of its native architecture and design. Here in Janos, too, signs of more recent Chihuahuan history begin to appear: *Se vende queso menonita*, these signs declare, or "Mennonite cheese sold here."

White cheddar is one of the surprising art forms of Chihuahua. A few miles off the main road, the scrubby landscape of the Chihuahuan Desert suddenly gives way to cottonwood trees, farmhouses, barns, and pastures; a trim horse-drawn carriage dashes past, driven by a tall blond woman in a long purple dress and wide straw hat with flying purple ribbons. Somehow a European country village from a bygone century has dropped down among the cactus. Chile peppers are growing in prim gardens.

This village, Los Alamos, is one of about twenty Mennonite colonies or *campos* in Chihuahua, although most lie farther south near the city of Cuauhtémoc. In the early 1920s President Obregón offered a religious refuge to a group of these traditional Protestant farmers who were being deported from Canada for their pacifism. In a sense, the Mennonites have been rebels and refugees ever since founding their sect in fifteenth-century Germany; they are still fleeing the Inquisition, speaking German, and making excellent cheese, perhaps the best in Mexico.

"The *quesería* is open to the public, yes, certainly, every morning from nine to two," says the trilingual, apple-cheeked storekeeper at Los Alamos. "Except Sundays."

What appears to be a farm shed is actually a state-of-the-art cheese factory, the *quesería*, where three muscular men toss troughs of white curds with sterilized steel pitchforks before packing them, dripping yellow whey, into cloth-lined hoops and sending them on their way to join the racks of pale cheeses aging in the cold room.

The Mexican Mennonites live partly turned inward, their backs to the modern world, by candlelight; and partly in the mainstream of modern Chihuahua. Men and boys wear denim overalls and white cowboy hats, while married women cover their heads beneath their hats with fringed black silk shawls, unmarried women and girls with white ones. Yet their stainless-steel *queserías* run on electricity and their green tractors are up-to-date John

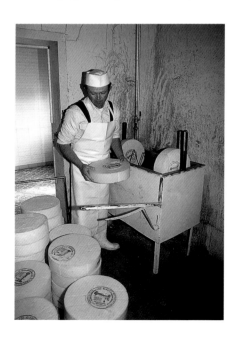

At the *quesería* in Campo Los Alamos, Mennonite cheese is being sealed in wax before aging in a large walk-in refrigerator.

Three Mennonite men are on their way to the market in Campo Los Alamos.

Deeres. And all good Mexican cooks prize the cheese for its delicate acidity and its melting quality.

Moving on, it's agriculture all the way for the remaining forty miles to Nuevo Casas Grandes: alfalfa, cotton, wheat, oats, and occasionally corn, followed by vast orchards of peach, pecan, and apple trees. Eventually, old mellow red brick houses begin to appear in tidy rows among the apple trees, followed by a steepled church and a school: a second uncanny glimpse of another place, another time. This time it's Anytown, Utah, U.S.A. a hundred years ago, as exotic in its own way as the earlier vision of rural Germany with cactus.

We have just arrived in Colonia Dublán, a Mormon colony settled in the 1880s by another group of religious refugees, this time fugitives from criminal prosecution by the United States government. Their crime was church-sanctioned polygamy, but Mexico was—and is—a tolerant place. Polygamy prevented Utah from becoming a state until the church officially abolished the practice in 1890, but many exiles continued the practice in the Mexican colonies (originally eight, now two). This latter-day Mormon migration took place during the dictatorship of Porfirio Díaz, known as the *porfiriato*, a thirty-year period of deceptive calm (and heavy foreign investment in Mexico) that preceded the storm of the Revolution. Both Mormons and Mennonites have been instrumental in developing the agricultural economy of Chihuahua, and the history of the Mormons in Mexico is interwoven with the history of Mata Ortiz.

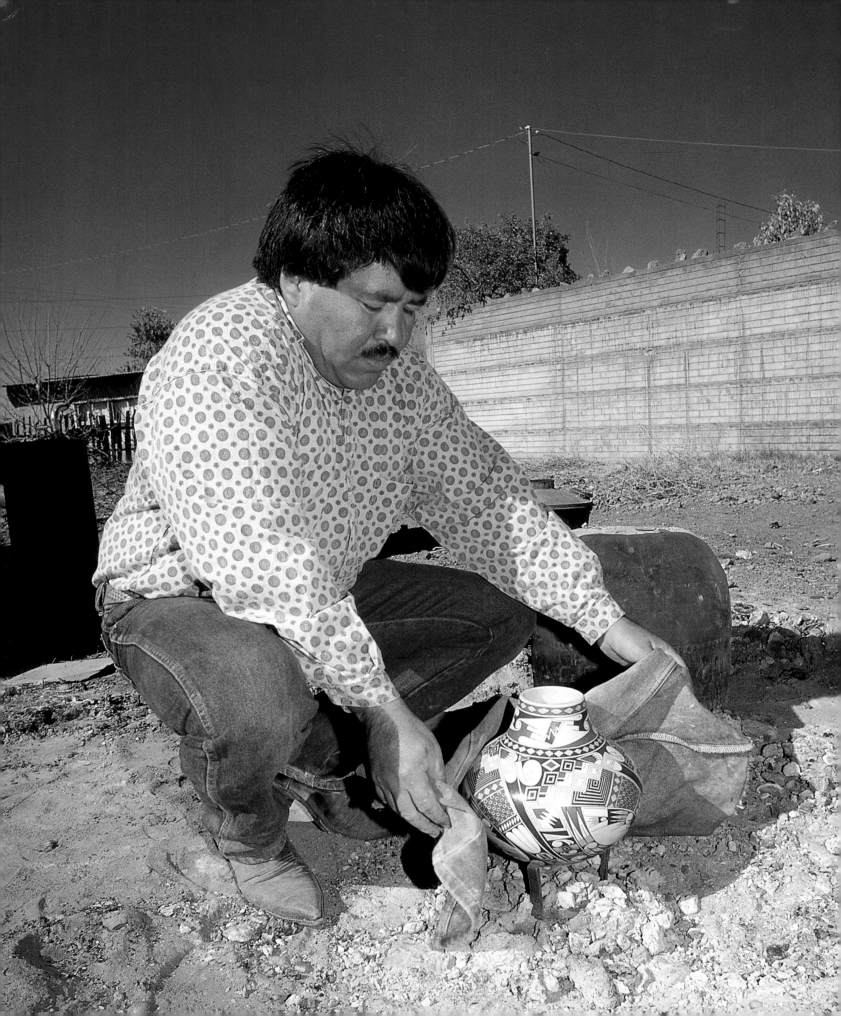

4. COLONIA DUBLÁN melts into Nuevo Casas Grandes (literally New Big Houses), a bustling modern city with a population of 80,000. Founded as a railroad station in 1897, Nuevo Casas Grandes was another byproduct of the *porfiriato*, which saw Mexico crisscrossed with train tracks. Then during the Revolution rival generals, including Pancho Villa, commandeered the trains for their armies, filling the boxcars with horses, the tops of the cars with soldiers, and nets slung underneath the cars with camp followers, including women, children, dogs, hogs, cats, monkeys, parrots, and songbirds. The Casas Grandes area was in the thick of the action, and by 1912 the terrorized Mormons were forced to make a temporary exodus to El Paso. By and large, Villa chose not to harm them physically, preferring to milk their prosperous colonies for all the supplies he could get. Once after playing cat and mouse for days with three captured missionaries, he let them go free at last—a favor they never forgot. In return, under his real name of Doroteo Arango, the general was officially converted to the Mormon faith in 1966. (He had been assassinated in 1923.)

Nowadays Nuevo Casas Grandes (not Janos) is the crossroads of northwestern Chihuahua. On its crowded streets, businessmen with cellular telephones do their banking at automated teller machines and then rub shoulders with Tarahumara women, down from the Sierra Madre, wearing stiff ruffled petticoats of shocking pink and neon orange and plump babies tied in shawls on their backs. Chinese-Mexican innkeepers welcome an international array of guests; shoeshine men polish cowboy boots all day long; restaurants serve tacos and pizza; uniformed children walk to school, trailed by lanky yellow dogs; funeral trucks weighed down with palm fronds creep

opposite
Jorge Quintana examining a newly fired pot at his studio in Nuevo Casas Grandes

toward the cemetery; chattering wedding parties dressed in white lace and red satin spill down the steps of the Church of the Holy Spirit, which is surmounted by a huge sheet-metal dove encircled with light bulbs; Mormon entrepreneurs in pickup trucks pass Mennonite farmers shopping on foot, their wives walking two paces to the rear; and every Sunday evening a whirlpool of youthful humanity rolls round and round the *plaza central* and up and down the main street, acting out a contemporary version of the traditional *paseo*: a weekly chance to see and be seen.

In gift shops around town, a selection of Mata Ortiz pottery can also be seen. This is the closest city to the village, and it offers visitors the widest choice of gas stations, motels, and restaurants. Nuevo Casas Grandes is also home to a group of important Mata Ortiz potters, including Lydia Quezada, Damián Quezada, Humberto Ponce, César Domínguez, Porfirio (Pilo) Mora, Jorge Quintana, and others who have moved here for the sake of jobs or education. All, however, maintain close connections with their hometown, located about twenty miles to the southwest, and with one another.

"There's a great interchange between potters here," says Humberto Ponce. "We work together. We exchange designs."

"We talk to each other often," says Jorge Quintana. "We discuss paint, clay, technique. We help to sell each other's work." Jars by other potters stand beside his own on the shelves in his living room. Meanwhile in the vacant lot across the street, a new pot is firing beneath a cloud of pungent manure smoke. The polished woodwork in his house is a clue that his original trade was carpentry.

"To be a carpenter, it's necessary to have a certain sensibility," Jorge explains, "and in some ways it's the same for a potter. Good potters must meditate first. You have to plan—to hold an image in your mind of the pot that you want to make real. And then of course the personalities of the potters are reflected in their work."

Before an audience of small grubby neighborhood boys, pet geese, stray dogs, and Americans, Jorge lifts the sooty terracotta flowerpot that serves him as a kiln, or *quemador*, and reveals his latest work. He is trying out a new design, a pot with something of the long-necked silhouette of a Greek amphora but without handles. Jorge has divided it horizontally into three zones of firm, well-proportioned design. The basic clay is cream-colored, the paints are black and brick red. Between the stability of the neck and base, which are neatly checkered, the wide center portion almost bursts off the pot in a riot of slants, swirls, spirals, circles, ovals, and arcs.

"An artist," he says, "is always searching for something better. He's always making different things. He's full of *inquietud*, an interest, a restless-

ness, an anxiety to improve. An artisan is always making the same thing hundreds of times."

Damián Quezada is decorating a jar in his little backyard workshop. His tools lie close at hand: a syringe, a rag, a baby food jar full of thin homemade black paint, a few razor blades, and the handle of an old felt-tipped pen that he has converted into a paintbrush. The studio also contains Elvira's equipment, but today a row of clothespins jauntily pinned across her shirt announces that she is doing laundry instead of building pots. In their collaboration Elvira sometimes forms a pot according to Damián's plan for painting it, and at other times she molds the pot, and he matches the painting to her design.

"I've been a potter for eight years," he says, running a hand through his short upright black hair, "and I've changed a *lot*." He looks down at the complex design in progress. "This is what characterizes me especially. There's no other person who makes designs in five to eight parts. But I never use a pattern, and I never measure, because a ruler would break the tradition. The whole design grows out of a single line."

He smiles broadly. "I'm a potter *por tradición*—and *por gusto!*"

Along the road to Mata Ortiz several miles south of Nuevo Casas Grandes lies quiet old Casas Grandes, which dates from 1661. With its small shady plaza and its baroque Franciscan church, it calls up yet another vision of the past, a sleepy Spanish colonial past this time. But Casas Grandes new and old are young compared to Paquimé. Here at last, on the edge of the town, stand the original *casas grandes*, big earthen houses impressive even in

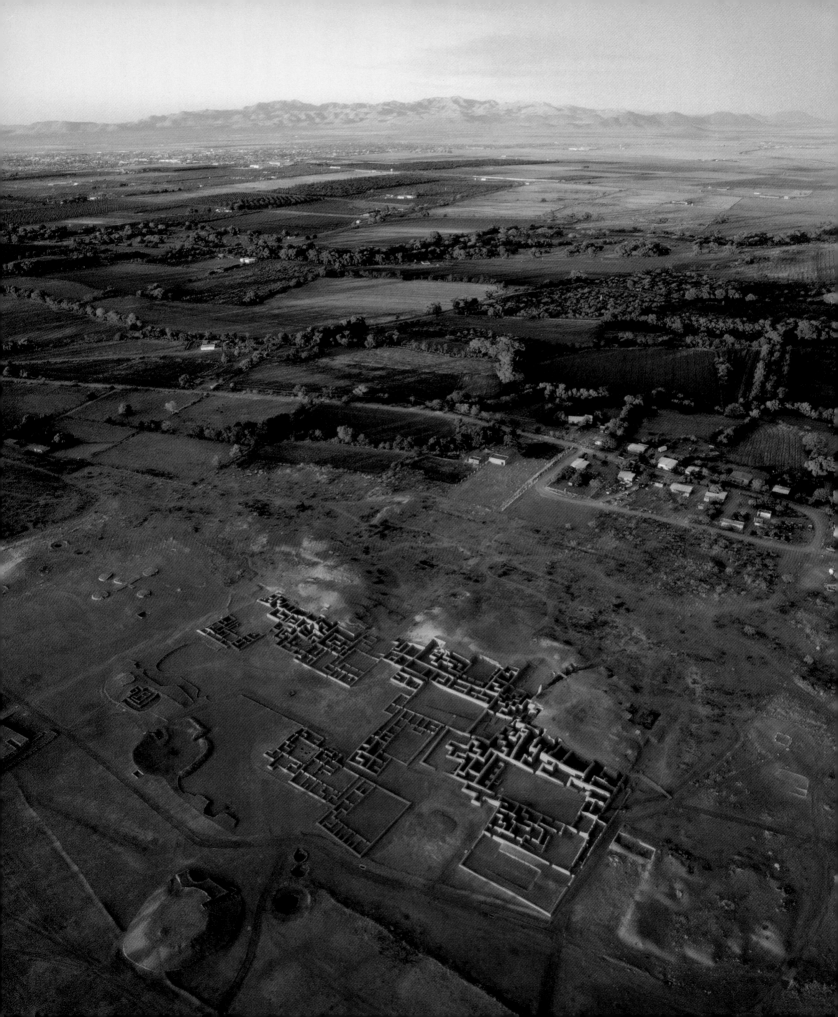

ruins—the source of the name of both towns and the fertile river valley. And here is the source of much else besides, as a self-guided walking tour of the *pueblo* and a visit to the superb new museum will show. Besides putting the local earth to use in their huge structures, the ancient inhabitants of the valley also shaped it into fine ceramics. Jorge Quintana puts it in a nutshell: "Our geometric designs come from Paquimé."

Like the two cities of Casas Grandes, the phenomenon of Mata Ortiz is both new and old: the modern potters are the heirs of a great tradition. Covering an eighty-eight-acre site, Paquimé is a truly massive pre-Columbian pueblo constructed of rammed earth rather than adobe bricks and once perhaps four stories high. With its water wheel, public plazas, and labyrinth of rooms connected by curious T-shaped doorways, it is easily as extraordinary as the ruins of Mesa Verde and Chaco Canyon, its contemporaries to the north. It was excavated between 1958 and 1961 by a team of archaeologists from the Amerind Foundation in Arizona and the Instituto Nacional de Antropología e Historia of Mexico. The earliest settlement on the site was a huddle of pit houses built about the year A.D. 700. Then, possibly conquered or colonized by traders from central Mexico, the village grew into a towering capital, a focus of religious, political, commercial, and cultural power throughout the whole Gran Chichimeca between approximately A.D. 1000 and 1400. Then decline set in, and Paquimé was burned and abandoned by about 1500. The era of the tall buildings coincided with the era of the finest pottery.

In the sixteenth century Fray Bernardino de Sahagún interviewed a potter from central Mexico, whose description of his work survives in the Florentine Codex. "I make *ollas*," he said. "I make water jars. I made large water jars. I make bowls, pots, basins. Whatsoever I make, I make with clay."

"I almost think," says Damián Quezada, "that they left an inheritance that stayed right here in the region." His cousin Leonel Quezada, another second-generation potter, agrees. "Our style is definitely related to Paquimé. And it was a great thing to reawaken that tradition, and to follow in the footsteps of *los antepasados*."

In ancient times, as in modern ones, the city was surrounded by many villages, probably political satellites or colonies, which too have melted into mounds and ruins along the rivers and throughout the foothills and mountains of the Sierra Madre Occidental. Then as now, the watercourses carried the lifeblood of this high desert land. The rulers of Paquimé were excellent hydrologists and engineers who managed the rivers as they controlled the inhabitants, building a water and soil conservation system of dams and irrigation canals throughout the area. Paquimé itself boasted the luxury of running water, also an aid to the various industries, for the *pueblo* seems to have

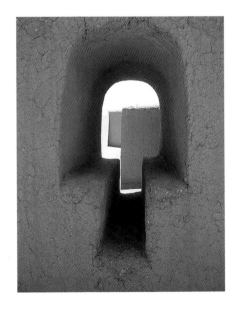

Symbolic of Paquimé, these low doorways were used throughout the complex.

opposite
Paquimé, the original *casas grandes*, in the foreground with the farmed fields of Casas Grandes and, beyond that, the town of Nuevo Casas Grandes.
Aerial photograph © Adriel Heisey

been a manufacturing and trading center. Four million seashells were recovered from the ruins. And probably for food and plumage, maybe for religious reasons, the Paquimeans raised macaws and turkeys, whose cages still remain; but the only feathers in the pueblo today have drifted down from wild pigeons flying overhead.

In the late twentieth century Paquimé is very quiet. (Even in urban areas, almost no airplane traffic rattles the clean skies of northern Chihuahua.) Its ball court, perhaps used for games resembling jai alai, is deserted; its ceremonial platform is occupied by hushed tourists wearing fanny packs, instead of high priests crowned with macaw and quetzal feathers. These two architectural features are clues that ancient Casas Grandes was connected culturally to the Mesoamerican civilization of the South—the same Aztecs who referred to the Chichimecans as "sons of dogs." Their way of life did have a dark side: to lose a ball game sometimes meant execution; human sacrifice was not uncommon at Paquimé, judging by certain burials; and most likely they suffered under slavery and war. But surely life in the Gran Chichimeca was not the unrelieved misery suggested by the Florentine Codex.

For there was also beauty. Exquisite artifacts, including jewelry, tools, clothing, and ceremonial objects, came from the hands of shell workers, lapidaries, coppersmiths, woodworkers, stonecutters, feather workers, weavers, bone carvers, and potters. Some of this treasure is on display in the museum: tiny copper bells, fragile necklaces of pale pink shell beads (brought three hundred miles across the Sierra Madre), and whimsical clay vessels in the shape of fashionable persons bedecked with jewelry and makeup and comfortably reclining on their sides while they stare coolly back at visitors gawking through the glass. Traders must have made long journeys, for prehistoric Casas Grandes ceramics have been found as far from Chihuahua as Mesa Verde, Colorado; Webb Island, Texas; the shore of the Gulf of California; and Mexico City.

One of the many fascinating discoveries in the ruins of Paquimé was a pottery workshop, complete with lumps of raw clay, rolled fillets of clay ready to be coiled, scrapers, polishing stones, and even an unfired pot. Archaeologists also recovered enormous quantities of finished pottery in many styles, especially the sophisticated red and black "Ramos Polychrome" that has been the single strongest influence on the work of Juan Quezada and the potters of Mata Ortiz. Other models for modern ceramics are also obvious. Paquimé and the surrounding ruins yielded plain and painted black, brown, white, and red ware, formed into bowls, canteens, and jars as well as miniatures, ceramic jewelry, and effigy pots shaped like lizards, macaws,

opposite
**Effigy pot, 10¾ x 9 inches,
Andrés Villalba, 1998**

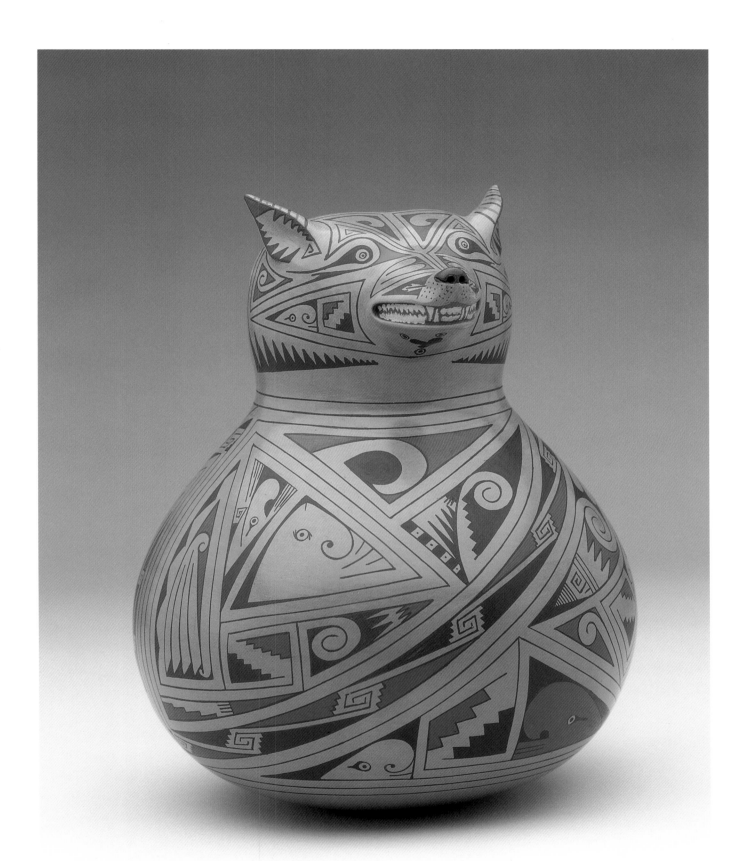

snakes (or plumed serpents), turtles, fish, and hooded humans. Most common of all were potsherds, the painted ones especially poignant, like scraps of messages in the language of the dead.

"The potter," proclaims the Florentine Codex, "is wiry, active, energetic. The good potter [is] a skilled man with clay, a judge of clay—thoughtful, deliberating, a fabricator, a knowing man, an artist. He is skilled with his hands. The bad potter is silly, stupid, torpid."

It is no coincidence that while the dig progressed at Paquimé in the early 1960s, Juan Quezada was conducting his pottery research fourteen miles upriver in Mata Ortiz. Interest in antiquities ran high throughout the area, and a market quickly developed for pots—old and new. Unfortunately, many archaeological sites were sacked for the value of their pottery. Meanwhile, however, Juan passed his hard-won skills on to some of his brothers and sisters, establishing the first pottery family in Mata Ortiz, a pattern that continues today.

"It's something that runs in the Quezada blood," suggests Damián, while Leonel sees it slightly differently. "The whole family has turned out to be very good workers," he says. "This is the best job you can get nowadays."

Families still tend to share knowledge and to specialize in particular styles, techniques, paint formulas, and clays. Very white clay is one hallmark of the Quezadas (although they work in all colors); another hallmark is a sharp, clear quill-like quality in the designs, owing to the extremely fine lines. The Rodríguez clan has a distinctly quirky sense of humor; for example, in Manolo's nativity scene, the Virgin Mary sports a spotted jaguar-skin halter top. Their close neighbors the Ledezmas specialize in precise, repetitive latticework designs. In Barrio Porvenir, the Ortiz family shares a sculptural flair as well as a taste for blackware and graphite finish, while the Villalbas strive for historical accuracy in the pots, effigies, and plates that they make in polychrome Paquimé and black-on-white Mimbres styles.

But in the middle of the 1970s when Juan quit his railroad job to become a full-time potter, none of this had happened yet. Obviously the excitement over Paquimé had created a demand for hand-crafted pottery in the Casas Grandes area, but what kind of market was it? Next to the ruins, crude imitations of Paquimé pots also sold well. And the purchasers of some of Juan's early pots deliberately distressed them for resale across the border as false pre-Columbian Casas Grandes ware. Would the new potters of Mata Ortiz choose to make curios, fakes, or original art? They had reached a turning point.

5.

THEN ONE DAY IN 1976 Spencer MacCallum went browsing through the rummage in Bob's Swap Shop in Deming, New Mexico, and three clay pots stopped him in his tracks. He was particularly fascinated to see that their red and black painted designs contained mazes. Labyrinthine pathways, full of twists and zigzags and tricky dead ends, completely encircled each pot.

"I sat tracing the designs on the pots for forty-five minutes," Spencer recalls.

Captivated, he entered the maze himself, finally arriving at Mata Ortiz, where he found Juan Quezada. For several years they worked closely

The late Don Luis Quezada (Juan Quezada's father), Spencer MacCallum, and Emi MacCallum sit among the honored guests at Juan's fifty-seventh birthday party in June of 1997.

together, and launched Juan Quezada and Mata Ortiz pottery into the wider world. In the process, Spencer learned that Juan had a name for the pathways through the labyrinth of design: he called them *caminos*, or roads. After that pivotal moment of seeing the three pots in the junk shop, certain other extraordinary experiences—-and certain pots—stand out in Spencer's memory.

"I have one by Lydia Quezada that I love," he says. He pauses, thinking how to describe it. "It looks like sewn leather," he says at last. "Light brown, with a darker design, very smooth. . . . It was when she was pregnant with her first child, working on a ranch in New Mexico, very happy, that she made it for me from clay she found there."

And then there is what Spencer calls the "levitation pot."

At the end of his first three years of working with Juan, their relationship changed. Juan's career was launched, and Spencer would no longer serve as his exclusive sponsor and buyer. "So I went to find Juan, to find the conclusion of the adventure of the three pots in the shop," Spencer remembers. "And when I got there, I found that it wasn't over after all. My eye fell on one of the nine or ten pots he had spread out on the ground, a large black one that I still have upstairs, and I experienced a psychological state that I've never felt before or after."

His experience will not surprise readers of recent Latin American literature or anyone who knows the special atmosphere of the region. The school of fiction called *realismo mágico* (which includes such writers as Gabriel García Márquez, Isabel Allende, and Laura Esquivel) is actually rooted as solidly in fact as it is in fantasy. With no change in his usual calm, clear, and logical tone, Spencer continues the story.

"Whoosh! I felt I was twelve to eighteen inches off the ground. The sensation lasted for twenty minutes, and it was so vivid, so real that I looked around, but nobody else seemed to notice. It meant, I think, that Juan was on his own; I felt a completion of what I'd originally come down looking for, three years before."

They had reached the end of one road. But they did carry on their association somewhat longer, although on different terms, and Spencer's warm interest in the village still continues. He was the first of many outsiders to discover Mata Ortiz, following the lure of the pottery all the way to its source, for today the old trade routes are active again. Modern traders and pot collectors came first from nearby areas, especially northern Mexico and the American Southwest (essentially the former Gran Chichimeca). But now they converge on Casas Grandes and Mata Ortiz from various parts of the world. "It's really put us on the map," observes Macario Ortiz with satisfaction. Some who came to visit or trade have found their lives inextricably linked with the village. Others have actually settled there. Exhibitions of pots

have traveled to both coasts of the United States, Mexico City, and Colombia. Tourists have come to Mata Ortiz from as far as Japan and Italy, and during his visit to northern Mexico in 1990, Pope John Paul II was presented with three Mata Ortiz pots, one by Juan Quezada, one by Andrés Villalba, and one by Macario Ortiz.

What gives Mata Ortiz pots their special charm?

"Yo no sé qué es el encanto," says Nicolás Ortiz thoughtfully. "I don't know what the enchantment is." But then he offers a theory. "Possibly it has to do with the very basic, fundamental materials and the fact that all of us work with nothing but our hands."

"Yes, the pots do have something magical about them," says Damián. "It's a special mixture of the old and the new. And they come from *here*, no place else."

Humberto Ponce has a different point of view. "Magical? I don't believe it," he scoffs. "I am not a magician. What happens is simply the act of creation, and creativity is a type of magic."

Bill Gilbert, a professor of ceramics at the University of New Mexico and the curator of several exhibitions of Mata Ortiz pottery, expresses its charm quite differently, with praise for its "elegant formal style," "the complicated iconography of [its] design systems," and its "powerful sense of movement." He sees the pottery as "one of the more successful weddings of two-dimensional and three-dimensional design in contemporary ceramics."

"Orbs from another planet," is Walter Parks's memorable description of Juan Quezada's early pottery in *The Miracle of Mata Ortiz*, his definitive study of the master potter and his village.

"Something is happening here that's happening in no other place on the planet," says Michael Wisner, a Colorado potter with extensive knowledge of other pottery traditions and who has long studied with Juan Quezada. He marvels over the fanatical attention to detail, the goal of extremely high technical quality, and the sense of energy that characterize Juan himself, all of which have spread to the community around him.

And Spencer MacCallum sums it up: "World class pottery in an unexpected setting."

Many of the unique characteristics of Mata Ortiz pottery are based on archaic models, but the modern potters have either extended these concepts or given them a fresh contemporary spin. For example, tiny checks (the *cuadritos*) can be found in Paquimé designs, but around 1980 Juan's daughter Nena connected them with the graph paper she was using in her eighth-grade mathematics class and saw the possibility of covering large areas of a pot with them, a notion that has now become part of the vocabulary of Mata Ortiz design. Classic Casas Grandes patterns tend to show bilateral or quadri-

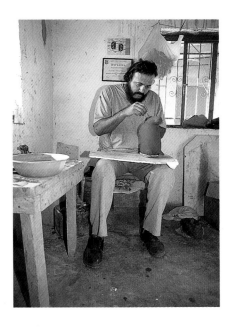

In a small studio attached to his home, Nicolás Ortiz forms a rabbit.

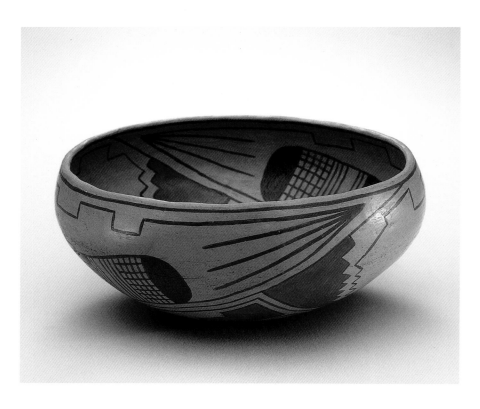

Olla, 3 ¼ x 7 ¼ inches, Nicolás Quezada, circa July 1979, San Diego Museum of Man Cat. No. 1997-2-242

lateral symmetry, a tradition that potters such as Damián have delighted in shattering with their difficult odd-number multiple designs.

More generally, Mata Ortiz pots are dynamic rather than static. The designs spin, they thrust, they swim, they leap back and forth. Perhaps influenced by the spirals of the seashells that were a prized jewelry material at Paquimé, the patterns painted on ancient Casas Grandes ceramics always tended to run more diagonally than the horizontal banded designs of Pueblo pottery. Early in his career Juan Quezada pushed this sense of diagonal movement even farther, and, looking for even greater scope, began to decorate the bottoms as well as the sides of pots.

For a cooking vessel meant to be blackened in the fire, obviously this would be wasteful. However, even though Mata Ortiz pots are intended to be decorative, not practical, they are fired at temperatures over one thousand degrees Fahrenheit and are fully as watertight and heat resistant as their utilitarian ancestors. Nor will their paint rub off. Some of the lively bases of Mata Ortiz pots really demand that the pot be turned upside down: they show an interesting flip-flop kinship with the round designs lining the insides of bowls, as though a bowl had turned itself inside out. But, as if to underline the differences between ancient and modern, Mata Ortiz pots grow ever thinner, shinier—the graphite finish may be seen as a kind of extension of manual polishing—and more completely symmetrical. They are a tactile art form, made with human fingers, sized to fit inside or between hands. To be fully appreciated, they must be touched; they communicate much of their magic through the skin.

"Every potter has his beliefs," says Jorge Quintana. "Nicolás Quezada doesn't want anyone to see a pot before it's fired, and I always make sure mine are signed before I fire them. And always when I begin a pot, I more or less offer it up to God. I believe that this way it will come out better. And when I'm working I say to God, 'Let this one come out better.'"

Juan's youngest sister, Lydia, and her husband, Rito Talavera, who is also an excellent potter, live with their two children in a quiet middle-class neighborhood of Nuevo Casas Grandes, in a comfortable house tucked away behind a cowboy boot shop. One leisurely Sunday afternoon, after church and dinner, several members of her family gather in her living room.

"The pottery is very different now, in the designs and in other ways, too," says her brother Nicolás, leaning back in an easy chair. Today he is wearing a Sunday-go-to-meeting *tejano* hat that matches his silver-gray hair. With his wife, Gloria, Nicolás has come across town from his own house, still under construction on the outskirts of old Casas Grandes.

"At first," he continues, "it was just the Quezada family, but now the new generation is doing very good work. What has changed? Well, the preparation of the clay, for one thing. Before, we used to grind it by hand with stones on *metates*, and now we soak it in tubs and let it settle."

"The pots nowadays are much less rustic," says Lydia. She is dressed in shades of cream and brown, with a long silk skirt and pearly polished finger-nails, and at first she is quite reserved.

"As with everything else, in pottery it's a matter of experimentation, improvement, and advancing techniques," Nicolás adds. "I think that in the future the pottery could fail to develop and all stay at the same level, if some of the potters don't change their attitudes. They're always thinking, 'More money! More money!' instead of how they can go beyond what they are now and constantly surpass themselves."

Lydia's teenaged daughter Paula, who is a beginning potter herself as well as a student at the premier high school in the area, slips onto the sofa

Moroni, Lydia, and Paula Quezada and Rito Talavera, 1997

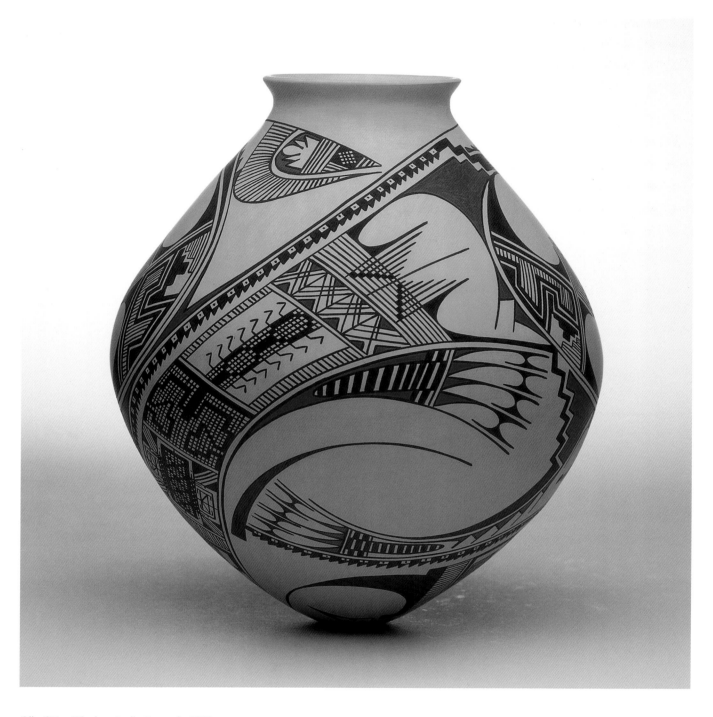

Olla, 9 ¼ x 7 inches, Lydia Quezada, 1998

beside her mother and listens intently as the Quezadas discuss what it means to be a potter. Clock time and psychological time, they say, are equally important.

"I never work in the middle of the day," says Nicolás emphatically. "I work at dawn, alone. I'm really at ease then."

"I think there are times, the very best times, when you totally surrender yourself to your work," says Lydia, leaning forward, her reserve melting. "When you are painting a pot you go to a different place, somewhere apart from everything else."

Dapper in his brown suede jacket and glittering cowboy boots, Rito puts in an occasional word, and Gloria smiles and agrees, but white-bearded Don José Quezada, the patriarch of the clan, and little Moroni Talavera, wearing a Spiderman sweatshirt, are both silent.

Two of Lydia's recent jars stand side by side, each perfectly balanced on a point no bigger than a fingerprint. For one, she turned white clay rosy by adding a small amount of red clay and then painted the pot with black and red: a young beauty. The other pot carries matte black paint upon burnished black clay: the dark side of the moon.

"Lydia didn't progress by plateaus or dramatic leaps," is Spencer MacCallum's admiring assessment of this artist. "Her career has followed a slow, perfectly straight, gently sloping line, and she's always had a fan club. There's a warmth, a humanness that attracts people to her pottery. And she also has a cosmopolitan quality."

"Sometimes I don't know exactly how the painting happened," says Lydia. "I can't stop. I say, 'Don't interrupt me because I'm really inspired!'"

Rito laughs appreciatively. "Yes, that's true!"

Inspired now, she goes on. "I have discovered something in the ancient *ollas*: all of the lines are interwoven. And I think there is a meaning in that, and it tells us that for *los antepasados* everything in the world was connected, as a family is connected among themselves and to society and the world. It's symbolic. And in my pots I am always searching for the same thing, always trying to interweave all of my own lines. I look for *la unión*, a perfect union between lines and pictures. Whenever I feel the world is disintegrating around me, I try to make my work more unified."

Where Juan and Spencer see open roads, she sees an intricate network of connected lines. "Complicated, like life," she says with a smile.

If fine labyrinthine patterns are a specialty of the Quezadas, they are also quintessentially Mexican. Derived from pre-Columbian art, the labyrinth holds a special symbolic resonance for Mexicans, according to Octavio Paz, who connected it with a national nostalgia for a lost golden world, perhaps a pre-conquest world, which causes Mexicans to feel a deep sense of solitude.

"We have been expelled from the center of the world," he wrote in *The Labyrinth of Solitude*, "and are condemned to search for it through jungles and deserts or in the underground mazes of the labyrinth."

Agriculture is the largest source of employment in Mata Ortiz and surrounding communities. This grain crop is on *ejido* land in Barrio López.

6.

BY ROAD, THE VILLAGE OF MATA ORTIZ lies a little more than twenty miles southwest of the ruins of Paquimé. A final sidewalk vendor offers a row of merchandise for sale (tombstones, televisions, typewriters, mangos, and industrial scrap metal) and then Casas Grandes vanishes. The route to Mata Ortiz is lined with memorial shrines as it winds between hills as gray-brown as wild animals. At one point, startlingly, the dry grass on the side of the road shoots up in flames. Later, also startlingly, a herd of registered Angus cattle graze in a lush irrigated field. Disappearing into the distance they look like fat black bugs on a lawn. Now the hillsides sprout apple trees, apple trees, apple trees, and the highway drops abruptly, past several huge satellite dishes and into Colonia Juárez, the other remaining Mormon colony in Chihuahua, which lies among the cottonwoods along the Río Piedras Verdes, about equidistant between Nuevo Casas Grandes and Mata Ortiz.

This town is older than Mata Ortiz. The first Latter-day Saints arrived by wagon train in 1885, purchased land, and set up housekeeping in a row of dugouts along the riverbank, not unlike the pit houses of their Desert Archaic predecessors. "We excavated some ruins and found one skeleton," wrote Hyrum Albert Cluff in his journal. "Many thoughts passed through my mind while working on these ruins and reflecting on who the people were who built those houses." Withstanding floods, earthquakes, smallpox epidemics, and Apache attacks, the Mormon pioneers remarkably soon raised red brick houses with gable roofs laid out in the typical grid pattern of Mormon towns in Utah and elsewhere. Nowadays these houses are mixed with Chihuahuan adobes and upscale contemporary architecture. A few

founders' names still stand out on mailboxes and over doorways: Johnson, Nelson, Romney. Colonia Juárez was the birthplace of George Romney, who later became governor of Michigan and whose possible American presidential candidacy in 1968 foundered for political reasons before the constitutionality of his foreign birth was ever tested.

Polygamous families usually occupied neighboring homes, sometimes all four corners of an intersection, and children called their father's other wives "Auntie." Half-siblings close to the same age were sometimes known as "Mormon twins." Sometimes the wives dressed alike and lived like fond sisters; sometimes perhaps they did not. Hyrum Cluff continued in his journal: "February eighth, was permitted to accept the high laws of God which was a very great trial to Rhoda [his wife]. . . . I'm sure everything will work out. [Today] I married Delia Floretta Humphrey here in Mexico. The year is 1903."

"Work" is a key word. Over the next two decades, through strenuous labor and with the financial support of the church, the Mormons built up a thriving network of towns and agricultural and commercial businesses in Mexico, providing jobs for themselves and their Mexican neighbors. They introduced the apples that are a major crop in Chihuahua today, bred animals, learned Spanish, celebrated Mexican holidays, promoted education, built electrical and telephone systems, and spread their gospel as they continue to do today. Lydia Quezada and her family are Mormon converts, and she has created pots that combine traditional Casas Grandes designs with Mormon iconography.

The pavement ends in Colonia Juárez. For the next ten or twelve miles a rutted dirt road runs to the southeast (turn left at the river) between cottonwoods, modest adobe houses, and open stretches filled with apple saplings and burnt fields. A white satin rosette springs out against a blue chapel door. Skinny dogs limp out of the way. The road bends, passing tumbleweeds caught against a fence, meager cholla cactus, and spiny, spindly mesquite bushes, while a longhorn cow considers whether or not to eat any of them. In the morning light, distant dry peaks seem pink, lavender, and diluted blue. A woman cranks a bucket of water from her backyard well.

As a child, Jorge Quintana lived near here in the village of Cuauhtémoc. "I remember that in the place where we lived when I was a very little boy there were three ancient ruins," he says. "And I used to play in them, and pretend that I lived there long ago, hunting and fighting with my bow and arrow. Of course there were always potsherds, and other things, too."

Modern potters, he remarks, often recognize familiar tools among prehistoric artifacts. "Today we sometimes use stones from the ruins for polishing pots," Jorge points out. "And in the museum at Paquimé I noticed a blue-

green pigment we call *carbón de cobre* [a copper mineral] displayed on some tiny grinding stones. *Carbón de cobre* makes black paint blacker. And look at this!" He holds up a jar filled with a thin, opaque, rust-colored liquid. "My uncle brought me some pigment that he found in a ruin, so I made it into paint, and I'm going to use it on my next pot," Jorge explains. "Who knows how it will turn out? But here we are, after all, on the same earth, under the same sun."

Just past Cuauhtémoc, the long buildings of the Hacienda San Diego stand proudly on a hilltop, their parapets zigzagged like crowns. Run on medieval lines, this ranch belonged to Luis Terrazas, the former governor of Chihuahua and owner of between fifteen and twenty million acres—practically his own state. With no hope of escaping their debts to the *patrón*, the impoverished *peones* of San Diego were really slaves. A vainglorious "L. T." still rises out of the stucco above Luis Terrazas's huge front door. Apparently unchanged for a century, the hacienda seems like an apparition in the desert, a setting for Laura Esquivel's romantic novel *Like Water for Chocolate*. And just for a moment, we can turn the clock back to the year 1907. The Hacienda San Diego continues to operate like a fiefdom, the Mormon colonies are flourishing, and a new town has sprung up about five miles to the south.

It is called "Pearson," a name that persists to this day in old-timers' memories and in the fading letters of a grocery store sign in the village now known as Mata Ortiz. But the village began as a construction camp for the Mexico Northwestern Railroad, a project of a Canadian inventor and entrepreneur, F. S. Pearson, whose ultimate aim was to exploit the timber of the Sierra Madre. Within a few years the flourishing town of Pearson was the headquarters of perhaps the largest lumber company of the West, with aspi-

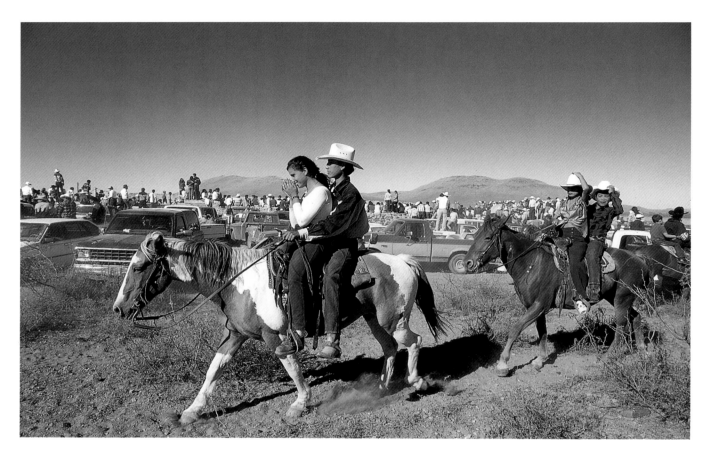

Hundreds turn out to see the *jaripeo*. Most young people dress up in their best clothes and promenade on horseback all afternoon outside the arena.

rations to become one of the biggest in the world. By 1910 a daily train connected Pearson with El Paso; the future looked bright. But on their way to work at the many new jobs there, some Mormon colonists caught an inkling of the real future when they passed through the Hacienda San Diego and sympathized with the workers' plight.

In November of 1910 a revolution erupted at last, with Chihuahua the first state to revolt. Rival armies ravaged northern Mexico, including the town of Pearson, and then the First World War broke out in Europe. The lumber mill was a casualty of both wars, for F. C. Pearson went down with the *Lusitania* in 1915. And in 1925 the town was patriotically renamed for Juan Mata Ortiz, a nineteenth-century fighter (and victim) of Apaches. But although a railroad repair shop remained in Mata Ortiz, the town's brief days of sawdust glory were over, and for much of the twentieth century it languished, managing to subsist off the railroad, a little local farming, and seasonal agricultural work for the Mormons. It is still quite remote.

Agricultural workers occupy all the buildings of the Hacienda San Diego now. After the Revolution, land reforms broke up the railroad, lumber, and cattle empires and created *ejidos*, or communal agricultural areas, at San

Diego and Mata Ortiz. The huge stone corral is used for neighborhood *jaripeos*, or rodeo days, when local *vaqueros* (buckaroos) gather to ride bulls and bucking broncos. Some of the cowboys are also potters, for Mata Ortiz lies just down the road, past the smoldering garbage dump and the cemetery, so white against the dun landscape that it pains the eyes.

Under an electric blue sky, at the foot of a peak with a human profile called *El Indio*, Mata Ortiz consists of a few rows of adobe houses sprinkled irregularly for about a mile between the murky green ribbon of the Palanganas River and the straight and narrow track of the Chihuahua al Pacífico Railroad. The village itself looks rather like a sidetracked train. Complex networks of relationship—family, social, economic, and artistic— link everyone in town. Most houses have electricity, but running water and indoor plumbing are not universal, and there are only two telephones. None of the streets are paved. Occasionally a horse and rider gallops past, more frequently a wandering burro. Delicious tortillas are still baked on wood stoves. There is a chief of police, but no doctor. There are several schools and churches, a baseball stadium, a rodeo arena, a soccer field fenced with old tires, and a little inn. There also appear to be several thousand dogs, no two configured alike, not one even remotely resembling a Chihuahua. The railroad yard closed in the 1960s and then the trains stopped running. Now the tiny depot is abandoned and even the track is being torn out, so in some ways Mata Ortiz is poorer and more isolated from the outside world at the end of the twentieth century than it was at the beginning.

But actually its ninety years of solitude have ended. To a visitor first arriving in the village after rattling down miles of dirt road, the first impression is of dust, fine brown dust exactly the color of the adobe bricks, and lots of it. Next, intense colors jump out from the dusty background: a turquoise wall, a magenta curtain, a lemon-yellow dress, a scarlet image of the Sacred Heart, a verdant, velvety wheat field. Then, if the weather is good, the next impression is of peculiarly pungent smoke rising from many small backyard bonfires. Soon a child runs up eagerly.

"¿Compran ollas? ¿Quiere comprar ollas?"

Do you want to buy pots? If you do, you will carry away far more from Mata Ortiz than your pots. The whole town is a workshop that buzzes with constant industry and a feeling of simmering excitement. Behind almost every door in the village, someone is pinching, polishing, or painting clay. Good things are happening here. Doors swing open and voices invite or indeed insist: *"¡Pásale, pásale! "* Come in!

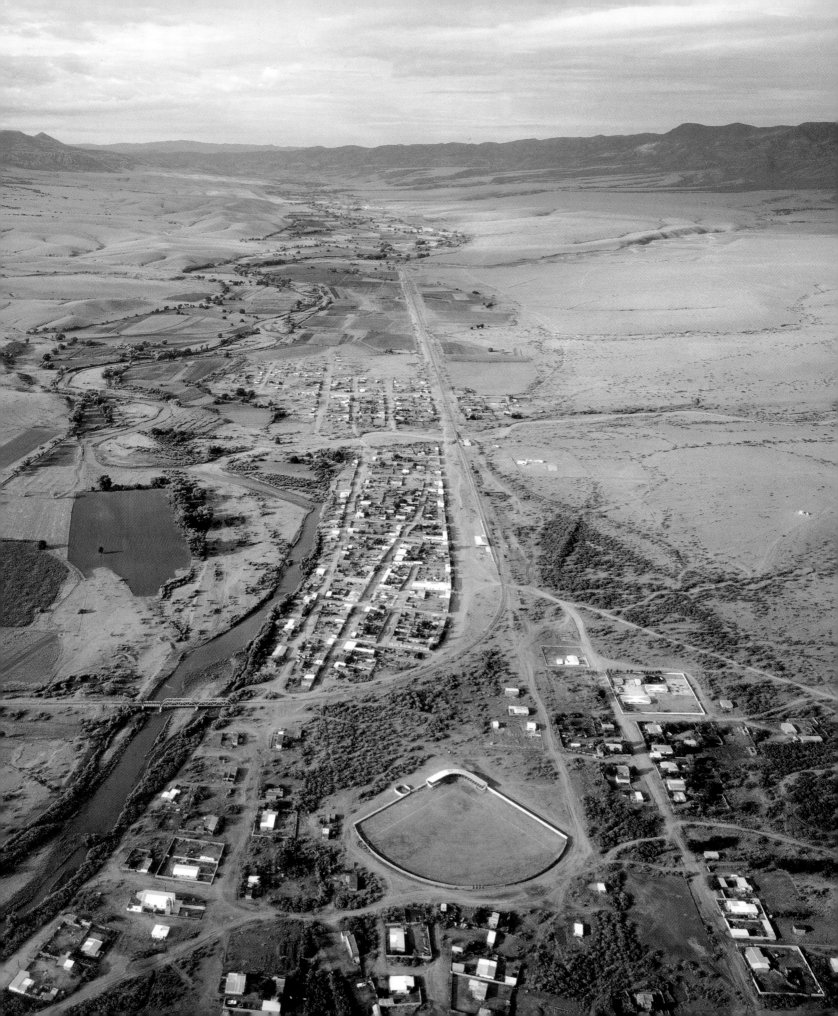

7.

SMALL AS IT IS, Mata Ortiz contains half a dozen distinct neighborhoods or *barrios*, and the first to come into sight is Barrio López. Several young men are sitting outside in the sun, sanding pots together, while piglets scuffle up the dust and buzzards cruise overhead. Here Leonel López specializes in handsome jars decorated with animal scenes, often involving engraved or *sgraffito* patterns, and young Laura Bugarini lives across the way. Or at least she used to live here.

"Oh, Laura's gone away," says her mother apologetically. The ceiling of their tidy house is papered with a design of dancing pandas in Mexican garb; the scrubbed floor is painted bright yellow. "Her pots weren't selling because other people were imitating her and charging less money, so she went to Denver and got a job cleaning houses. I don't know when she's coming home."

Just down the road, Gerardo Cota has an outstanding polychrome pot for sale, and his younger brother Martín plans to fire several amusing little *figuras* (effigy pots) and a bowl decorated with what seem to be fish on tiptoe, as soon as he finds the kerosene can. In his early thirties, Gerardo wears a vivid cowboy shirt and jeans that stay spotlessly white even while he squats in the dust and ashes beside Martín's fire, tactfully coaching his brother. Teenaged Martín sports a baseball cap and a Pittsburgh Steelers T-shirt. Gerardo lives in a house once occupied by Juan Quezada, which was built in the midst of a Mimbres ruin or *moctezuma*, as archaeological sites are called in colloquial Spanish.

"There are more than twenty *moctezumas* in Mata Ortiz," says Gerardo, "and seven are around here. I've found bits of designs, *metates* (grinding stones), and bones. The pots all have holes in them, and they're all Mimbres style, not Paquimé."

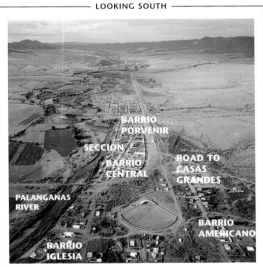

— LOOKING SOUTH —

BELOW THIS PHOTO (TO THE NORTH) IS BARRIO LÓPEZ

opposite
Looking south over Mata Ortiz with Barrio Iglesia below the baseball diamond, Barrio Americano to the right of the ballfield, Barrio Central in the center, and Barrio Porvenir at the end of the town before the farm fields. Aerial photograph © Adriel Heisey

Gerardo Cota at work in his studio

He never copies the old designs—"I create as I paint"—but he and Martín have often tried to recapture the general feeling. "We really like painting in the Mimbres style, but we wish we could get our clay to fire as hard and stay as white as theirs."

"The Mimbres white clay is very strong," puts in Martín. "And their black paint is very bright, even after being buried so long."

"I don't think it's necessary to be an Indian to make pots," Gerardo says. "Because you can learn. Anyone can do whatever he believes he can do." He thinks for a moment about the process of design. "It's strange, how it all happens. Sometimes we don't even know how we invent things—suddenly, in an instant, it just comes out."

A little farther on, three or four boys are riding burros, vigorously whacking their furry sides with sticks all the time. An old lady muffled in a scarf walks slowly past the church. This is Barrio Iglesia, where remodeling (a widespread sign of new prosperity) proceeds on the home of Carmen and Jesús Veloz. On their new kitchen counters, white clay is desiccating in trays under the watchful eye of a life-size color portrait of the Pope in his younger days. Dozens of *ollitas crudas*, or small unfired pots, are gently baking dry in a box like a homemade chicken incubator, and quantities of finished *ollitas* lie tucked under sheets on top of the beds, but there is nothing for sale. It's all promised for a show and sale at a college in Arizona.

As their youngest child toddles about, Roberto Bañuelos and his wife, Angela López, are sanding small bowls on their front porch. But these, too, are already sold as part of a large commission for a trader. A girl strolls by, wearing a Marilyn Monroe T-shirt. A neighbor hangs out her laundry. A

three-legged dog lets out a series of barks. And two small boys peer intently through the Bañuelos's wrought iron fence. Entirely without telephones—possibly by means of boys—a report of tourists is spreading through the village, for soon a car pulls up in a cloud of dust and the figure of Gerardo Ledezma emerges through the haze, bent over a cloth-wrapped object about the size of a cantaloupe. He instantly reveals a creamy globular jar covered with a network of brown and black geometric figures packed with optical illusions. Giving the impression of rectangles and squares, they are really mostly trapezoids.

Gerardo Ledezma

"Look at the bottom," he insists.

Here Gerardo has turned the design upside down, too, by breaking into curves and teardrop shapes that hint at a Paquimé macaw head. And here he engraved his signature into the pot, a practice promoted from the beginning by Spencer MacCallum and now followed by all but the most casual potters.

The Ledezmas, many of whom make good pots similar to this one, live in Barrio Americano, an area originally settled by Pearson lumber mill workers, where their neighbors include the Gallegos and Rodríguez families, as well as a number of goats, burros, violently speckled chickens, and one dog so ferocious that nobody will go past him.

There is a long waiting list for Gallegos pots, and the examples that fill their sparkling display cabinets show why. The pottery of Hector Gallegos and his wife, Graciela Martínez, which they make both individually and as a team, is remarkable for its confidence and near-perfect control of the medium. She is about forty and serene, with deep dimples; he is slightly older and seems more at ease working on a tractor in the *ejido* or in a saddle in the mountains than sitting over a graceful urn with a paintbrush in his hand. Their adult daughter Miriam also does admirable work, and Hector Jr., a recent graduate of the eighth grade, holds out one of his *ollas*, a flattish gray jar that fits comfortably in the palm of a hand. It's a whimsical stampede: imaginary insects swarm and wriggle, hop, skip, and march two by two from top to bottom, with hungry lizards, toads, and turtles in hot pursuit.

Down the street, around the corner, and up the hill lives Manuel (nicknamed Manolo) Rodríguez, one of the most innovative of the younger generation of Mata Ortiz potters.

"*¡Pásale!* " Manolo's tiny, elderly, hospitable mother waves guests through her kitchen, where vegetable soup simmers in a blue enamel pot at the back of an antique wood stove. On the TV screen in the next room, a row of giggly people dance the macarena in Mexico City. The room itself, a combination of bedroom and parlor, is decorated with golden china mushrooms and pink china elephants, a pre-Columbian jar glued back together, and the gray, sunken, shattered mass of Manolo's own very first attempt at

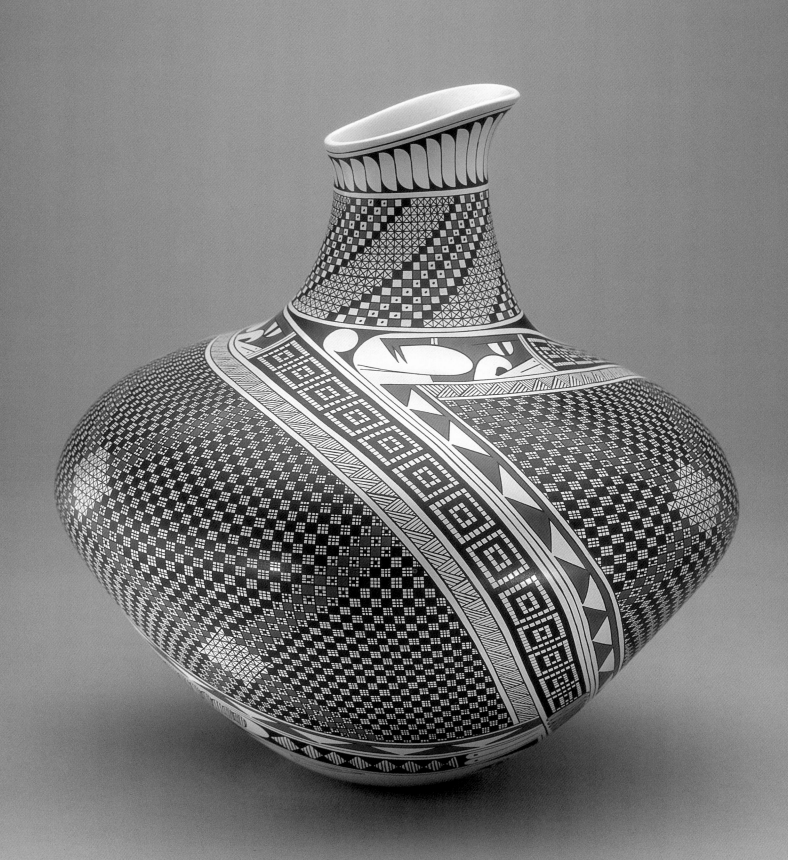

pottery, which dates from his boy-hood. Now in his late twenties, thin, agile, and shy, he is one of the premier painters in the village.

"I like making the pictures best," he says.

The games he plays with space and perspective may have been suggested originally by the M. C. Escher pictures which illustrate secondary-school textbooks in Mexico, supplemented later by Escher reproductions supplied by traders. But Manolo has created his own style. He has built fantastic stairways on three-dimensional surfaces, blended dream imagery with the geometries of the ancient Casas Grandes style, and added amazing animals.

"*Pinto una raya y sale un animal*," he explains. "I paint one fine line and out comes an animal! What I like best is animals *con movimiento*, in motion, and the form of the pot is important to me.

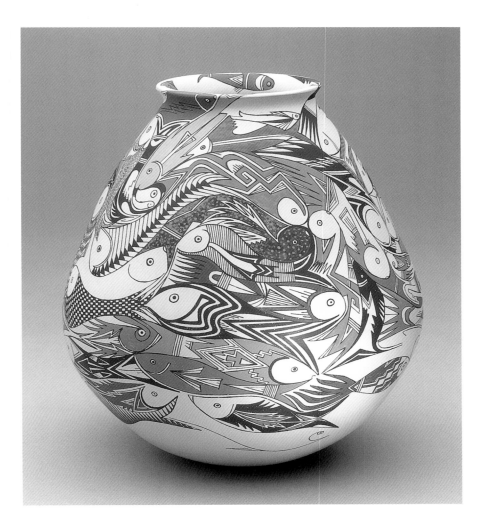

Olla, 9½ x 8½ inches,
Manolo Rodríguez, 1994

The rounder the pot, the more motion. I don't work so well on a flat piece of paper. And also a paintbrush is much better than pens and pencils because it has more . . . *movimientos.* " He doesn't want to repeat himself, however. "To do the same thing over and over is very boring. I want to do new things."

He scoops a cat off the bed and pulls away the spread, which covered three pots. Two exotic crested birds and a cross between a rabbit and a deer fly through a lightning storm. Hummingbirds zigzag through a new form of space, perhaps two-and-a-half dimensions. And then there are the fish: fish upon fish, fish head to fish tail, positive fish, negative fish, every fish different from every other fish. Definitely fish in motion.

"I just paint the rabbits, rattlesnakes, and birds that I see in the wild," says Manolo, with deliberate understatement. Like his pots, Manolo can be surprising, funny, or eloquently silent. And where did he see the fantastic fish? "Why, they're in the river," he says, straight-faced. Any truth to the rumor that he's getting married? "No comment," grins Manolo. But a lovely new house is going up next door, and the rumor turns out to be true.

opposite
Olla, 12½ x 11¾ inches,
Héctor Gallegos, 1995

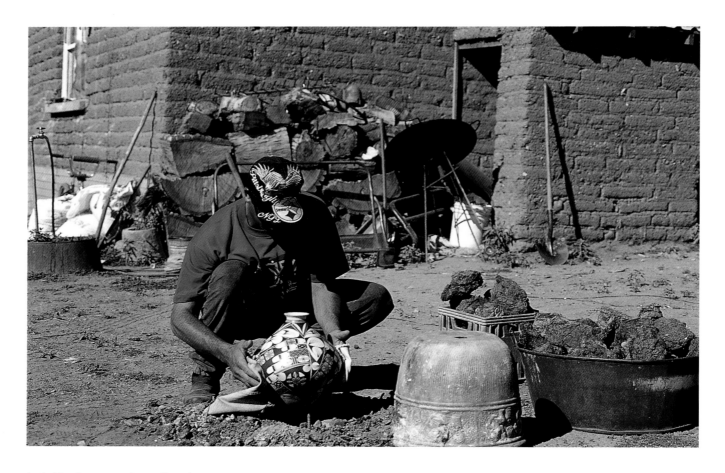

Jesús Martínez preparing to fire a large *olla*. He uses a terracotta *quemador* to cover the pot and dry cow manure (*buñigas*) for fuel.

Probably suggested by Mimbres designs found in the village *moctezumas*, the fish motif has become to Mata Ortiz almost what the bird was to Paquimé: a source of rich and infinite variations. Other favorite modern animals include rabbits (a particular specialty in Barrio Porvenir), lizards, and rattlesnakes. But this is only the beginning of the Mata Ortiz bestiary, which ranges from antelopes to bats, caterpillars to toads, camels to *chupacabras* and fellow inhabitants of the universe of magical realism.

A bored gray dog and a pig in a pen are the only creatures to be seen in a bare side yard in Barrio Centro, or Barrio de la Plaza, where Jesús Martínez (nicknamed Chuy), aged about thirty, is preparing to fire a large *olla* formed by his slender, bubbly wife, Socorro Amaya, and painted very elaborately by himself. The abstract red and black pattern, which seems to contain prehistoric gears and Slinky toys, took him six weeks to complete, although he worked on it only part time since he also enjoys making adobe bricks for a peso apiece and does a little farming. A stack of sun-dried adobes stands in his yard, next to two nonfunctional cars, a satellite dish, and a dry manure heap.

"I almost don't like to make big pots," grumbles Jesús, placing the preheated *olla* on a tripod of broken bricks. "Well, yes, I like it, but it scares me."

Yesterday the green pot was sitting casually in a corner of the family sofa, jiggled by preschoolers. Now he covers it with a terracotta flowerpot and begins to build a neat beehive of manure, which he then soaks with kerosene from a plastic Coke bottle and ignites with a cigarette lighter.

"Half an hour," he estimates, looking moody. He doesn't feel well enough this morning to pitch as usual for the local baseball team.

If a pot survives its early stages, firing is the great moment of truth. If the clay conceals a flaw, if the weather is wet or windy, or the fire is incorrectly managed, six weeks' work may explode, crack, or emerge smudged with fire clouds. The paint may come out dull instead of bright. The clay may fire gray instead of white. And at any time, of course, the potter or someone else may have a fit of clumsiness. Stoical acceptance of failure is a prerequisite for this life.

"I've made five big pots this year," says Jesús, "and only one turned out well. Small ones are easier, safer." He adds more manure, snatching his hand back from the flames. "Whew! Lots of heat there! But if you don't take care of the fire, the pot won't turn out well."

The green river oozes slowly by, and the bored dog decides to take a dip. The pig burps, grunts, and rumbles. Buzzards circle the radio tower at the police station. A small boy sits in the middle of the road, playing with matches. Fast, plaintive *norteño* music pours from a radio somewhere.

"Just a little longer," says Jesús after half an hour.

A partial catalogue of the contents of the dust: waffle-soled footprints, broken glass, ants, a snarled ribbon of audiotape, a beer can, a belt buckle, and several varieties of wild flower. A cowboy dandy on a sleek horse, accompanied by a dog with no tail, stops to chat. So does a small girl in a Pocahontas T-shirt. "*¿Quiere comprar ollas?*" she asks hopefully, and soon her young uncle arrives in a pickup truck loaded with fish effigy pots.

An hour later, Jesús's fire is still smoldering, but he decides the time has come to remove the pot. Knocking away the hot ashes, he raises the cover with a heavy hook, looks, pushes up his glasses, and looks again. The gears and Slinky toys interlock against a matte black background; pinwheels spin; fans unfurl. The pot is very good, if not transcendent. Certainly he will be able to sell it, and now Jesús allows himself to smile.

In the baseball stadium a few blocks away, the crippled umpire hobbles into place and shouts, "*¡Pley bol!*"

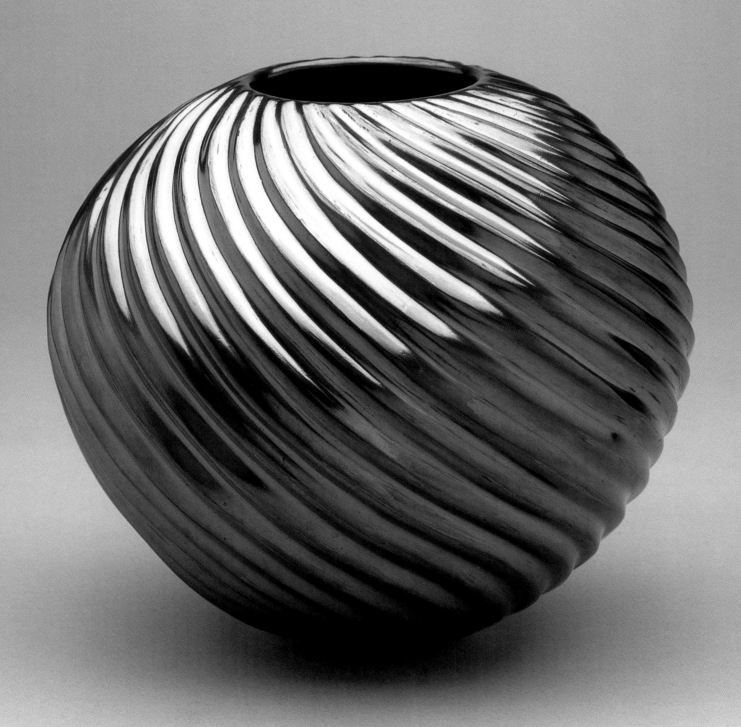

8.

BARRIO PORVENIR (which has the slightly surreal meaning of Neighborhood of the Future) lies across the big arroyo at the south end of town. In more than one way it is somewhat detached from the rest of Mata Ortiz, almost like a second and even more rural village with its own chapel and traditional dancing *matachines*, a community tradition combining elements of Christian, Moorish, and Native American religions. Its pottery tradition stems from Félix Ortiz as well as Juan Quezada, and it is the homeland of the flashy, fragile graphite finish. For years the Porvenir area had a reputation of emphasizing quantity over quality, but recently several of these potters have taken their places with the creative artists of Mata Ortiz, rather than the repetitive artisans.

Smoke is always rising over Porvenir. A boy on a bicycle tows a burro on a rope. A dog with an extraordinary black and white coat like a skunk goes trotting along behind.

Dressed in a Tasmanian Devil T-shirt, sweat pants, and bedroom slippers, Macario Ortiz leads the way into his spacious living room, which has an orange velvet theme. He and his brothers Nicolás and Chevo, who used to play in a band together with their three other brothers, are unrelated either to Juan Mata or to Félix. The father of the graphite process is now about forty years old; he wears his long hair in a ponytail and a green earring in one ear. He is tall, energetic, and very articulate.

"What makes our work distinctive? Well, the whole Juan Quezada event, and then what's happened since. The Paquimé designs are really behind us now because there's so much new work being done. And there are new techniques for working the clay, too."

Félix Ortiz

opposite
Olla, 9 x 9 ¾ inches, Chevo Ortiz, 1994

67

Macario himself specializes in sophisticated blackware of all sizes, and he has a special fondness for rabbit designs. His wife Nena often collaborates with him but also works on her own.

"The special mystique of Mata Ortiz pottery is not something divine that came down from *los antepasados*," Macario says. "But it's possible that it may have to do with this place and the presence of the ancestors here—*that* may be what makes our work different."

He touches his own chest, smiling. "Almost all of us *are* Indian, of course, at least partly. I myself am Tarahumara, Apache, and Spanish. And then above all there's *la necesidad*, necessity that made us all potters."

Macario's older brother, Chevo, is also tall and also molds strong and interesting shapes out of the clay, especially a series of graphite pots that resemble swirls of metallic ice cream, which Chevo makes with the help of his wife Tencha. Their waiting list is six months long, Chevo explains, sipping a beer while sitting on his front step.

"Maybe November?" he suggests.

From inside their house come the sounds of guitar music and percussion instruments. Wedged in among the beds, chairs, and pots in progress, a television screen flickers with bright dancing figures: a small enthralled audience is watching a videotape of a recent performance of the *matachines*.

The youngest Ortiz brother, Nicolás, is the most talented sculptor of the three. At least six and a half feet tall, he towers over all the other men in Mata Ortiz, and he comes to his door wearing an Adidas basketball T-shirt and a harassed expression. Shooing away one or two rambunctious small children, he sits down at his lace-covered dining table, sighs, smokes, and remarks in a melancholy tone that he has a two-year waiting list for his work. Working in both black and polychrome ware, he makes fine *ollas* but is probably most famous for his highly imaginative ceramic sculptures.

One of his masterpieces is a desert tortoise pot, life-sized and highly expressive—a reptile with an attitude. The tortoise shows a masterly hand not only in its modeling but also in the subtle use of marbled red and white clay and geometric decoration. And Nicolás also makes this tortoise's shadow: a blackware and graphite version, equally compelling.

"I used to carve stone," says Nicolás, "and sometimes I would look at the rock and not know at all what I was going to do, and then suddenly it would come to me. Inspiration is very mysterious. It arrives . . . and it flies away."

Sometimes he feels overwhelmed, he confides.

"It's important to think of new ideas, different ideas," he says, "but it's hard. Oh, well, life in itself is hard. *Hay que sufrir para poder.* You learn by suffering. I have a lot of dreams, of course; I'd like to learn English, and I like traveling very much. I really want to see Europe. But who knows when?"

A black eagle head screams silently from his coffee table. Worn stuffed toys are scattered on the floor, and there is a lingering smell of burnt food. The music escaping faintly from his workroom is opera.

The Porvenir chapel consists of one small, low whitewashed room, roofed with tin and tucked modestly into its neighborhood. On one side of the chapel stands the house of Félix Ortiz, still a prolific and influential potter, who is modeling the figure of a clever white fox today. His wife, Otila Sandóval, inherited the responsibility for caring for the church and organizing the dances of the *matachines* from her father. On the other side of the chapel lives Andrés Villaba, a potter with a serious, inquiring mind and a mechanical bent; he has invented many of his working tools. His front windows are ingeniously constructed of colored bottles set in mortar, and his fenced front yard is full of tumbling, hopping white, black, brown, and spotted rabbits. On the wall of his combined bedroom and workroom hangs the hunting bow that he doesn't use anymore, along with three guitars. In these cramped quarters he paints his pottery at a small table and keeps his library of reference books, for Andrés, more than any other Mata Ortiz potter, is deeply interested in history. Occasionally he copies an antique pot for a client or for himself, but mostly he works from original combinations of ancient designs.

A polychrome *olla* reposes on the bed. Formed from a satiny skin-colored clay, it bears a wide variety of classic Paquimé motifs, finely painted yet executed on the somewhat larger scale of ancient Casas Grandes decoration,

The Virgin Mary in the Porvenir chapel

Andrés Villalba

compared to modern Mata Ortiz style. Macaw heads squawk, a plumed serpent bares its teeth, speckled birds spread wide tails. The bottom is not decorated.

"That," he says, pointing to a tiny square with a dot in the middle, "is a symbol for water, according to what I've read. And these little painted stair steps? They're terraces for farming. They made those on the hillsides."

He wears a Moosehead Beer sweatshirt and speaks with passionate intensity. In the next room, separated from him by a thin curtain, a group of teenagers watches a dark thriller on television.

"My ancestors bequeathed me a talent," says Andrés. "I believe that those who have talent got it from their ancestors, although certainly Juan Quezada started our pottery movement."

There's a story to be read in the ancient pots, he says. "There's a type of writing there, even though I can't totally decipher it. Through their work, we can begin to understand how they thought." He eagerly spills out his interpretation. "I think it's a record of their daily lives, right here where we live now, and we have much in common with them. They worked to live; we do, too. They made ceramics; we do the same. They sowed their crops; we do, too. Of course, there are great changes as well. We have more communities now, and meat is very expensive, but they just went hunting. Now there's nothing left to hunt."

In a plowed field he once found the top of an effigy pot that originally possessed four human faces looking outward in the four directions. But only three faces were left. So he brought the fragment home and lovingly recreated the original pot.

"For me," says Andrés, "pottery is a way to honor *los antepasados*. Out of affection for my ancestors, I want to make it."

At Jesús Manuel Mora Villalba's house, the family has just finished their midday dinner, and Manuel emerges accompanied by his young son, daughter, and toddling nephew.

"We potters are like a family, with its history and its inheritances," he observes, "except that what we have here is a cultural heredity. It's very important to us. Although you may never have known your grandparents, you still resemble them."

Manuel is a teacher in the primary school, a job that he clearly loves. He is also a maker of round, engaging pots with a slightly frosted texture and interesting use of color in the orange range. Today he himself wears a cowboy shirt brightly striped with orange. He learned his ceramics technique from his brother, the well-known Pilo Mora; his Villalba heredity shows in his mechanical inventiveness and his philosophical cast of mind.

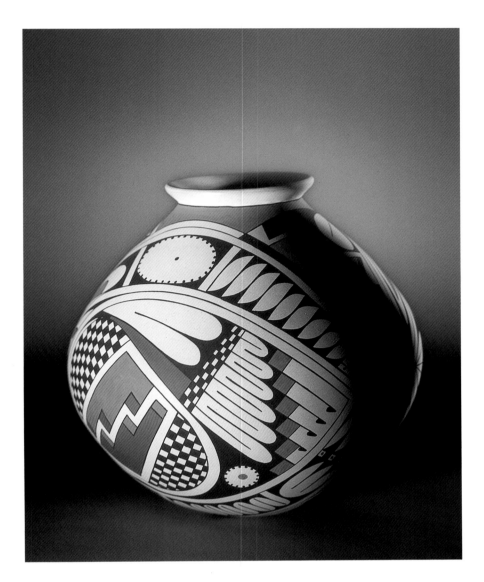

Olla, 7 1/4 x 7 inches, Manuel Mora, 1997

"This inheritance is also important to us because our ancestors were wise, and they had contact with nature, something we lack nowadays," he says, speaking slowly and thoughtfully. "There is a line of work between them and us."

He leads a tour around his old stone house, pointing out his father's antique saddle, the new room being built, his children's book collection, and his orchard, as well as two huge plastic sacks of dry clay, unshaped pots waiting in his shed.

"There are many new potters who seem very original," Manuel says, pondering the future as he plays with his little nephew. "And there has to be competition, even though the competition sometimes gets very strong. Everything has a bad side, too, and some people are thoughtless and careless. We must be careful, very careful, and always keep on trying to surpass ourselves."

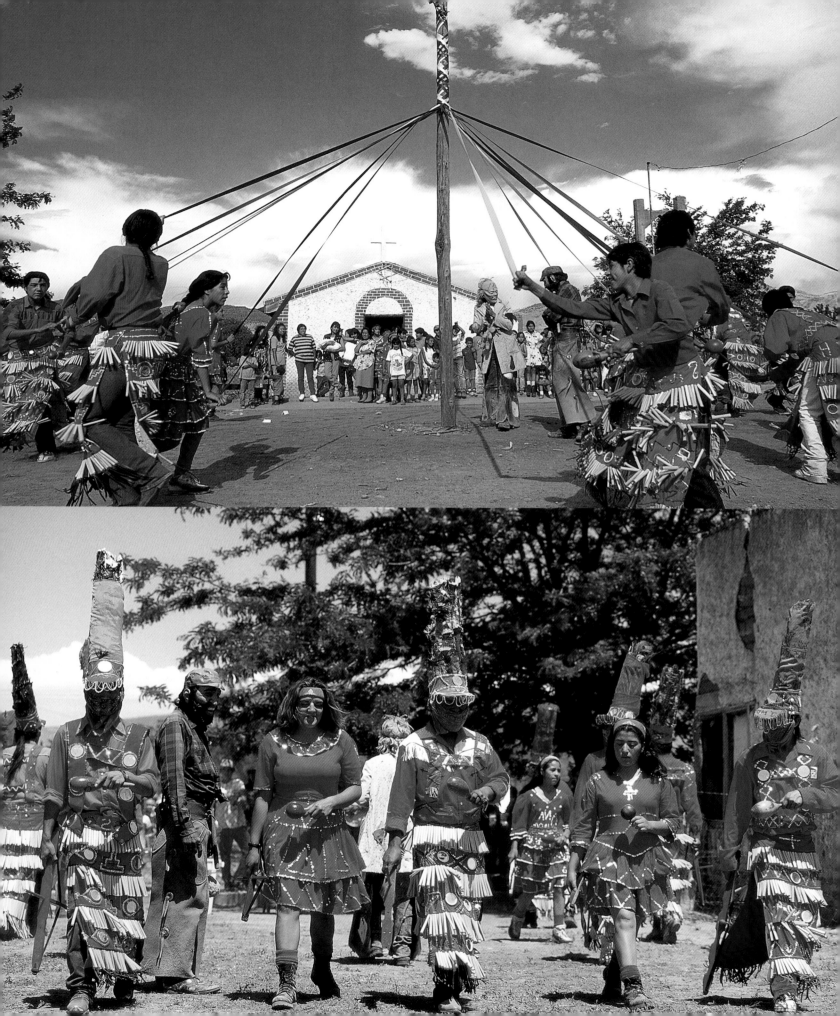

9.

MAY 15 IS THE FEAST DAY of San Isidro, patron saint of farmers. Very early in the morning, a religious procession approaches the Porvenir chapel, which Otila Sandóval calls "*el templo*," or the temple. The first of several church services takes place inside the tiny building. Magenta silk flowers adorn the image of the saint. A guitarist and an accordion player strike up a folk song, and two dozen scarlet *matachines*, gorgeously costumed in beads and sequins, mirrors and plumes, T-shirts and athletic shoes, move into place. They are all teenagers, including several young potters. Cylinders of turkey and peacock feathers crown the boys, who are masked with bandannas and harnessed into elaborate kilts; the girls wear short glittering tiered dresses, red ankle socks, and combat boots.

Dust begins to rise. The temperature goes steadily up, too. The dancers sweat. Small children, dogs, and other spectators line the fence to watch, and soon the ice cream cart comes trundling up.

Like kachina dances in the *pueblos* of the American Southwest, these run in cycles throughout the day, they involve masked dancers and sacred clowns, and although they occur in a holiday atmosphere, they are taken very seriously. Besides the music, the performers accompany themselves with rattles (the familiar *maracas* of Latin music groups), as well as unique percussion instruments that resemble wooden bows. *Matachines* dance in many areas of Mexico and a few in the western United States; they are not associated with one particular Indian group but with *mestizo* culture. Although a class system and a traditional prejudice in favor of Spanish heredity still exist, the Mexican population in general is much more racially mixed than the North American one. The population of Mata Ortiz also includes Chinese, Gypsy, and Anglo heredity.

opposite
At the end of the afternoon on San Isidro Day, a pole was set in the dirt in the street in front of the chapel in Porvenir for *la danza de cintas,* **a Mexican maypole dance.**

bottom
Matachines **dancing on the feast day of San Isidro, patron saint of farmers.**

And as Humberto Ponce puts it: "We all carry the influence of the Indian in our blood. *Somos mestizos*: we are mestizos. My maternal grandmother was an Indian from Zacatecas."

To be *una persona indígena* in Mexico today usually implies speaking an Indian language or living in tribal communities apart from the *mestizo* mainstream. Most Mexicans probably are descendants of several different Native American groups who have deeply influenced Mexican daily life—bequeathing everything from the corn tortilla to the Day of the Dead.

"Past epochs never vanish completely," writes Octavio Paz, "and blood still drips from all their wounds, even the most ancient." He compared the psychological situation to an archaeological site. "Sometimes the most remote or hostile beliefs and feelings are found together in one city or one soul, or are superimposed like those pre-Cortesian pyramids that almost always conceal others."

The *mestizo* culture of Mexico does not exist apart from Roman Catholicism or from the modern world. Silver sequins spell out the dancers' names or initials on their costumes, as though they were players on a sports team. Scaring children and mugging for cameras, the sacred clowns wear rubber masks, silly hats, cowboy chaps, a blond wig. They carry teddy bears. Late on San Isidro's day, a tall pole is raised in the road in front of the chapel, and a group of Quezada women, well dressed and perfumed, arrive from Barrio Centro to join the large audience for the climax of the day, *la danza de cintas*, or Mexican maypole dance. As the young dancers interweave their colored ribbons, the clowns shinny up the pole and place their teddy bears so that the ribbons will lace them into the pattern. This is an offering, not a comic stunt, for the bystanders do not laugh. As the dance winds to its conclusion, summer clouds blossom in the fading sky, and the pole seems to impale them.

"Myths and fiestas, whether secular or religious, permit man to emerge from his solitude and become one with creation," said Paz. This includes the experience of art. "Every poem we read," he said, "is a fiesta."

In many ways Mata Ortiz is a microcosm of the art world. This tale of a master and his followers puts human faces on abstractions like tradition and innovation, artists and artisans, individual accomplishment and collaborative effort, imitation and originality. It raises such issues as copyright, market forces, and relationships between artists, patrons, and dealers. Many Mata Ortiz potters approach their work with great seriousness—no one more so than Juan Quezada, whose passion to make ever better pots still sometimes drives him to work through the night. In describing their work, potters use strong words. One of these is *chiste*, which literally means "joke," and by extension the "punch line" or the point of something, in this case spending one's life making pots.

"The *chiste*," says Humberto Ponce, "is to improve every day."

Another favorite term is the verb *superar*, which is much more forceful than "to improve." Instead it means "to exceed," "to go beyond," "to surpass," and it carries a sense of breaking records, overcoming obstacles, leapfrogging.

"*El chiste es ir superando—superando uno a otro*," says Leonel Quezada. "The point is to keep going beyond—to keep surpassing one another."

"There are people who are going way beyond the others," remarks Gerardo Cota. "Many very good new potters are emerging."

And what about the future? There is a widespread understanding of the necessity for constant improvement. Nicolás Quezada sometimes worries that the potters of Mata Ortiz will stagnate, although this has not happened yet. Gerardo, too, emphasizes the need for high quality, "or else some people are going to flood the market with quantity without quality." Damián feels the pressure of competition. "The ones that come up from the bottom come up very strong," he says, shaking his head.

Another danger is the possibility of their materials running out, warns Humberto. Already the favorite new firing fuel, cottonwood bark, which must come from dead trees, is growing scarce, possibly endangering the remaining trees and the potters' livelihood as well. (Manure producers, however, are not an endangered species.) And moral dangers also exist.

"I think that all the potters must have respect for themselves, and for the clay," says Jorge Quintana. "In ancient times this work was honored by the Indians. These were sacred things."

In general the potters are very open to modernization and innovation, although as Nicolás Ortiz points out, they are caught in an odd paradox: "As long as we do everything by hand and in a traditional manner, we have a future!" Gerardo defines the essence of Mata Ortiz pottery in a two words: "*Puro natural*." By this he means it involves no chemicals, no machines, nothing commercial. Leonel adds, "But by now our style has changed a great deal from Paquimé. Each potter has his own style of painting, in black and red or whatever he likes." Damián agrees, noting that he himself, like many of the younger generation of potters, never looks at old Casas Grandes pots but draws his ideas from modern ones instead.

Macario Ortiz is optimistic. "There are many very, very good potters in Mata Ortiz, and many different styles of pottery. The Paquimé designs are really behind us now, and many new ones are springing up. Also there are more techniques for working the clay, and I don't think the clay will ever run out. Now we have fifteen or twenty different kinds—reds, greens, blues, grays. . . . No, I don't think it will end, and neither will the pottery."

"I think that if we are careful, our tradition can continue," says Manuel Mora, "because art has no limits."

During weekdays it is unusual to see groups of people out on the street, since most are busy working or at school. On Sundays, however, groups of young and old people gather in the late afternoon to play or enjoy the end of the day.

10.

IN JUNE OF 1997 Juan Quezada's birthday party, given by his siblings, is a gala event that draws many visitors to the village. They include relatives, friends, supporters, traders, collectors, political candidates, and at least one descendant of the Mormon colonists in Colonia Juárez. The day is blazing hot. The peak called El Indio seems baked out of clay. Even the distant blue Sierra Madre, where Geronimo's great-granddaughter lived when Juan first went out to gather wood there, hardly looks cool today. Boys herd bony cattle across the *altiplano*, which shows a very low level of green; the only plants in bloom are thistles and prickle poppies. The Río Palanganas trickles

Guillermina and Juan Quezada at the head table at the midday celebration of Juan's birthday in 1997

opposite
A highlight of Juan's fifty-seventh birthday party was a performance by a troupe of *folklórico* dancers.

Elí Navarrete

downstream as it has for thousands of years.

The road to Mata Ortiz seems endless, but at last it reaches the end of the labyrinth. The fiesta centers around the expanse of bare earth that lies between the Quezada house and the train station, which has been boarded up but still bears a sign reading "Mata Ortiz." Vehicles have raised a brown haze of dust elsewhere in the village, but today the open area is blocked off from traffic by a pair of police cars borrowed from Nuevo Casas Grandes. Folding chairs and tables have been set up for the guests, and the depot porch and platform have become a stage for various tributes to the man of the day.

"Everyone's designs," says Jorge Quintana, "contain a little bit of Juan."

The fiesta is a kind of culmination. Old friends, including Spencer MacCallum, make speeches. Politicians make speeches. A Quezada granddaughter, dressed in pink ruffles from head to toe, gives a fiery political oration. Cold drinks circulate. One-eyed dogs slink after scraps. A poet reads a poem. "Art has come out of the dust of this village!" he proclaims. "The potsherds have been put together again!" Mariachi and *norteño* musicians perform. A dark brooding bust of Juan is unveiled. A troupe of *folklórico* dancers mounts the railway platform and leaps into action under the noonday sun beside the abandoned track. The girls whirl their skirts—yellow, orange, purple—and the boys stamp their heels. "*¡Echale!* " they shout to one another, according to ritual. Throw yourself into it! They have been imported for the occasion from the Francisco Villa Preparatory School in Nuevo Casas Grandes, for unlike the dances of the *matachines*, this

78

is a highly institutionalized part of mestizo culture. Photographers capture the image of Juan, his wife Guillermina, his patriarchal father Don José, and (it is rumored) the reigning beauty queen of Chihuahua. At last a bountiful meal is served. Juan receives it all with embarrassed resignation.

Cooling off afterward in the shade of his own living room, he looks much more at ease even though the small space is crammed with guests. Large glass cases are also bursting with pottery, including three spectacular white *ollas* by Juan's oldest son, Noé, and a luminous orange jar by Juan himself. Usually the dining room table, draped in lace, overflows with a variety of smaller pots for sale—perhaps a stately black jar by Lydia, or one about the size, shape, and delicacy of an ostrich egg by Juan, along with many pieces by younger Quezadas. (The family actually eats in the kitchen.) But today the table holds half a dozen birthday cakes instead, each topped with a small clay *olla*.

Warm, personal, earthy, unearthly, magnificent, fragile. Pottery is a metaphor for Mexico itself.

Outside, young Elí Navarrete Ortiz exhibits a slender black pot decorated with graphite and seven different colors of paint, mostly soft golden browns and turquoise greens and blues true to their mineral origins. Eyes roll. Heads shake. "This is revolutionary. This is gaudy. This will never do." Juan, however, seems quite interested in the experiment.

"And you know," says Spencer MacCallum much later, long after the sun has set and the dust has settled on Juan's birthday, "after about half an hour, I said to myself, Why not?"

God Who Comes Forth from a Ceramic Orchid

> *Among clay petals*
> *is born, smiling*
> *the human flower.*
> — OCTAVIO PAZ
> *from "Object Lesson"*

The

Potters

by Jim Hills
with consultant
Jorge Quintana Rodríguez

Angel Amaya

Angel Amaya Mora and his wife, Avelina Corona de Amaya, make small pots of non-traditional shapes, such as "flying saucers," seed pots, and vases with long necks. The pots are very fine and thin walled with streamlined shapes and designs and a modern appearance. Angel paints original interpretations of Paquimé designs in red and black on a white clay body.

Angel and Avelina live in Barrio Porvenir and practice a style of pottery making more reminiscent of Juan Quezada's than that of his neighbors. This is partially because he learned to paint from Consolación Quezada, Juan's older sister, and her youngest son, Mauro Quezada. His pots resemble the work of his brother-in-law Jesús Martínez in technique, shape, and design.

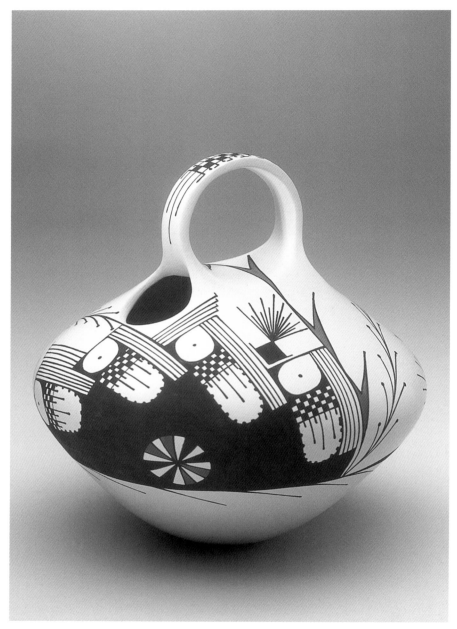

Matrimonio, 6½ x 6 inches, 1998

Salvador Baca

Salvador Baca and his wife, Virginia Lozoya de Baca, were born in Mata Ortiz and have been potting since 1995. He learned first from Gloria Lozoya de Veloz, his wife's sister, and later from Jorge Quintana after the family moved to Nuevo Casas Grandes to enroll their children in one of the better Mormon schools.

Salvador and Virginia work together: Virginia forms the clay and Salvador paints the surface. Their pieces are delicate works with sparkling designs on black, stone-polished clay. Salvador's designs are well executed in a unique non-traditional style that utilizes both the open spacing of the Quezada style and the free-form designs of the Porvenir style. He comes from a talented family of potters which includes his cousins, Taurina Baca and Luz Elva Ramírez.

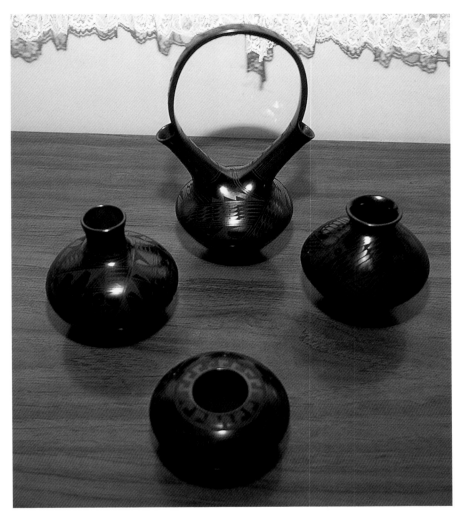

Small *ollas* and *matrimonio,* each approximately 5 inches in diameter

Taurina Baca

Taurina Baca was Juan Quezada's first non-family student and probably learned the craft as early as 1973 or '74. She makes large *ollas* of white, yellow, or mixed clays in the typical Quezada style with limited graphics swirling from top to bottom amid large open spaces.

Taurina made a number of trips outside Mexico between 1980 and 1984 with Spencer MacCullum, which exposed her to the work of Native American potters María Martínez, Lucia Lewis, Blue Corn, Priscilla Nampeyo, Jody Folwell, and Michael Kabotie. In a 1998 pottery exhibition at the Museo de las Culturas del Norte in Casas Grandes she was the first-place winner in the *Baya* category (all colored pots besides black and white). She won the equivalent of $470—about three months' wages for an average female wage earner in Mexico today.

Taurina is still one of Juan's best-known students and continues to sell all that she produces, usually to collectors, from her home in Barrio Central.

Taurina and her three daughters

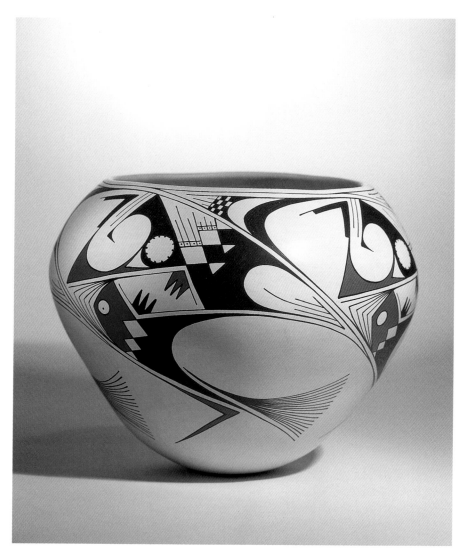

Olla, 11½ x 14 inches, 1996

Roberto and Angela Bañuelos

Roberto Bañuelos Guerrero and his wife, María de los Angeles López de Bañuelos, represent the epitome of teamwork in the village. Although Roberto paints and signs all pots pro-duced in their household, the union could not succeed without the contin-ual production of Angela's *ollas*. Angela forms, sands, and polishes the vessels, while Roberto paints the designs. They work in a multitude of colored clays: yellow, black, white, red, and mixed. Roberto paints in all color combinations using double, triple, and four-part fields. They learned the principles of ceramics in 1988 from Angela's sisters Rosa Irene and Gloria Isela López, both related to Reynaldo Quezada by marriage.

Mimbres pots have inspired the Bañuelos team to produce a host of innovative designs with animal motifs: rabbits, fish, lizards, and fan-tastical creatures, as well as the feather (or knife-blade) designs from early Mimbres work. Experimentation is a strong underlying component in their work. Roberto initiated the practice of spattering paint drops across the clay before painting the dominant design elements. When discussing their art, both Roberto and Angela emphasize the importance of innovation and their need to push for change on a daily basis.

Samples of their mastery were included in the University of New Mexico Art Museum show of 1995. They live in Mata Ortiz's Barrio Iglesia to the west of the railroad tracks near the stadium.

Olla, 6¾ x 9¾ inches, 1997

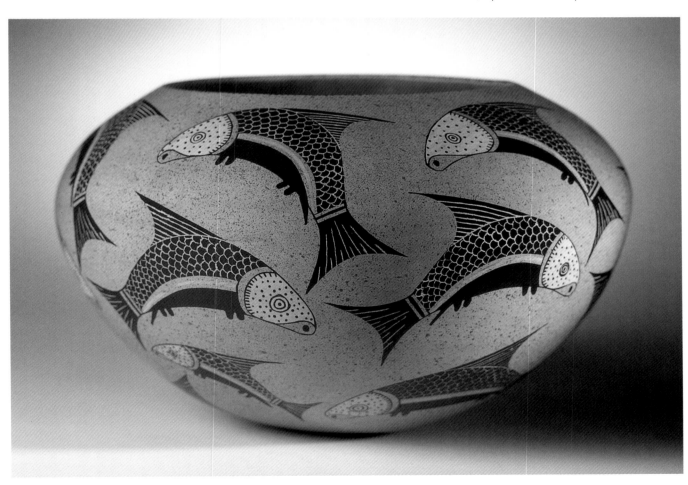

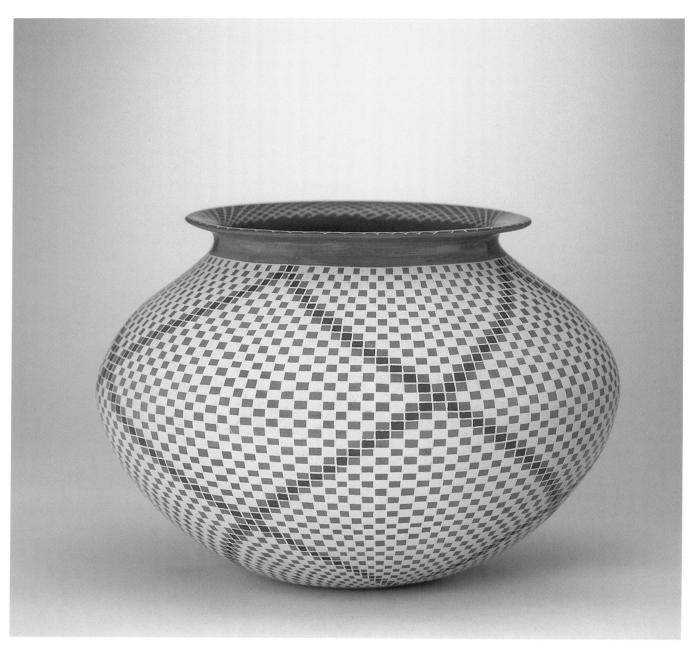

Olla, 7 ¾ x 9 ¾ inches, 1997

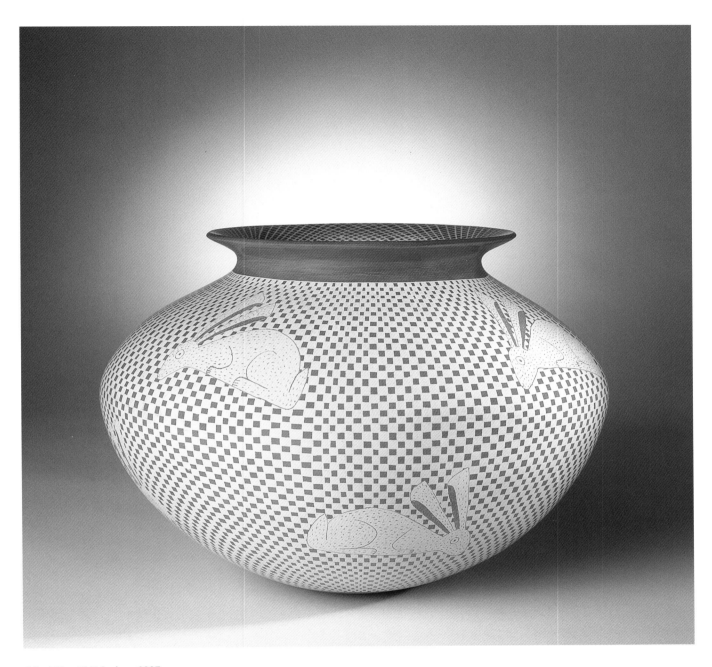

Olla, 7 ½ x 10 ½ inches, 1997

Laura Bugarini

Laura Bugarini Cota is one of the youngest, more successful second-generation potters. She has been working with pottery since she was fourteen and has established her own design motif. Because her designs are so novel and easy to recognize, they can be traced throughout the village as new potters incorporate Laura's designs into their work. Her mother, Guadalupe Cota de López, makes all of her pots.

Laura developed her interest in pottery when she worked for the Quezada household as housekeeper. Although she identifies Juan as her inspiration, she began painting pots in 1994 with the help of her mother and her cousin Gerardo Cota. Her style is completely unlike that of the Quezadas. She fills most of the space on her pots with thousands of tiny strokes and dots in designs consisting of a series of delicately spaced concentric rings that circle the pot in perfect symmetry, much as one would expect to see meridian lines circling a globe. Laura was the first to paint her matching ceramic pot rings, or *aros*, using this technique. Her achievements require excel-

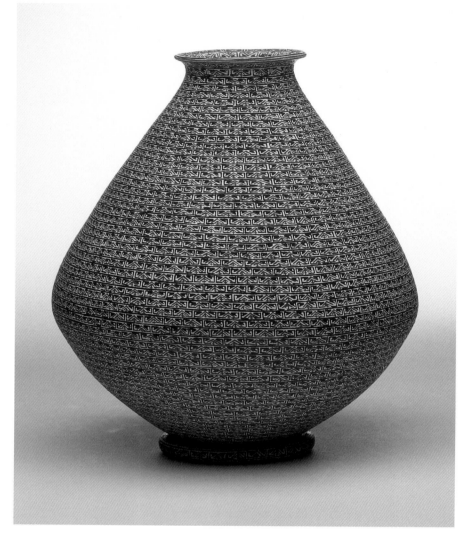

lent eyesight, a steady hand, and unfailing patience.

Laura presently lives and works as a housekeeper in Denver, Colorado. She lost enthusiasm for potting when others in the village began copying her techniques and her prices began to drop. Her geometric designs spread first to her cousins living next door, Leti and Norma López, and then to cousins living a few doors away, such as Lourdes López de Corona and Pati López de Mora.

Olla, 9¼ x 7¼ inches, 1997

opposite
Olla, 10 x 11 inches

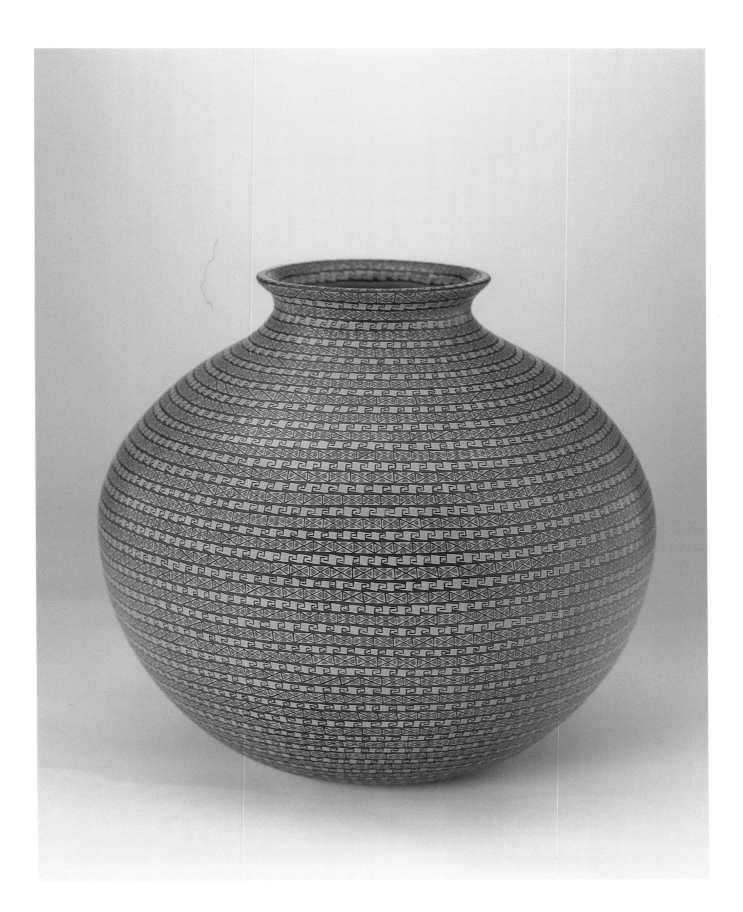

Gerardo Cota

Gerardo Cota Guillén has been making pottery since he was twelve years old and says he learned by watching Juan Quezada. His meticulous work focuses on elaborate imagery of frets, dots, and curved lines of intense black and red paint, polished to perfection. Because of the Quezada influence, particularly the rich curvilinear black and red designs on white clay, Gerardo was considered one of the rising stars among the potters of Mata Ortiz some years ago. He was featured in the University of New Mexico Art Museum exhibit in 1995.

Gerardo lives in Barrio Iglesia on the north side of the railroad tracks in a house built by Juan Quezada twenty years ago and in which Gerardo played as a child. He can often be found at his parents' home, just a short walk away, discussing potting with his brother, Martín, or sharing a leisurely cup of coffee with his mother.

Olla, 9 x 8½ inches, 1997

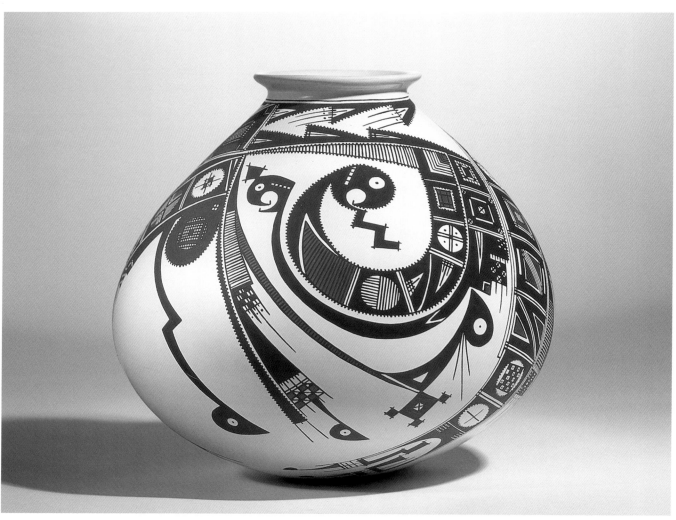

Martín Cota

Martín Cota Guillén has a brilliant imagination. He and Manuel "Manolo" Rodríguez are probably the two most creative and exuberant designers among the second-generation potters. Martín claims his work is Paquimé in style because he prefers to form human, fish, and other animal figures. His style, however, is truly much more difficult to define. He does use traditional Paquimé designs and shapes, but he bends and stretches those ideas into new and unusual geometric motifs that often seem surrealistic. His pieces are works of art with a uniquely inspired approach in construction, detailed line work, and rich combinations of colors.

Martín learned to pot from his brother Gerardo in the early 1990s, yet he claims his first interest came when he was much younger. He often proudly shows a photo of himself at seven years old watching Juan Quezada working on a pot. He continues to live in the Cota family home between Barrio López and Barrio Iglesia with his mother and father.

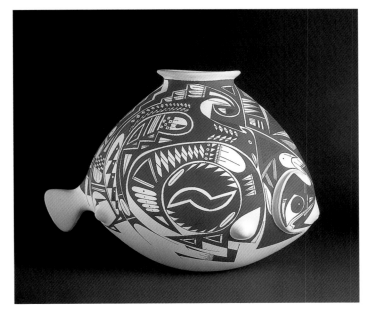

Effigy, 8 x 11½ inches, 1996

César and Gaby Domínguez

César Domínguez Alvarado and his wife, Gabriela "Gaby" Almeida de Domínguez, work on pottery as a team. Gaby builds and polishes and César sands, paints, and fires. The couple is best known for their polychrome Mimbres designs on large bowls, especially four-part patterns on *cazuelas* (rimless bowls) as large as eighteen inches in diameter. They learned pottery making from César's brother Jaime Domínguez in the

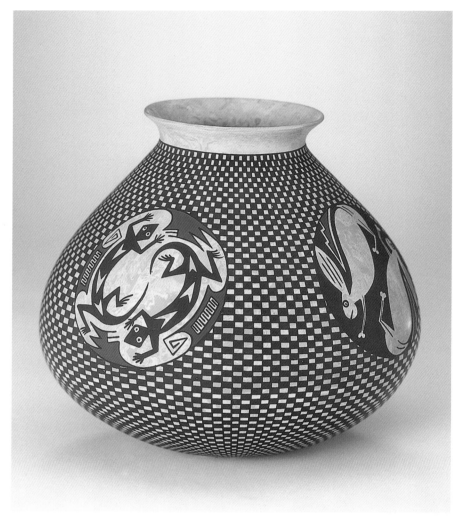

Olla, 8¼ x 7½ inches

1980s, when they still lived in their native Barrio Americano in Mata Ortiz.

Their work appeared in the University of New Mexico Art Museum's show in 1995 and is often seen in regional ceramic shows in Casas Grandes. Both César and Gaby have traveled extensively in the western U.S., occasionally giving demonstrations.

They moved to Nuevo Casas Grandes for César's job as a schoolteacher and for better educations for their children. Gaby's sister Blanca and her husband, Humberto Ponce, both potters taught by César, live across the street.

Martha Domínguez

Martha Elena Martínez de Domínguez began making small pots around 1985 after admiring the work of her relatives, including her brother-in-law César Domínguez and her sister Graciela Gallegos. Graciela assisted Martha in perfecting her art, which today consists of white *ollas* no more than six inches in height and painted with Mimbres designs of rabbits, lizards, and birds. Her husband, Antonio Domínguez Alvarado, assists her with the sanding and polishing and fires all her pots. She taught her daughters, Angélica and Brenda, to paint, and they now help her.

Martha is one of the original fifty-two potters of the Pearson Group organized in 1996 by the Mexican government to help women become part of the market economy. The family lives behind their store in Barrio Central next to the Posada de las Ollas.

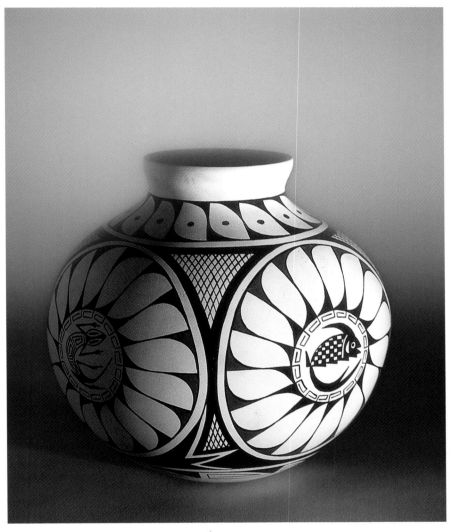

Olla, 7 x 7 ½ inches, 1998

Ismael Flores

Ismael Flores Ledezma learned to pot in the late 1980s from his cousin Manolo Rodríguez and recently has been studying with Jorge Quintana. He and his wife, María Loya de Flores, work together as a team: she builds, sands, and polishes; he paints and fires.

Their work has improved dramatically over the past two years, moving from the easier *cuadrito* style to designs that sweep and move across the face of bowls, pots, and wedding vases more in the Quezada style. They live in Barrio San José, sometimes considered part of Barrio Iglesia, in a small two-room house with their four children. Ismael enjoys working in construction, particularly with adobe, and is involved in several of the building projects presently going on in the village.

94

Guadalupe Gallegos

Guadalupe Gallegos García began potting in 1992 when he was fifteen. He is another of the second-generation potters specifically influenced by Juan Quezada. Guadalupe's parents lived in the same general neighborhood as Juan and his family during the early 1980s, in Barrio Iglesia just north of the railroad tracks. Like the other kids in the neighborhood, Guadalupe could always be found in and around the Quezada home.

Today Guadalupe can often be found in the home of his famous aunt and uncle, Graciela and Héctor Gallegos, discussing his latest creations. He uses rich paints of intense colors, reminiscent of the paint and line work of Gerardo Cota. Guadalupe has also experimented with new potting techniques in which he makes an *olla* with extra thick walls and then carves out a *pueblo* scene in its side, often depicting the ruin known in the area as Cueva de las Ollas (Cave of the Pots). In another technique, he applies red slips (much like those of Leonel López) to his pots and then scratches away the red or black paint to expose the white clay underneath. This creates a mottled background over which he paints a repetitive design of animal figures, such as fish, ants, lizards, or birds.

Guadalupe lives with his wife near the plaza in Barrio Central.

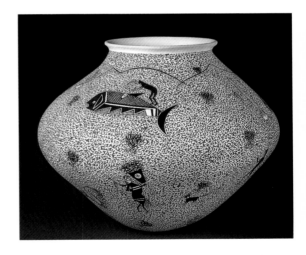

Olla, 7 ¼ x 9 inches, 1997

Héctor and Graciela Gallegos

The Gallegos family, like the Quezada family, is miraculously talented. This talent came to the surface only a dozen years ago in 1987, when Graciela Martínez de Gallegos began to experiment with small, simple figures of clay. Her neighbor Armando Rodríguez, who lived just north of the Gallegos home in Barrio Americano, taught her to make pottery. During these early years, Graciela taught her husband, Héctor Gallegos Esparza, to use Mimbres-style designs on white pots of innovative shapes.

Graciela and Héctor are now considered masters of the art form, working as an efficient team on the more complex and difficult pieces, such as the larger wedding vases, urns, and long-necked vessels with animals formed in the clay. Butterflies in a four-part design are a prevalent theme. Their pottery shapes are inspirational, and their line work detailed, precise, and brilliantly polished. Neither Héctor nor Graciela hurries their work, making every piece a study in wonder. As is customary in Mata Ortiz, the person who paints the pot, Héctor, signs it. The Gallegos pottery is almost impossible to obtain, since the waiting list is months' long.

Like Juan Quezada, Héctor would rather be working his cattle, farming his *labor* (plot of irrigated land), or building an adobe wall, rather than concentrating on meticulous line work on a pot. For Héctor and so many other potters of Mata Ortiz, these traditional tasks have become leisure-time activities, because it is the pottery that now brings in over 95% of their annual income.

In 1995 the Gallegoses presented their work in the prestigious University of New Mexico Art Museum exhibit. Since then they have traveled frequently for exhibitions and shows. They live west of the soccer field in Barrio Americano.

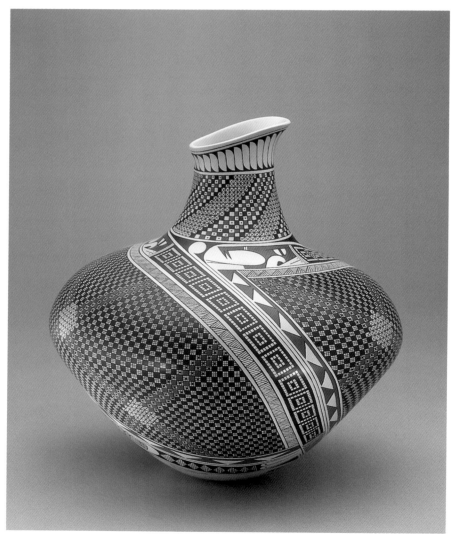

Vase, 12½ x 11¾ inches

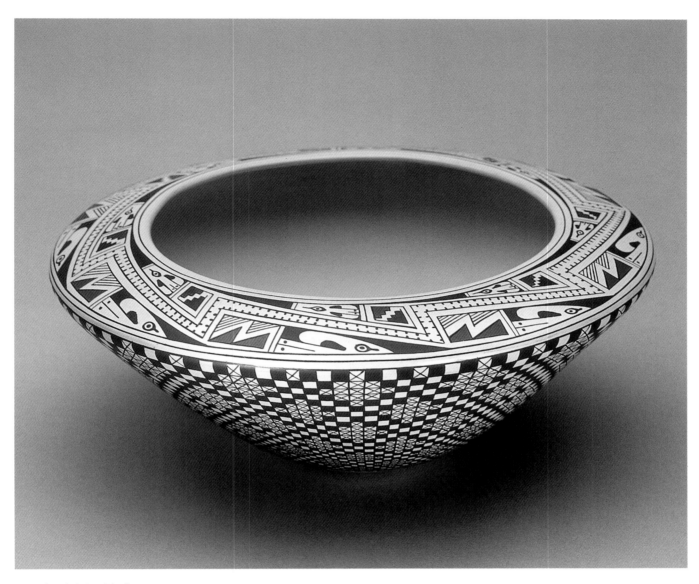

Large bowl, 3¾ x 8 inches

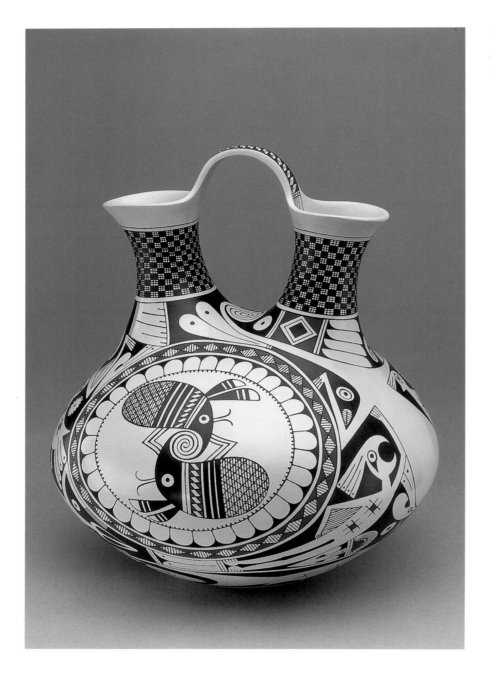

Matrimonio, 12½ x 10½ inches

opposite
Plato, 2¾ x 9½ inches

Héctor Gallegos Jr.

Héctor Gallegos Martínez is the son of Héctor Sr. and Graciela. He learned to pot from his mother in the mid 1990s when he was only eleven years old. Héctor Jr. follows in the footsteps of his parents with tight, well-executed, and innovative designs with quirky modifications. He sometimes paints dozens of small animals, such as bees or ants, connected to one another with "animal tracks" that cover the surface of his white pots. He prefers to use white clay for miniature pots that seldom exceed six inches in height and is one of the few potters (such as Roberto Bañuelos) who sometimes spatter red paint over the surface. The spatter technique gives his *ollas* a happy, folkart appearance.

Olla, 5 x 6 inches, 1998

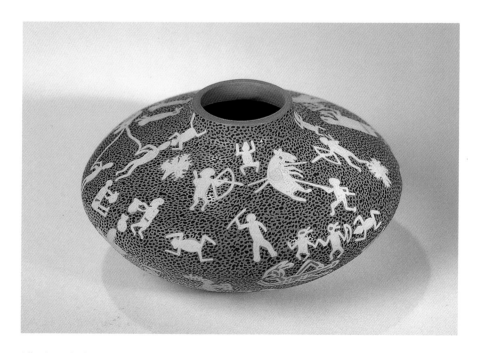

Olla, 3 x 6 inches, 1998

Miriam Gallegos

Miriam Gallegos Martínez is the oldest child of Héctor Sr. and Graciela. She began potting in the early 1990s and is noted for delicate and precise line work on small pieces of pure white clay. She is following closely in her father's footsteps as a rising star among the second-generation potters, painting both geometric and Mimbres designs. Her line work is stunning, incorporating lizards, rabbits, and birds on the lids or bottoms of her *ollas*. Her mother, Graciela, makes most of Miriam's pots. She lives near her parents in Barrio Americano.

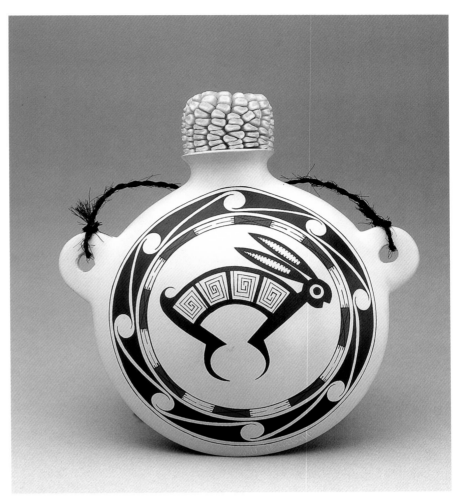

Canteen, 8 ½ x 9 inches

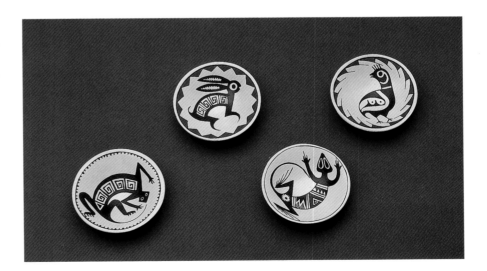

Platos, each ½ x 3 ½ inches

Daniel González

Daniel Villalpando González makes large Porvenir-style *ollas* with dramatic and very original designs. He can produce large quantities of inexpensive, yet well-made pots, making him a favorite with traders.

He lives in Barrio Porvenir near the playground.

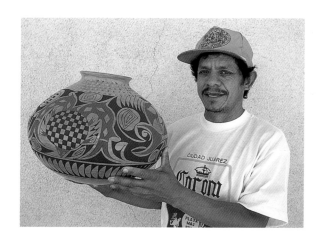

Gloria Hernández and Gregorio Silveira

Gregorio "Goyo" Silveira Ortiz and Gloria Hernández de Silveira are one of the more productive husband and wife teams working for the lower-priced commercial trade. He learned to pot fifteen years ago from his brother, Rogelio Silveira Ortiz, and then taught Gloria the basics. They are one of the few couples who work together as a team while also developing their own individual styles. Each one signs the pieces he or she paints.

As is typical among Mata Ortiz couples, the husband usually fires all of the pots produced in their household.

Gloria's work tends to be of higher quality, with bold designs depicting reptiles, birds, or human figures. She produces mostly red *ollas*, but the couple also produces large tan, black, and yellow pots up to twenty inches in height. Their home is often filled with pottery in varying phases of construction: recently fired *ollas* lying on beds, pots being built on kitchen tables, pots drying in cabinets and on the floor.

They live today in Barrio Porvenir in a large adobe home across the street from Chevo Ortiz.

Olla, 13 ½ x 12 ½ inches, 1998

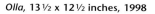

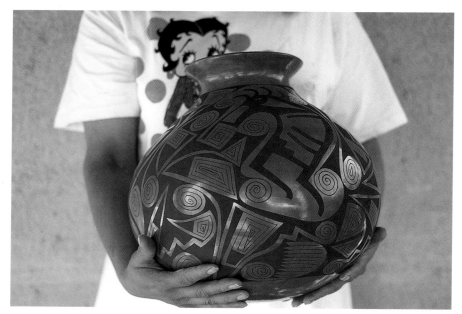

Arturo Ledezma

Arturo Ledezma Veloz is the oldest of the four Ledezma brothers and was the first to learn the craft from Manolo Rodríguez, in about 1992. His success has had a profound influence not only on his immediate family, but on his extended Veloz family as well. Like that of his brothers, his style consists of a complicated geometric checkerboard pattern of alternating squares painted in red and black on the typical white surface. He often connects the horizontal bands of colored squares with a light gray or black diagonal line. The lines link the center of each square from rim to base in an arcing pattern, giving the pot an optical illusion of horizontal as well as of sweeping movement. Olga Quezada and Yoli Ledezma, among others, also utilize this technique on red clay bodies.

Arturo lives with his wife and children in Barrio Americano.

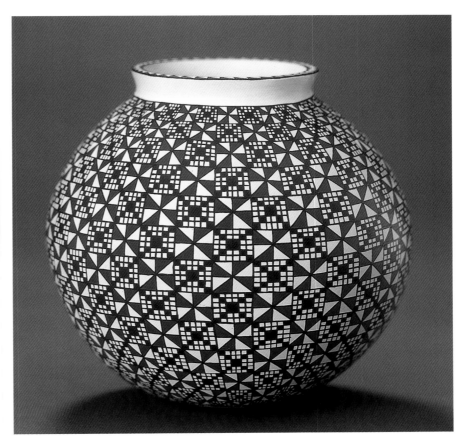

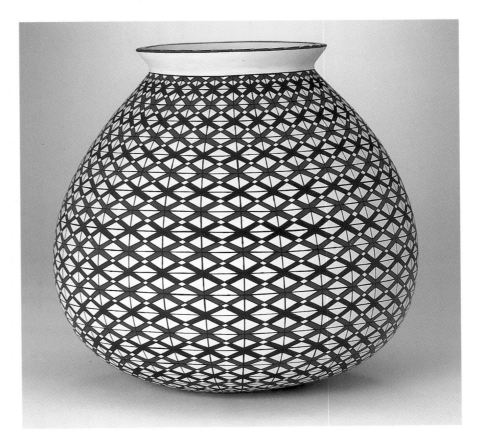

Top
Olla, 7 ½ x 8 inches

Bottom
Olla, 9 ½ x 10 inches

103

Efrén Ledezma

Efrén Ledezma Veloz may be the most creative of the Ledezma brothers. Efrén says he learned from his brother Gerardo, but his present style certainly reflects the work of neighbor Manolo Rodríguez. Efrén's better pieces, seldom over five inches in height, consist of complex repetitive geometric designs in red and black paint on a bright white clay body. What makes his work distinctive from his brothers and more like the work of Manolo Rodríguez is the superimposition of painted animals, such as birds, a swarm of bees, or lizards, in a contrasting single color over the design. Also unlike his brothers, he paints repeating triangles, hexahedrons, pentagons, and rhomboids as the backgrounds for these animals.

Efrén has been potting since 1995 and lives in Barrio Americano near his brothers.

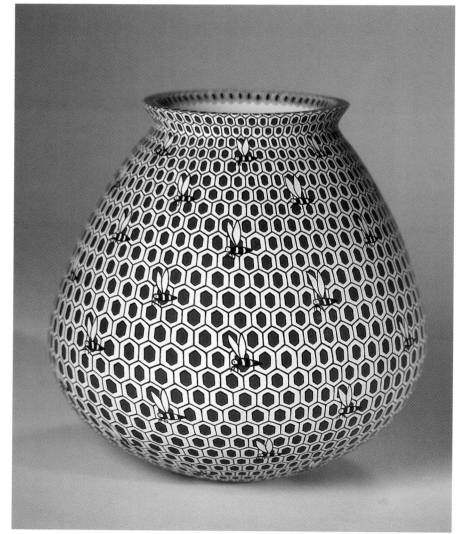

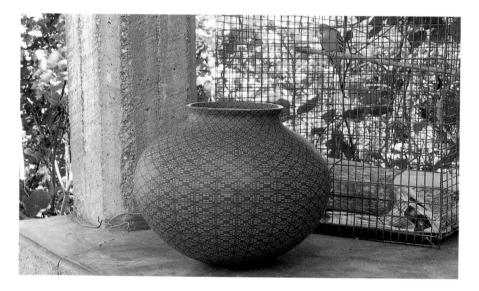

top
Olla, 7¾ x 6¾ inches, **1997**

bottom
Olla, 9¾ x 12 inches, **1996**

Gerardo Ledezma

Gerardo Ledezma Veloz and most of his brothers share a distinctive "Ledezma" style. They work primarily in white clay and paint rich red and black geometric designs, called *cuadritos*, in a checkerboard pattern that repeats over the entire surface of the pot. Gerardo is the most proficient in brush and line work, so that his pots have a stunning and complex appearance when viewed for the first time.

Of all the Ledezma potters, Gerardo consistently produces the highest quality. He is particularly known for wedding vases covered with black or red squares alternating with white squares left unpainted. He often places animal designs on the bottom of his larger pots. He has a particularly good sense of design when arranging the red and black squares on the white surface.

Gerardo first learned to pot from his next-door neighbor, Manolo Rodríguez, and has been potting for only five or six years. He and his family live in Barrio Americano near Manolo's new home.

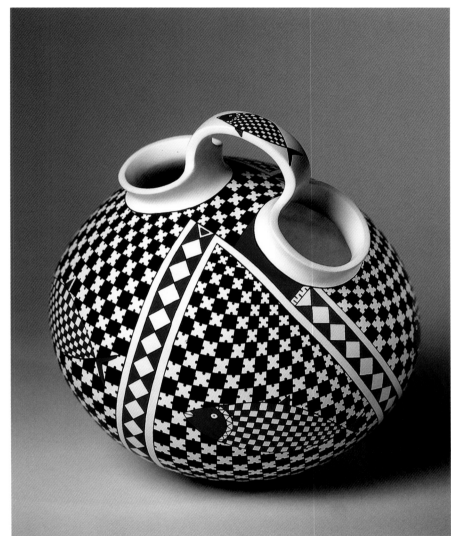

Olla, 9¾ x 7¾ inches, 1997

Baudel López

Baudel López Corona has been potting since 1993 and taught all his older brothers the craft. He doesn't acknowledge anyone in particular as his teacher, although he admits he learned by watching others. His mother still makes his pots, which are mostly smaller *ollas* of highly polished reddish-brown clay, two to three inches in height, on which Baudel paints his intricate designs. American trader Steve Rose encouraged Baudel to make bowls that are painted on both the outside as well as the inside surfaces, a feat of immense difficulty, due to the inside concave surface of the bowls.

Baudel has had a profound influence on his family and has been directly responsible for raising the standard of living not only for his parents, but for all his brothers as well. With several older brothers to work their father's land, the youngest did not need to become a cowboy. Thus Baudel had the time to experiment with clay. When the drought of 1992 became so severe in Chihuahua that some of the family's cattle died and prices were too low to sell the others, Baudel's pottery produced important income for the whole family.

Baudel is unmarried and lives in his parents' home in Barrio Americano behind the school.

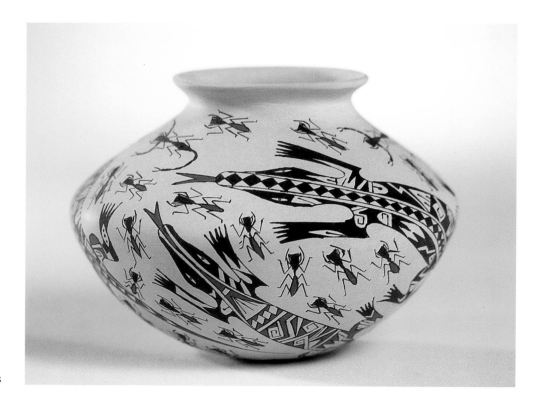

Olla, 4½ x 6 inches, 1998

Edmundo López

Edmundo López Aldováz is related to a number of influential potters in Mata Ortiz, and the quality of his work reflects those connections. His sisters, Nena Ortiz, Gaby Marín, Susy Martínez, and Silvia López, are all accomplished potters, as is cousin Angela Bañuelos.

Edmundo learned to pot in the mid 1980s from his brother-in-law Macario Ortiz. Today he makes only graphite blackware. Although his work is not well known to the average tourist, it is recognized by commercial buyers for its high quality. Edmundo's pots are difficult to obtain due to limited production and to the fact that he lives in Barrio Central in Mata Ortiz only part of the time, with his wife Luz Elva Ramírez de López, and the rest of the time builds houses in Nuevo Casas Grandes. He taught Luz Elva to pot several years ago. Her work is similar to Edmundo's, except that she seldom makes pieces over five inches in height. She is one of the original members of the women potters of the Pearson Group.

Edmundo has won several awards for his excellent work both in local exhibitions and at shows in Guadalajara and Chihuahua over the past few years.

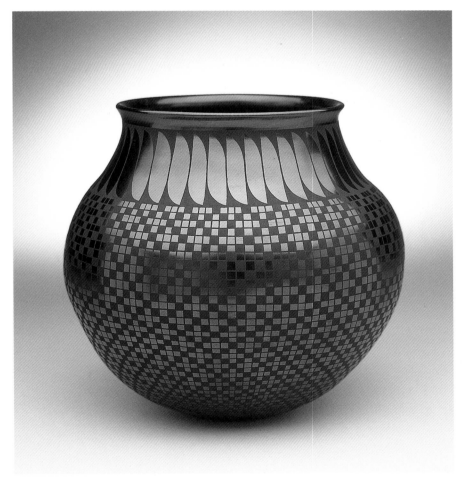

Olla, 10¾ x 11 inches

Leonel López

Leonel López Sáenz is one of the most successful potters in Mata Ortiz, known for a unique style copied by many. Leonel's most singular characteristic is the practice of *sgraffito*, scratching designs onto the surface of the clay body rather than painting them on. His etched geometric feather images are highly calculated, down to the last millimeter, as they radiate around the rims of the pots in perfect symmetry. He also scratches and incises less calculated designs in which animals dance and frolic around the pot. Fish swimming in rows, deer jumping, or lizards and scorpions crawling around the clay globe in perfect symmetry give his animal pots a true folkart feel.

Leonel's work begins with the purchase of an *olla* from one of several potters who furnish unfired *ollas* from clay prepared and provided by Leonel. His suppliers include Tomás Osuna, Rosa Ponce, Miguel López, and Vidal Corona. Leonel first sands and then polishes the surface of the pot with oil

and his favorite polishing stone. Next he covers the surface with a colored clay slip, usually black or red, but in some cases he uses multiple colors. He begins by using a small pocketknife or dental pick to painstakingly cut the images onto the pot, exposing the white clay through the red, black, café, and sometimes yellow slips.

He learned to pot in 1992 from his wife, Elena Rodríguez de López, an older sister of Manolo Rodríguez, when the drought hit the northern plains of Chihuahua and put him out of work. To pass the time away, he assisted his wife in sanding her pots and slowly learned the total process.

Today, Leonel is the best-known potter in Barrio López (named after his extended family who settled that part of the *pueblo*) and one of the most prolific in the village. He would not consider going back to work in the fields or punching cattle full time, as he once did. "Disaster brings both good and bad to our family. We lost a lot of cattle in the early 1990s," he says. "But with our new source of income, as a result of those problems, we are all better-off today."

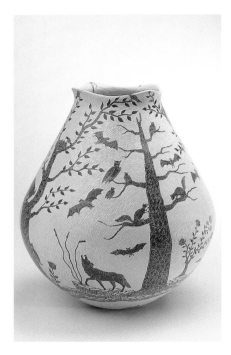

Olla, 12½ x 11 inches, 1999

opposite
Olla, 12 x 11 inches, 1997

Olla, 7½ x 8½ inches

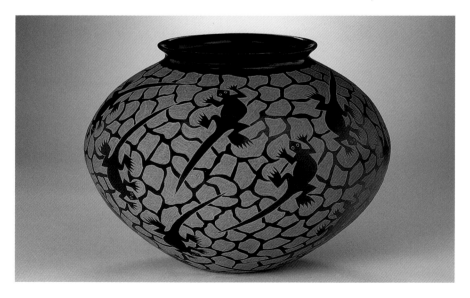

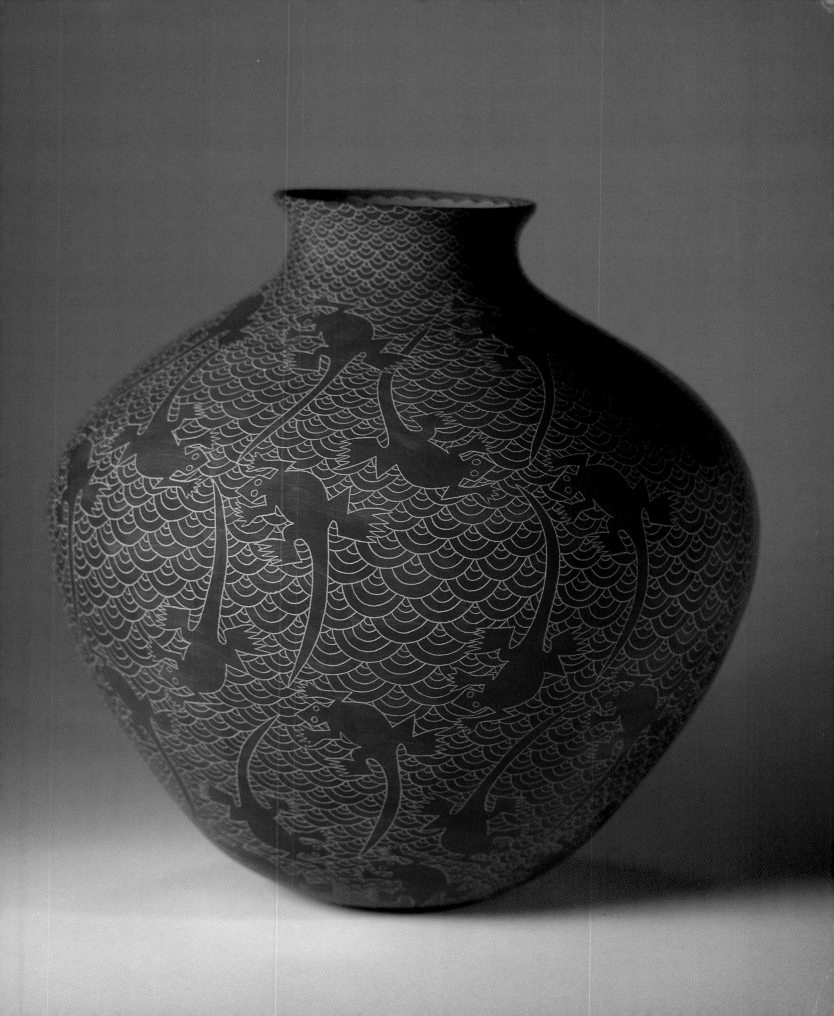

Lourdes López

María de Lourdes López de Corona was born and raised in Barrio López (sometimes referred to as Barrio Adobe) on the far south end of Mata Ortiz. She learned to pot from her grandmother Jesús María Sandóval and her mother, Velia Mora de López. The color and quality of her very small seed pots (two inches in diameter by one inch in height) reflect an astute attention to detail. Lourdes is meticulous in the execution of her designs and draws heavily on the use of Mimbres motifs, particularly in animal forms such as quail, parrots, fish, and deer. She is one of the few potters who use white paint as an accent to black designs on yellow, red, or ash gray clay bodies. Some of the López brothers living next door are copying her use of multi-colored patterns.

Interestingly, Lourdes makes her own clay and forms her own pots, as well as polishes, sands, paints, and fires. She's a member of the women's pottery association formed under the auspices of FONAES, a federal government agency that encourages economic independence for Mexican women. She recently moved from Barrio López to Barrio Americano where she and her husband live next door to her cousins Baudel López and family.

Samuel López Quezada

Samuel López Quezada works with his wife, Estela Silva de López, who assists him in the polishing and sanding of large *ollas*. Most of Samuel's pots are polished, sculptural forms with only limited painting. His large turtle and frog *ollas* of blackware are similar to the work of his mother, Reynalda Quezada. He also makes red and blackware with designs of spiraling swirls molded into the clay. Samuel smoothes the surface of his *ollas* after firing with wet/dry sandpaper of varying grades. (Most potters sand their work to remove rough surfaces after the clay has dried but before they begin the laborious polishing process and the firing.) Samuel is among the very few to practice this innovative technique.

As with many potters, Samuel puts most of his disposable income into his house and now has one of the finer homes in Mata Ortiz. He began potting full time when he was seventeen years old but has been around pottery making all his life. He lives in Barrio Central near many of his relatives.

Olla, 10 x 8 inches, 1999

Rubén Lozano

Rubén Lozano Lucero is one of the few successful potters who was not born in Mata Ortiz. He came to the village in his teens from Mexicali. He was one of the first to take up the craft in the late 1970s or early '80s. In the beginning he worked with Emeterio Ortiz and Pilo Mora, who were both established potters in Barrio Porvenir by 1979. He also worked with the very creative Ortiz brothers: Chevo, Nicolás, and especially Macario Ortiz, who may have had the greatest influence on him as a potter.

Along with Macario, Rubén experimented with bright greens, turquoises, reds, and yellows on blackware in the mid '80s but settled for his award-winning style of perfectly formed, thin, black balloons of graphic clay, highly polished but with no painting on the surface. His pieces are perfections of form, with wide shoulders and small mouth openings, in a style described as *barro bruñido* (burnished clay). He has won a number of national awards, first in the state of Puebla in 1993, for a pot formed for him by Pilo Mora, and two years later in Veracruz.

Rubén works with his wife, María Anastasia Villa de Lozano, in forming large pots (Pilo Mora used to build his larger *ollas*), some of which are almost eighteen inches in diameter. She also assists him in the delicate and time-consuming process of polishing. They presently live next door to the Mercado Pearson on the main street across from the train station in Barrio Central.

Olla, 8½ x 12 inches, 1996

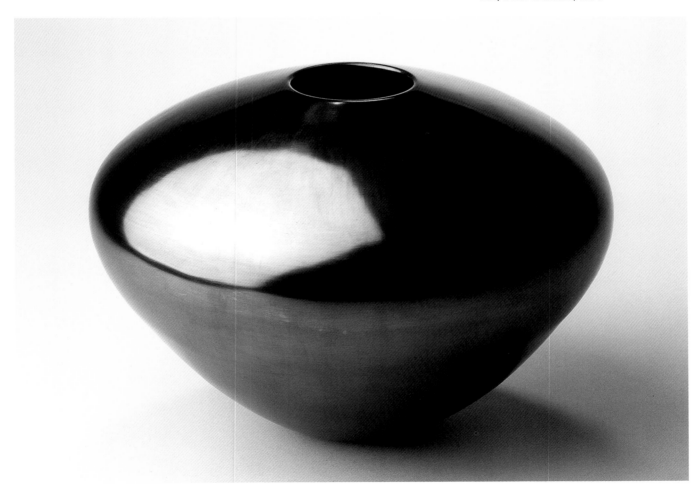

Efraín Lucero Sr. and Efraín Lucero Jr.

Efraín Lucero Juárez has been potting for over a decade, after learning to form clay from his brother-in-law Juan Andrew. His highly polished, black graphite pots show the influence of two of his teachers, Macario Ortiz and his nephew Rubén Lozano. His wife, Antonia Andrew de Lucero, and their five children assist him.

Eighteen-year-old Efraín Lucero Andrew is the most talented of his sons. His work looks much like his

father's, except that he tends to form pots with wider mouths and paints in a style more delicate and studied than his father's. Efraín Jr. is dedicated to the craft and has the potential to be a great potter.

The family lives in the Sección neighborhood of Mata Ortiz.

José Marín

José "Pepe" Marín Olveda was born in San Pedro Corralitos and has been potting for nine years. His teacher was Macario Ortiz. Although much of his work consists of small, finely finished pots in the graphite style developed

by Macario, Pepe also makes very fine Paquimé designs on white clay. José's wife, Gabriela "Gaby" López de Marín, is an accomplished potter in her own right.

José and Gaby live in Barrio Central.

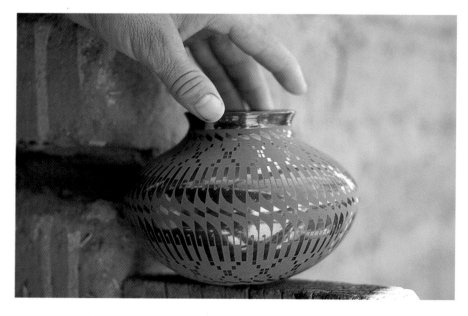

Olla, 4½ x 5½ inches, 1997

Jesús Martínez

Jesús Martínez Rentería Jr. and his wife, María del Socorro Amaya de Martínez, are a team that produces some of the most complicated design patterns on pottery from Mata Ortiz. Their work is executed with precision in multiple colors of red and black on a beautiful white background of clay. Socorro forms, sands, and polishes all their pots. Jesús paints each piece and does the firing. His painting is similar in style to that of Mauro Quezada, his brother-in-law and teacher.

Their work was featured in the University of New Mexico Art Museum's exhibit in 1995, and Jesús attended the exhibition at the Arizona-Sonora Desert Museum in Tucson in 1996. They presently live along the Palanganas River in Barrio Central near where Jesús grew up.

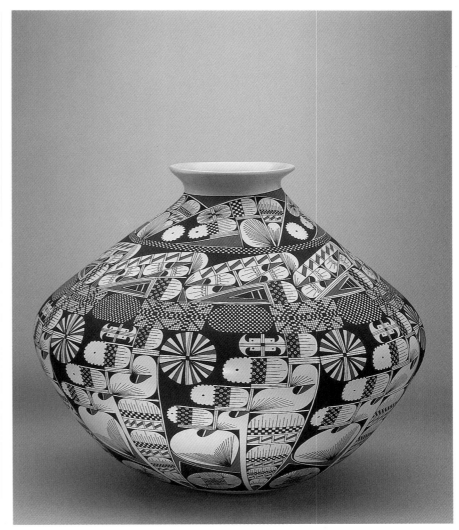

Olla, **12 x 14 inches**

José Martínez

José Manuel Martínez López has been making pots for six years. José says his teacher was his *tío político* (uncle by marriage) Héctor Gallegos. But he also admits that many of his own relations have influenced his work. José works with his wife, Suzy López de Martínez, making small pots with elegant Mimbres designs. Occasionally they make elegant and original effigy pots with two or four heads on a round body of Mimbres design. The couple is equally adept at graphite blackware and fine polychrome pots of white clay. José and Suzy frequently purchase unfired pots from José Cota and Florentino Cota.

They live in Barrio Central.

Olla, 4 x 6 inches, 1998

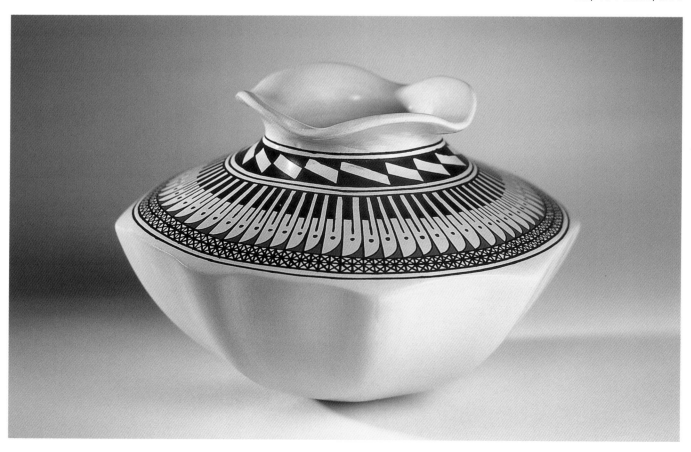

Luis Martínez

Luis Martínez López has been making pots for nine years. Like his brother José, he claims Héctor Gallegos as his teacher. Luis makes mostly white pots of Mimbres style design. He frequently makes unusual shapes, including rectangular and octangular vessels. His painting is very fine and reminiscent of the work of Héctor Gallegos.

He lives in Nuevo Casas Grandes.

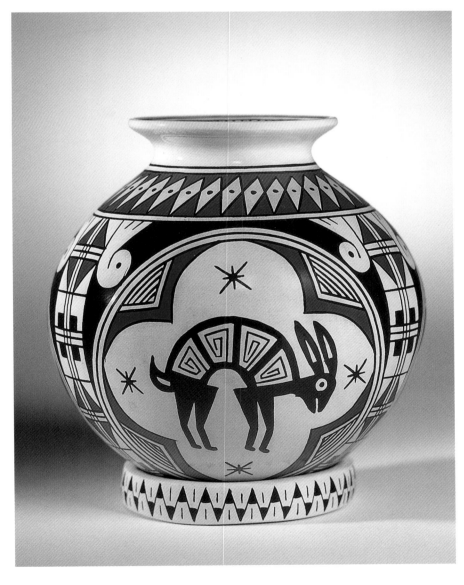

Olla, 4¾ x 4½ inches, 1998

Julio Mora

Julio Mora Sandóval is a full-time cowboy who makes very fine, thin miniature pots in his spare time. His pots include a variety of fine design elements on light and highly polished white and tan clays.

He lives with his wife and young family on the north end of Porvenir near the railroad tracks.

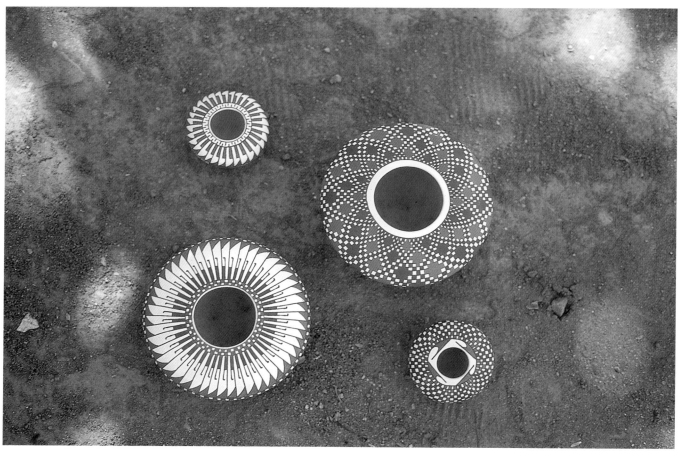

Miniature *ollas*, 1 x 2 inches and 2 x 4 inches, 1997

116

Manuel Mora

Jesús Manuel Mora Villalba is an innovator of studied precision. He learned to pot from his brother Pilo in 1989, and by 1991, after difficulty firing his pots in the wind and dealing with idiosyncrasies of the process, he set out to find a new way of doing things.

Unlike other potters who use oil or water with a smooth stone to polish their unfired *ollas*, Manuel sands his inside and out with sandpaper varying from 150 to 600 grit. He doesn't polish his pots at all. Because of this sanding process, his polychrome pots have a matte finish, rather than the high-gloss finish most potters strive for. The matte finish can have up to five colors of varying hues (on either white or red clay) that give the impression of a desert mountain range changing colors at sunset. What is more interesting, however, is the manner in which he fires his pots. He created a double-screen contraption called a *quemador* that consists of rebar, a lattice framework made of heavy wire, pieces of metal, and several buckets. The structure stands about two feet high when erected and allows him to fire several *ollas* at once, in sequence, even under difficult conditions of wind and humidity.

Manuel is the headmaster of the elementary school in Barrio Americano and expects his three children to finish school before they become potters. He and his wife live in a well-maintained adobe and stone house in Barrio Porvenir.

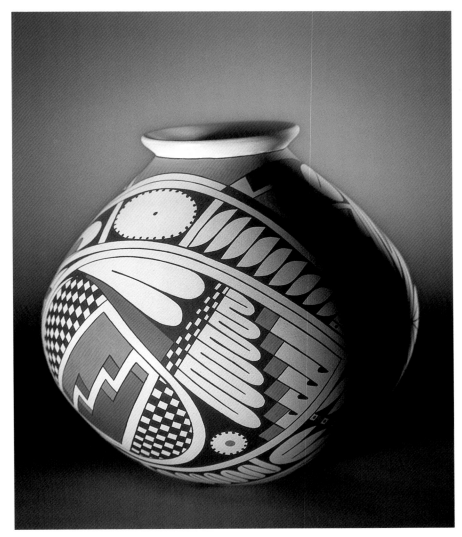

Olla, 7 1/4 x 7 inches, 1997

Porfirio Mora

Porfirio "Pilo" Mora Villalba is one of the most influential of the early potters from Porvenir. Before he moved to his present home in Nuevo Casas Grandes, he lived in Barrio Porvenir where he learned to pot from Emeterio Ortiz. Pilo may have begun potting as early as 1973 when he was in his late teens, assisting Emeterio with all phases of the process. He says that during those early years the potters of Porvenir were Félix Ortiz, Salvador Ortiz, Macario Ortiz, Nicolás Ortiz, José Silveira, and himself.

Pilo is well known for his use of mixed clay (over 98% of all his pots, and those of his students, are made from *mezclado* clay) that yields a marbleized finish and for fine thin pots with incredible line work. His ability to paint is unsurpassed and is often done as a complex maze that starts at the top of his *ollas* and winds its way to the base. He says, "A lot of people look at my pots and just see a lot of lines, but what they don't realize is that this maze design represents my life." He admits, somewhat sheepishly, that he got the idea for this design from his dreams.

Pilo is losing sight in one eye and has taken on several apprentices to help him paint the *ollas* he makes. He often works with people in need of financial assistance and looks for those willing to work hard and commit the time required to become outstanding artists. Two of his most recent students, Javier Pérez and Salvador Almazán, are excellent potters.

Olla, 8¾ x 9½ inches

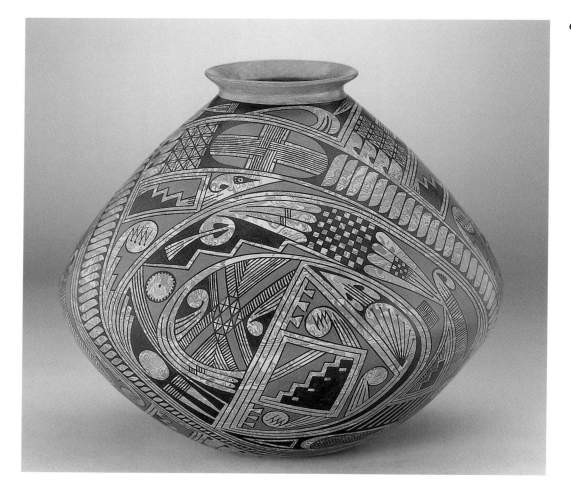

Elí Navarrete

Elí Navarrete Ortiz is one of the finest second-generation potters from the Porvenir tradition. His artistic ability and his application of paint are inspirational. While most potters from Porvenir repeat the same design over and over again around the surface, Elí paints complicated designs that, when studied closely, reveal interlocking animals and geometric forms in a Paquimé motif. Sometimes he paints up to five different animals hidden in the design and makes a great game of challenging the viewer to find them all.

Elí was born in Chihuahua City and has been potting barely five years, after learning from his uncle, Macario Ortiz. Although others had experimented with multiple colors on blackware before (Macario Ortiz, Rubén Lozano, Reynaldo Quezada, and others), Elí pushed the technique to new levels, innovating technically and artistically. In March of 1997, Elí and his two brothers, Jesús and César, began painting multiple colors over black graphite earthenware. While attempting to explain this complicated process, without giving away too much of his "secret," he only says,

"You can turn a gray pot black, with a little bit of graphite and manganese rubbed into the surface. . . . It takes a little bit of this and a little bit of that," he adds with a sly smile. Over the top of this dark surface he paints whimsical designs in red, green, blue, and white mineral paints. The colors he painted a year ago were brighter and more distinct (probably from commercial clays). Today Elí understands the combination of various natural compounds better, and his colors reflect a more sophisticated shading, with as many as five colors on one *olla*.

Elí's work is nothing short of brilliant. He could become one of the top two or three potters to ever come out of Mata Ortiz. He lives in Nuevo Casas Grandes with his older brother, Jesús.

*Olla*s, 7 ½ x 4 ¾ inches and
8 ½ x 5 inches, 1997

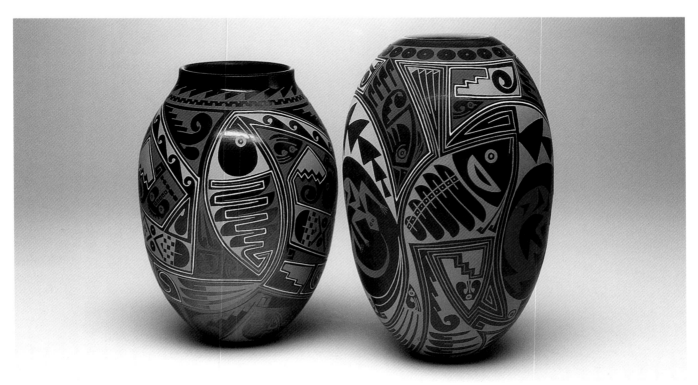

Manuel Olivas

Manuel Olivas is not often considered as a potter from Mata Ortiz. In fact, he has lived on the outskirts of Casas Grandes overlooking Paquimé for more than fifty years. For forty years or more he has been making replicas of prehistoric Casas Grandes pottery and guiding tourists to archaeological sites in the surrounding areas. A number of dealers believe that some of the pottery passed off as prehistoric Casas Grandes pottery may, in fact, have been made by Manuel. Several pottery dealers in Arizona and New Mexico believe that Manuel Olivas was the father of the pottery revival near Casas Grandes years before Juan Quezada began working with clay.

Manuel lives in a street-side house identified by a concrete chicken and other large, curious sculptures on the main road to Mata Ortiz, just south of Casas Grandes, near the home of Nicolás Quezada.

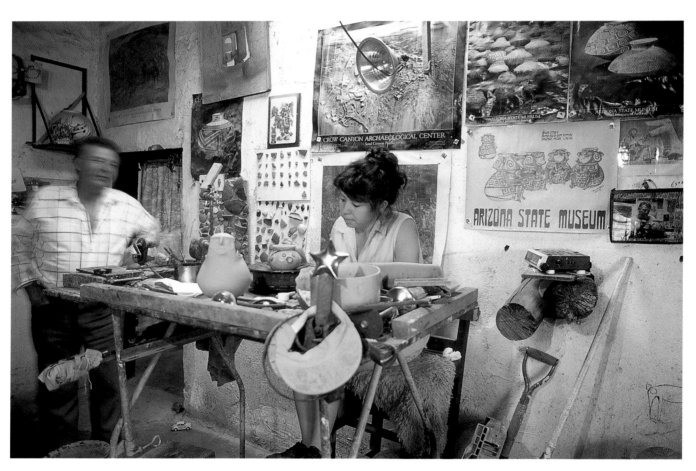

Manuel Olivas and his daughter Blanca

Héctor Ortega

Héctor Ortega makes well-executed black and red *ollas*, in which he combines design elements similar to those developed by his brother-in-law Chevo Ortiz and Chevo's brother Nicolás. From Chevo he learned to make pots with swirls, or *turbinos*, and *ollas* with concave sides. From Nicolás he learned to sculpt animal figures. Héctor is now best known for two sculptural forms: pots up to eight inches in height with the heads of either rams or bears looking at each other from opposite sides of the rim and twelve-inch-high pots with swirls that sweep down from the rim and rotate to the base. He fires both red and black pots and keeps his painted designs on the clay limited.

Héctor and his wife, Olivia López Quezada, daughter of Reynalda Quezada, live in Barrio Central along the Palanganas River near the railroad bridge.

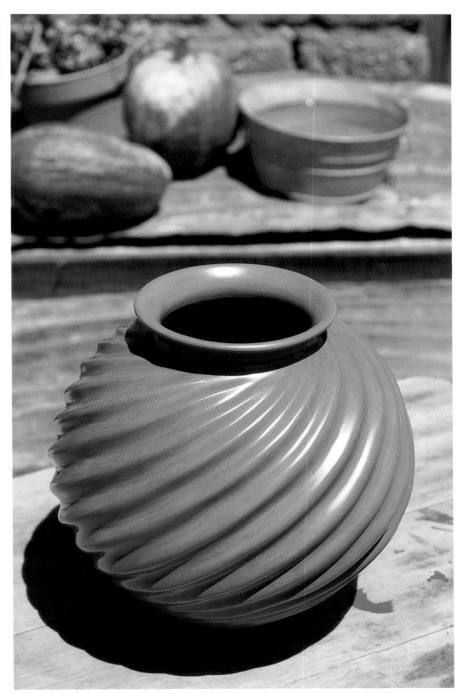

Olla, 8½ x 9 inches, 1996

121

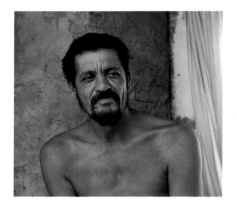

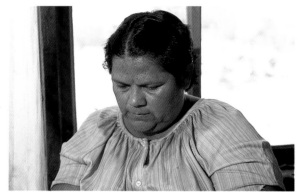

Eduardo Ortiz

Eduardo "Chevo" Ortiz Estrada and his wife, Hortencia Domínguez de Ortiz, are one of the most productive couples anywhere in the village. Chevo makes the *ollas*, often over fifteen inches in height, and paints the surfaces with the basic *cuadrito* elements, while his wife sands, polishes, and "fills in" the painted lines. When the pots are ready for firing, Chevo undertakes that chore effortlessly without a thought of cracks or breaks-and he loses very few *ollas*. (Graphite firings require less heat, for example, than a pure white *olla*.) At least 95% of their work is graphite blackware that shines like polished metal, although, like his brothers, they used to do primarily polychrome.

Chevo is best known among the traders for three distinctive pottery forms. The first is an *olla* with round, concave circles on four sides, highly decorated with *cuadritos*. Second, *ollas* with pottery rings and hooks attached to the top of the pot as if it could be hung from the ceiling with ropes (don't try this). Finally, one of his more recent designs, now being copied by Samuel Quezada and Héctor Ortega, is an *olla* in which the surface is formed with half-inch rippled spirals that rotate downward from rim to base in the form of *turbinos*.

Along with his more famous brothers Macario and Nicolás, Chevo is considered one of the best potters of Mata Ortiz. He and Hortencia live near the other Ortiz brothers in Porvenir.

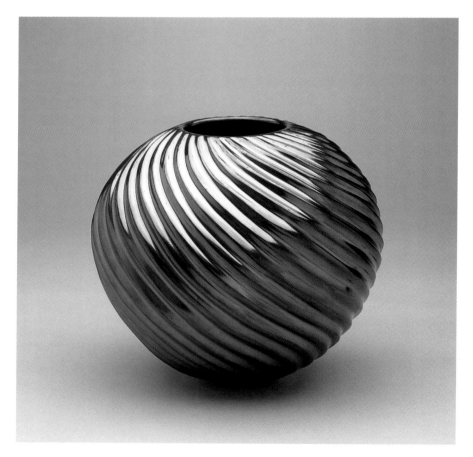

Olla, 9 x 9¾ inches

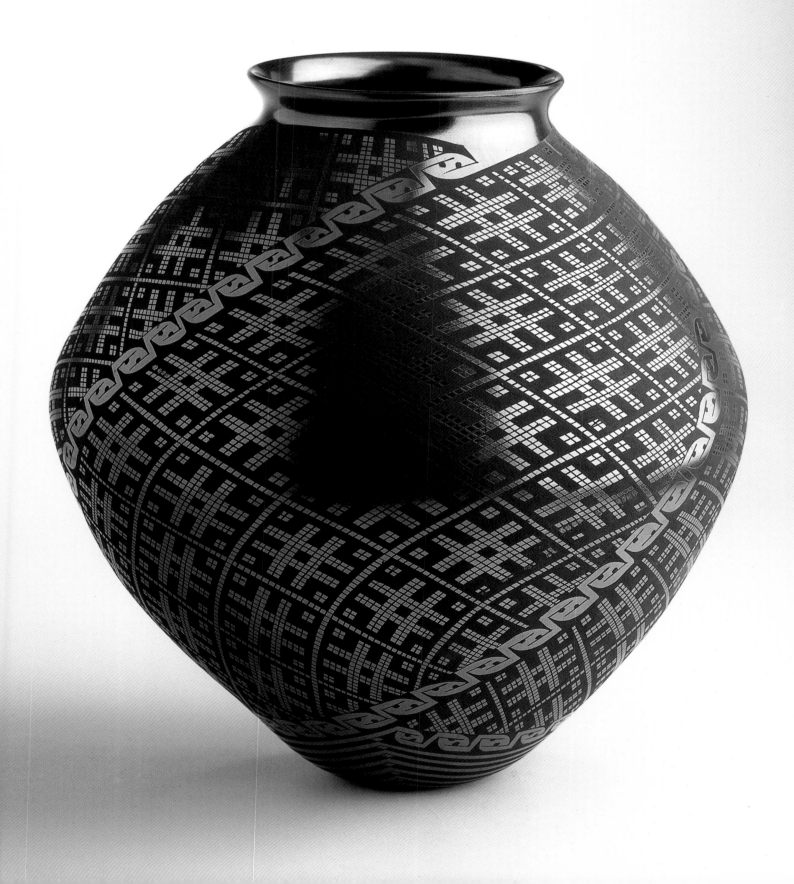

Félix Ortiz

Félix Ortiz Rodríguez is one of the most influential potters in Mata Ortiz, yet he is hardly known outside of Barrio Porvenir. Many great Porvenir potters learned directly from Félix and his early group of potters. Well-known students of Félix Ortiz include Pilo Mora, Rubén Lozano, Enrique Pedregón, Pati Ortiz, the three Ortiz brothers Macario, Chevo, and Nicolás (only distantly related to the Félix Ortiz family), and many others.

Félix was the first person to begin potting in Barrio Porvenir, beginning in the early 1970s and followed shortly thereafter by his brother-in-law Salvador Ortiz (related only by marriage). By 1975 Félix's older brother, Emeterio, was working with them in a tiny studio next to Félix's home. A year later Amalia Ortiz, a sister of the Ortiz brothers, joined this core Porvenir group.

During the early years, Félix and his friends did not have direct access to the same information, clay, or paints as Juan and his students, just a few hundred yards to the north of Porvenir. Most of what they gleaned from Juan came through serendipitous observation, rumor, or stealth.

Crucifix, 9 x 5 inches

Accordingly, the early Porvenir potters developed unique methods and designs. For example, Félix developed a continuous-coil method of forming a pot that is still used in Porvenir today, a technique that resembles the Pueblo Indians of the American Southwest more than it does Juan's single-coil, or "donut," approach. Style was another distinguishing difference. Porvenir potters avoided the time-consuming process of painting mirror images on opposite sides of the vessel in two, four, or six quadrants. The Porvenir style took a simpler approach, *sin geometría*, in which painted designs flowed around the surface in no particular order.

Early Porvenir potters were not as serious in the pursuit of quality as Juan and his students. Félix's mind did not run in that direction, a circumstance that continually caused friction between Juan and Félix.

Porvenir remained isolated from mainstream buyers until the early 1980s. Out of concern for the future of the village, Juan and later buyers tried to impress Félix with the importance of quality. As Spencer MacCallum explains it, Juan acted more as a classicist; his designs were guided by order, proportion, and intellect. Félix's designs came from the heart of a romantic, in which imagination and emotions dominated.

Today Félix makes a fine pot in both polychrome and graphite black. His designs are largely animal and effigy figures, much as they were ten years ago. In addition to finishing his own work, Félix has made pots for other Porvenir artists. He lives in Barrio Porvenir next to the Catholic church.

Isídro Ortiz

Isídro Ortiz Chacón is a nephew of the Ortiz brothers, Macario, Chevo, and Nicolás. He makes highly polished graphite blackware using fine Mimbres designs.

Isídro lives across the street from Nicolás Ortiz in Barrio Porvenir.

Paty Ortiz

Paty Ortiz de Santillán learned potting from her father, Salvador Ortiz, one of the original innovators of the Porvenir style. (This Ortiz family is not directly related to the Ortiz brothers.)

Paty uses only *barro mezclado* (mixed clay) for her pots and paints designs inspired by Paquimé motifs. Her *ollas* are much like those made by Pilo Mora in that they are light in weight and well formed. She is an excellent potter and has recently taught her husband to polish, sand, and fire. They live southeast of Macario Ortiz in Barrio Porvenir.

Macario Ortiz

Macario Ortiz Estrada is one of the best known of *Los Hermanos Ortiz* (The Ortiz Brothers band), in which Macario is the lead singer. Macario, his brothers, and nephews form a family of multiple talents. Macario first learned to pot in 1982 by watching Félix Ortiz at work in his tiny studio. By 1984 he and his brother Nicolás were working together on a regular basis with the assistance of American trader Debi Bishop, who helped them get to the U. S. for museum shows and sales exhibitions. During the mid 1980s their work improved dramatically, not only due to Debi Bishop's initial encouragement but spurred on by the arrival of trader Jerry Boyd, who paid top dollar for quality pots.

Around 1982, Macario and Rubén Lozano discovered a bright shiny black mark on a pot after firing, the result of a pencil mark (graphite) left on the pot. This was the initial discovery of the graphite additive that would revolutionize the making of blackware without firing by the traditional, oxygen-reduction technique. From then on, this technically simple process has become the most common way to turn pottery black in Mata Ortiz. Blackware made with graphite is easier to fire, more sensitive to fingerprints, more

tolerant of coarse polishing, and more susceptible to surface damage than blackware made by reduction firing.

Macario and Rubén were also the first to experiment with bright colors of green, blue, red, and white painted over black graphite. Finding that buyers were not ready for such "wild"

colors, however, they abandoned the process during the late 1980s. In 1997 Elí Navarrete revived the process.

Macario and his wife, María Elena "Nena" López de Ortiz, occasionally collaborate on large or complex pieces. Although they have a home in Nuevo Casas Grandes, they can be found most often in their two-story home in Barrio Porvenir.

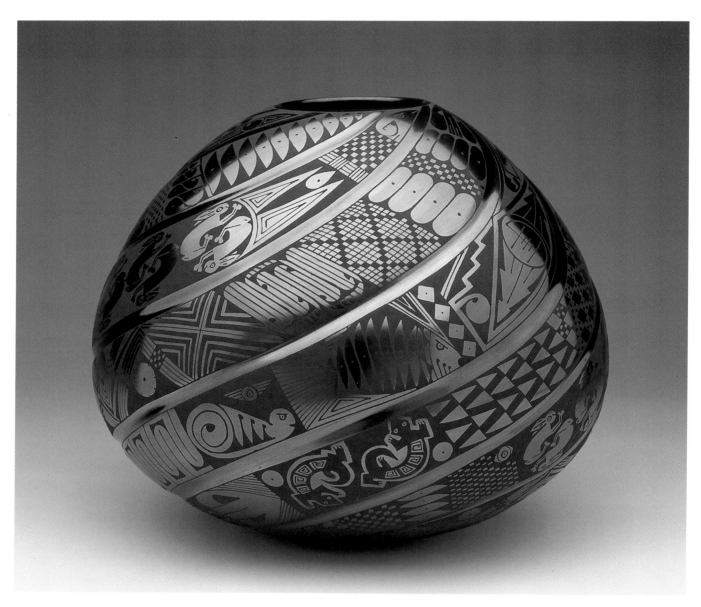

Olla, 11 x 12 inches, Macario and Nena
López de Ortiz, 1997

opposite
Olla, 12½ x 13 inches

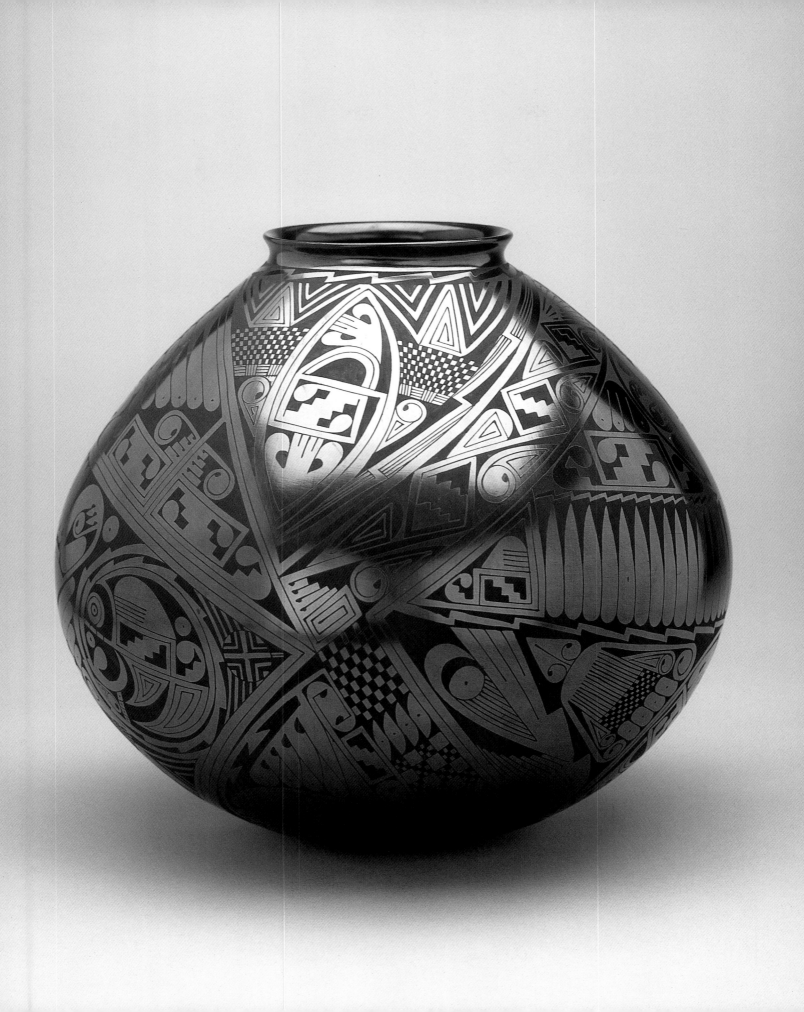

Nicolás Ortiz

Nicolás Ortiz Estrada may be the most inspired of all the Mata Ortiz artists. His abilities are legendary, and his creative energy is boundless. Not only does he sing in the *Los Hermanos Ortiz* band, he plays the violin, piano, banjo, saxophone, guitar, and drums. As a potter, Nicolás is a sculptor first and a painter second, and his effigy pots are both realistic in form and beautifully painted. Nicolás learned the basics of potting from his younger brother Macario and from hanging around Félix's group during the late 1970s.

His work was featured in the University of New Mexico Art Museum exhibit in 1995, and ever since he has been overwhelmed with orders. His painted rabbit of polished buff clay in that show attracted numerous requests for more. In the last four years Nicolás has made hundreds of rabbits in response and has rabbits on order hanging on slips of paper all around his studio. And despite the benefits of the opportunity, Nicolás is tired of dreaming of rabbits almost every night.

Nicolás stands 6 feet, 7 inches tall and is warm, mellow, and gracious. He speaks a little English, which allows him to communicate with American buyers who have requested other zoomorphic effigies also, such as javelina, black rabbits, eagles, snakes, mice, and even a desert tortoise. He lives with his family in Barrio Porvenir.

Double *olla*, 6¼ x 12 inches

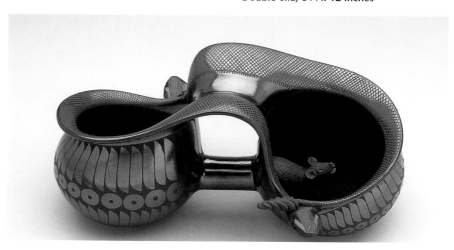

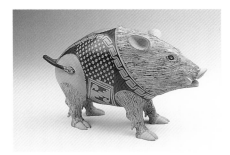

Javelina, 8 ¼ x 13 inches, 1997

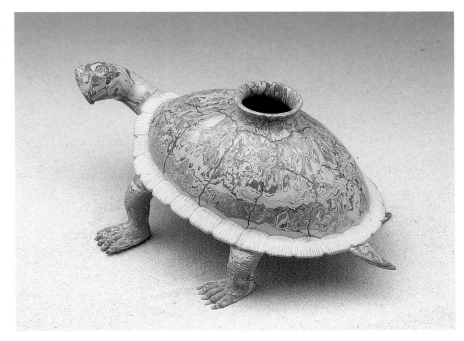

Turtle, 7 ½ x 13 ½ inches, 1997

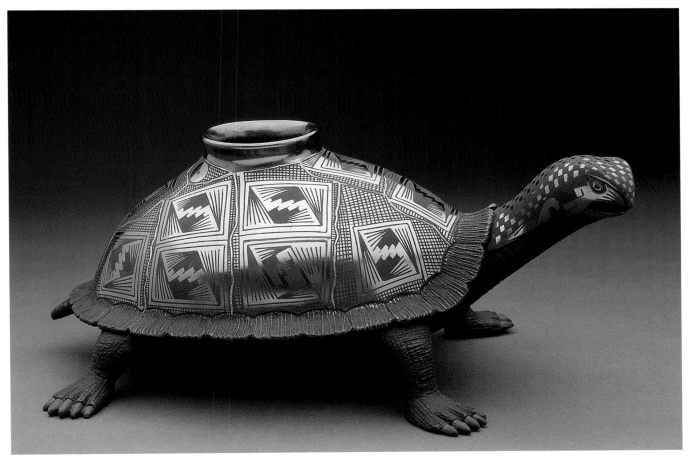

Turtle, 7 ½ x 13 ½ inches, 1997

lar pit-firing technique, unique among the potters of Mata Ortiz, accommodates one large pot or numerous smaller ones in a single firing. Tomás uses pine and cottonwood to stoke the fire, woods which burn hotter and longer than bark or cow dung. He claims his firings take up to two and a half hours to complete, longer than any of the other firing techniques used in the village.

Tomás Osuna

Tomás Osuna is one of the more important potters living in Barrio Porvenir but little known because he doesn't sign his pots. As is the tradition in Mata Ortiz, only the painter signs the bottom of the *ollas*. Most of Tomás's pots are sold unfinished to a number of the better-known potters.

Tomás learned potting a decade ago from his wife, Silvia Silveira de Osuna, who now assists him with sanding and polishing. Tomás has a knack for building large, stunning *ollas* of perfect proportions quickly and with little breakage in the drying process. They are usually large *ollas* of yellow, brown, or gray clay with small openings and flaring necks at the top. Potters who consistently buy his "greenware" are Leonel López, Oscar Rodríguez, Armando Rodríguez, Manuel Rodríguez, Nicolás Quezada, and Oscar Gonzáles Quezada.

When Tomás does paint his own *ollas*, they are usually black-on-black with a graphite finish. He fires his *ollas* inside a large metal tub placed over a large hole in the ground. This particu-

Enrique Pedregón

Enrique Pedregón Ortiz is a nephew of Félix Ortiz and was born and raised in Barrio Porvenir. He learned to pot at fifteen from his parents, Teodora Ortiz and Reynaldo Pedregón. Like so many of the second-generation potters, Enrique is a better potter than either of his parents. He is known mostly for small, polychrome *ollas* of intricately painted designs on tannish-brown clay. He is one of the younger potters who use a shoe polish to bring out the luster of their pots after firing. Enrique has developed a distinctive style of intricate banded designs, which give his *ollas* a cloisonné look. Enrique participates in the *matachines* dances during religious days, so popular in Barrio Porvenir. He can still be found living with his parents on the north side of the barrio.

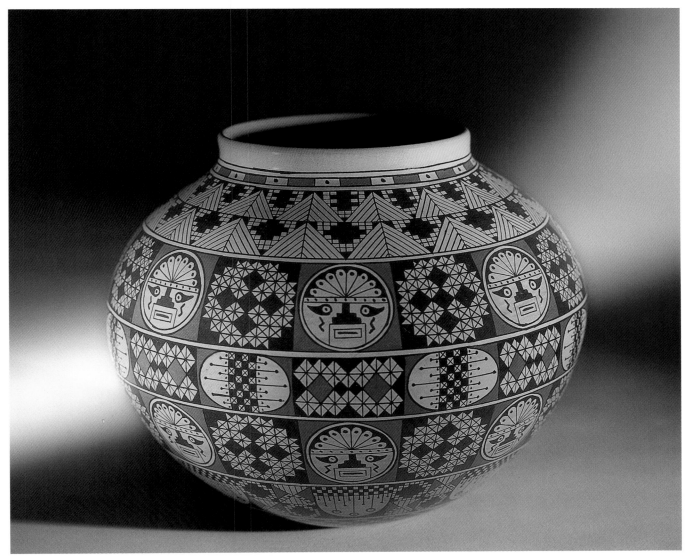

Olla, 8 ½ x 10 inches, 1997

Javier Pérez

Javier Pérez Olivas has been working with his teacher, Pilo Mora, for only a few years. Pilo forms the pots and Javier does the actual painting. Almost all of the team's *ollas* are of mixed clay. Over the past year or two, Javier's work has improved tremendously in quality of design and execution.

Javier was born in Colonia El Rusio nineteen years ago and has worked in Pilo Mora's studio in Nuevo Casas Grandes alongside Salvador Almazán for his entire apprenticeship. Javier is a natural artist, a talent apparent in spite of his limited experience. He lives in Nuevo Casas Grandes.

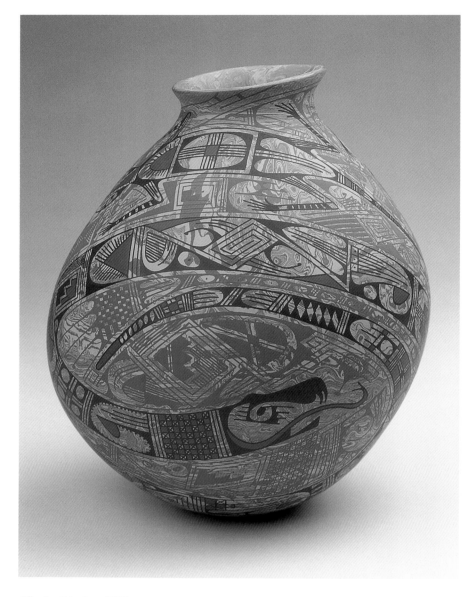

Olla, 9 x 7 inches, 1999

Humberto and Blanca Ponce

Humberto Ponce Avalos and his wife, Blanca Noelia Almeida de Ponce, work as a team. Blanca forms, sands, and polishes and Humberto paints. He works with prehistoric Paquimé design elements but has become most famous for his delicate polychrome *cuadrito* motifs. Humberto and Blanca learned to pot from Blanca's sister Gabriela Almeida de Domínguez and her husband, César, when they all lived in Mata Ortiz.

In 1991 the two families moved to Nuevo Casas Grandes, so that both César and Humberto could expand their opportunities as primary school teachers, as well as to provide a better education for their children. Their work appeared in the University of New Mexico Art Museum exhibition in 1995, and they won awards in 1998 at the local anthropology museum in Casas Grandes.

They live in the south end of Nuevo Casas Grandes near the prison.

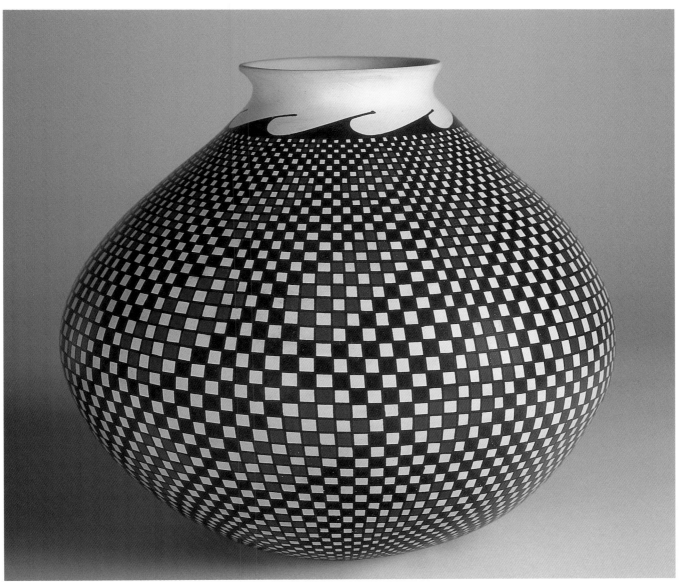

Olla, 9 x 9½ inches

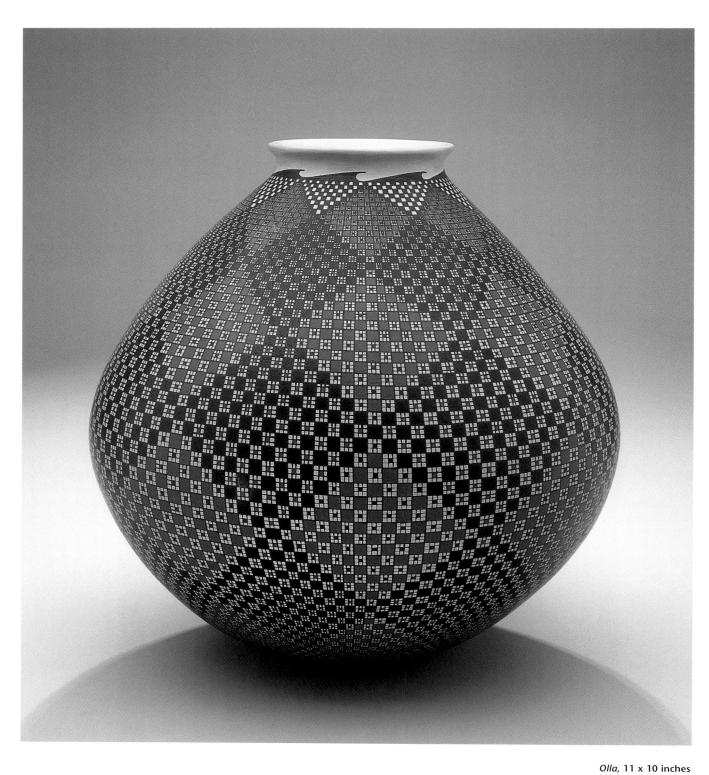

Olla, 11 x 10 inches

opposite
Olla, 9 x 10 inches

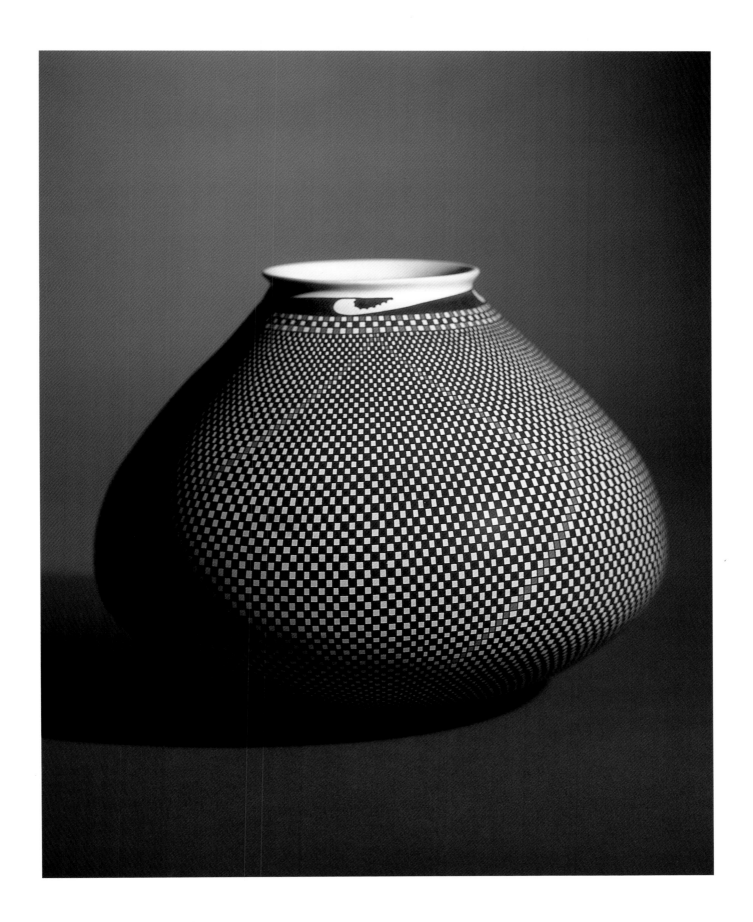

Arturo Quezada

Arturo Quezada Olivas is the next-to-youngest son of Juan and Guillermina Quezada. Like most of the Quezada children, Arturo has grown up watching and helping Juan and Guille. In 1998 Arturo's work improved dramatically, resulting in a number of prestigious sales, including the San Diego Museum of Man's permanent collection. In addition to creating his own pieces, Arturo continues to help his father with sanding and polishing.

Arturo lives with his parents in Barrio Central.

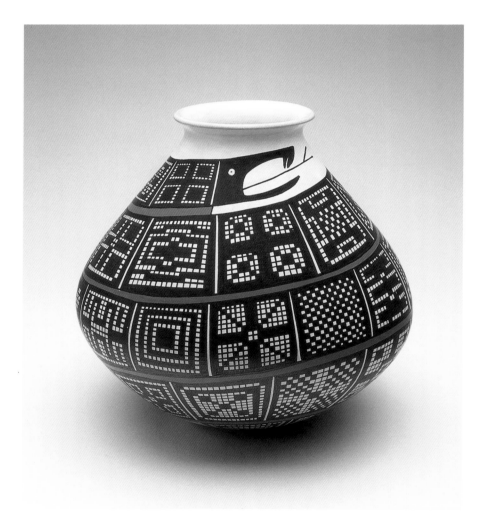

Olla, 7 5/8 x 7 3/4 inches, 1998, San Diego Museum of Man Cat. No. 1998-37-1

Betty Quezada

Betty Quintana de Quezada has been making small pots in the Quezada style for a number of years, but only recently has the quality of her work improved so significantly. Both her designs and her pot-forming skills have combined to produce large, reduction-fired blackware in the classical Quezada style at a very high level of accomplishment.

Betty and her husband, Noé Quezada, live along the Palanganas River in Barrio Central.

Photo by Diego Samper

Olla, 12½ x 13¾ inches, 1998

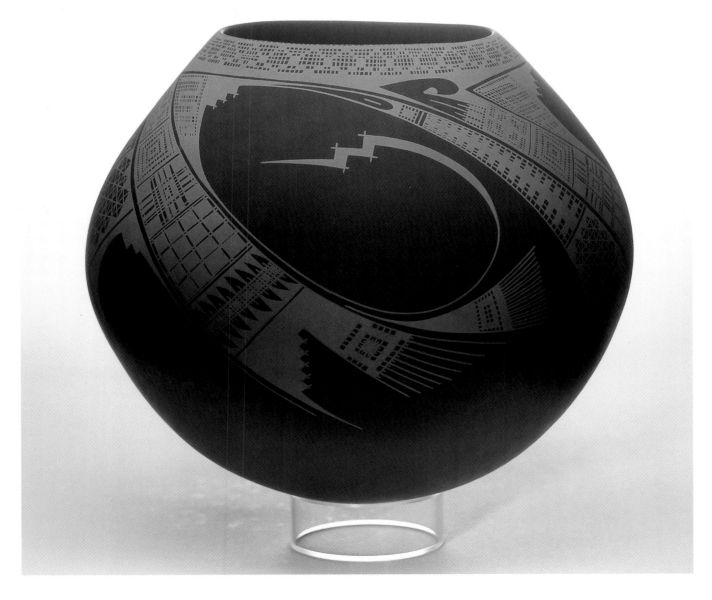

Blanca Quezada

Blanca Quezada de Rentería is a young potter living with her husband, Cruz Rentería, in Barrio Americano. She has been potting for only a very few years, having learned from her neighbor Graciela Gallegos. Blanca works in white clay with wonderful Mimbres designs reminiscent of the Quezada style, although there is no family connection to either Juan Quezada or the Gallegos family. She is building an outstanding reputation for small *platos* and *cazuelas* painted with animals in the Mimbres tradition and commands high prices for her work.

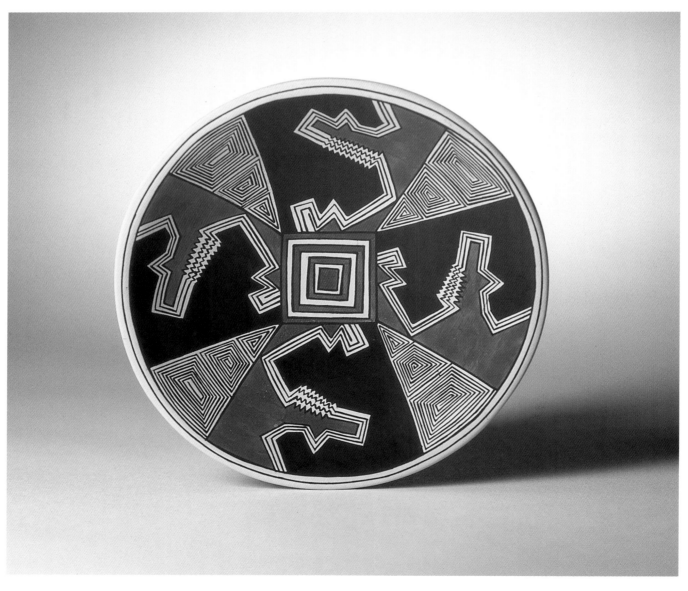

Plato, ½ x 4¾ inches, 1997

Consolación Quezada

Consolación Quezada de Corona is the oldest of Juan Quezada's siblings and was one of the first to begin potting over twenty years ago. She was born in Santa Bárbara Tútuaca in 1933. With her first husband she had two children, Oscar and Manuel Gonzáles Quezada. Her present husband, Lupe Corona, is the father of Hilario, Dora, and Mauro Corona Quezada.

Consolación learned to pot from her brother Juan in the early 1970s, although she attributes to her younger brother Nicolás much of her later improvement. She makes large *ollas* with polished black-and-red designs combined with indented elements circling the rims, a technique she learned from her brother Reynaldo. She taught all of her five children to pot, with Mauro, the youngest, being the most talented.

Consolación is not only the matriarch of the Quezada family, but the adopted mother of many tourists who come into town. She is a close friend to many American buyers and is always extending her home and hospitality to weary travelers. She lives in Barrio Central on the Palanganas River, near her son Mauro and across the street from her brother Reynaldo.

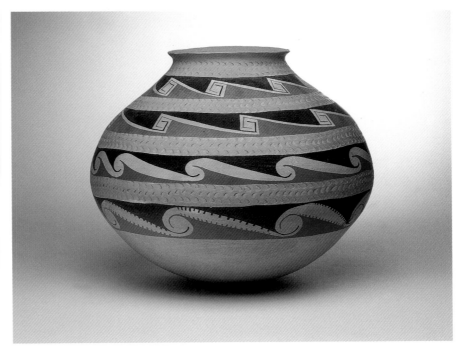

Olla, 13 ½ x 15 ¾ inches, 1978–1982,
San Diego Museum of Man Cat. No. 1887-2-182

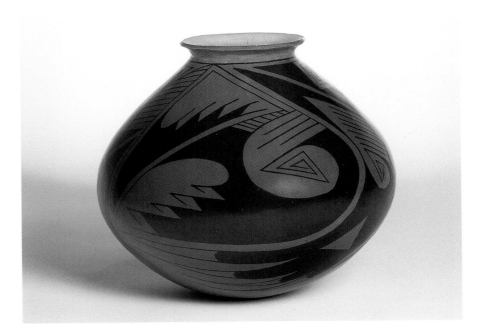

Olla, 9 ¾ x 11 inches

Damián Quezada

Damián Escarsega Quezada and his wife, Elvira Antillón de Quezada, have been working together for almost five years. Damián learned to pot from his uncle Nicolás Quezada and his cousin Oscar Gonzáles Quezada (Consolación's son) after he moved to Nuevo Casas Grandes seven years ago.

Elvira forms the vessels of white and pink clays, while Damián paints the complex polychrome images. One of his unique characteristics is the manner in which he lays out designs on his jars. The surface is divided into five, six, or eight divisions of identically repeated elements. Most potters prefer to divide their designs into either three or four sections. Needless to say, because of the large number of sections, the complexity of Damián's work is difficult to see with just one casual glance. He paints exclusively with polychrome red and black mineral oxide paints in classic Quezada style.

At the second pottery competition held at the new Museo de las Culturas del Norte in Casas Grandes in 1998, Damián won first place in the Mimbres (white) category for an elegant eight-segmented *olla*, which

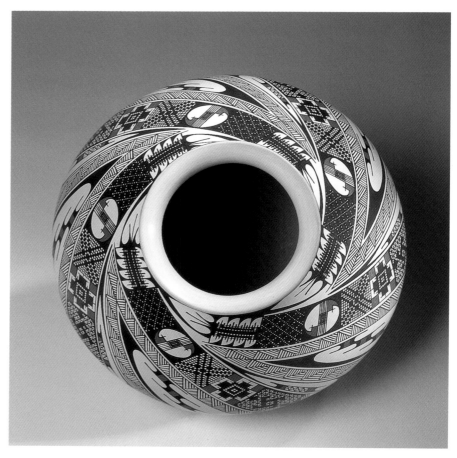

Top view of *olla* on facing page showing five-part design

brought him $470 in prize money. Damián is one of the finest of the second-generation potters and has the potential to become a master potter in the tradition of his uncle Juan Quezada.

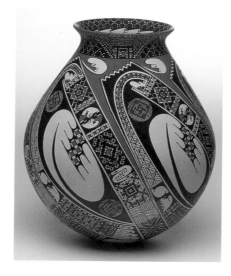

Olla, 11⅜ x 9¾ inches, 1998

opposite
Olla, 12½ x 12 inches, 1997

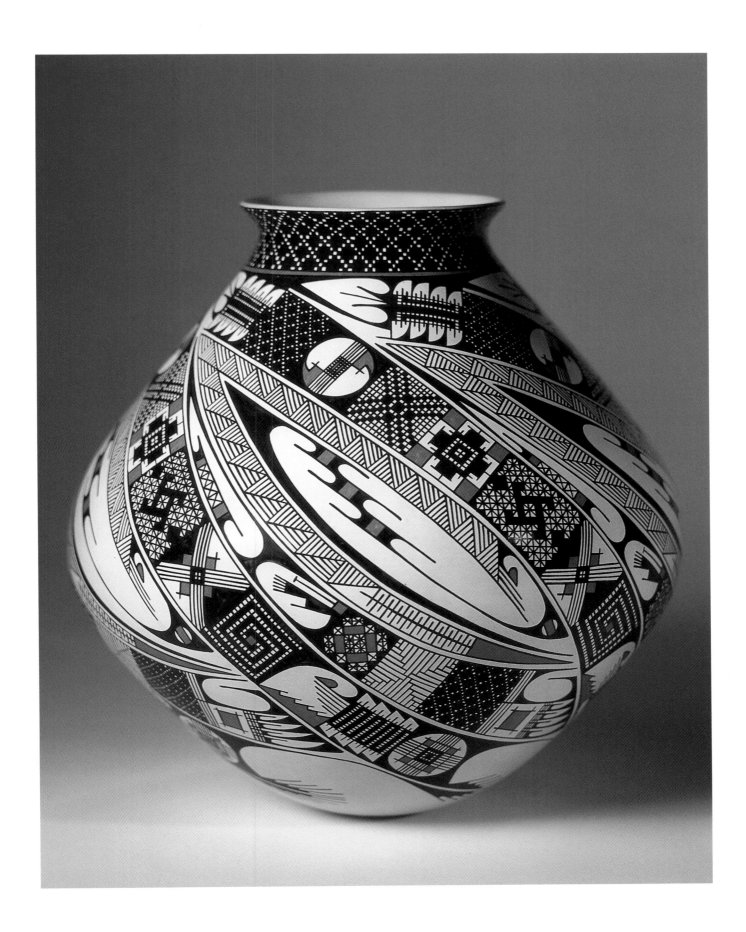

José Quezada

José Quezada Talamontes, the oldest child of Nicolás and Gloria Quezada, has been potting for nine of his twenty-nine years. José learned to pot from his father, who encouraged his son to venture out and develop his own characteristic style. At first glance, José's pots look like those of his father, but on closer inspection subtle differences emerge. José paints very long, curving, sickle-like lines in a unique way that enhance the typical Quezada sense of movement.

Marcela Herrera de Quezada and José work together on his pots. She assists by sanding and polishing; he completes the painting and firing. José is known for large *ollas* up to eighteen inches in height with strong polychrome colors of red and black on white clay. In the early 1990s he worked with a local trader Steve Rose in developing his signature style, and during this period his prices tripled. Like so many of the second-generation potters, José has experimented with commercial paints; but by and large, he uses mineral paints mined locally near the village. José and Marcela live in Barrio Central with their daughter.

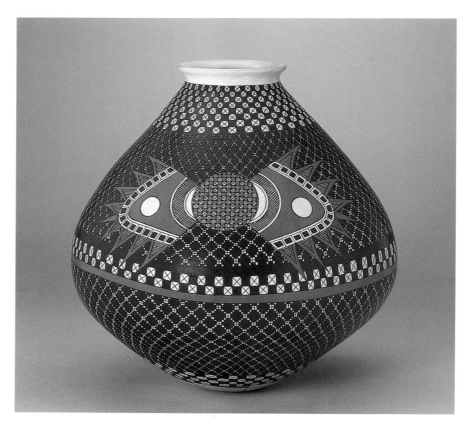

Olla, 12 ¼ x 11 ½ inches

opposite
Olla, 12 ½ x 12 inches, 1997

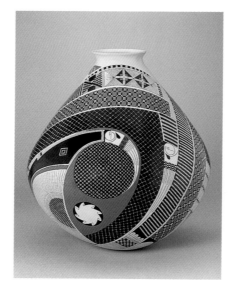

Olla, 15 ½ x 13 inches

144

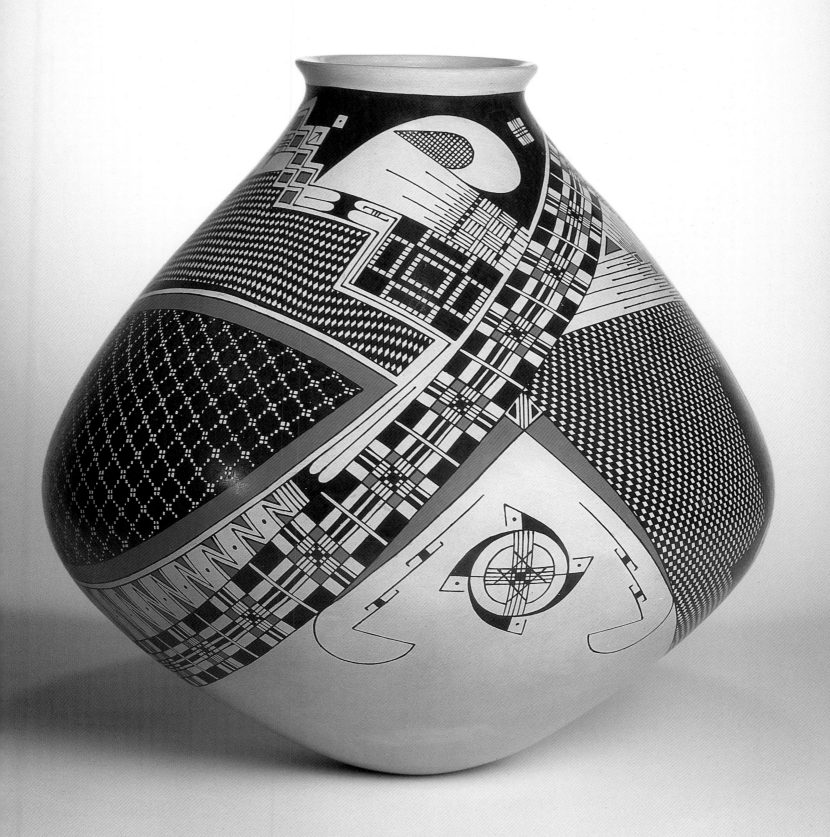

Juan Quezada

Juan Quezada Celado is responsible for the revival of pottery in the Casas Grandes, Palanganas, and Piedras Verdes river valleys that surround Mata Ortiz and Casas Grandes. By 1970 Juan had perfected the manufacture of slip oxide paints, probed the secrets of clay sources, learned how to use tempers to keep pots from cracking, and developed other crucial techniques. He also discovered fuel sources and developed methods of firing, found stable sales venues, and overcame many other hurdles. The younger potters of today have no idea how difficult and exciting the early 1970s were for the early pioneers of clay in Mata Ortiz.

Juan developed what is now called the "Quezada style" of pottery, a time-consuming process of painting exact mirror images on opposite sides of the vessel in two, four, or six quadrants. S-curved lines and other design elements swing across the entire vessel from rim to underside. Occasionally Juan crisscrosses these outlined bands of curved lines with hatches, circles, and dots. But such treatment is sparse, as Juan doesn't like his designs to appear cluttered or busy. He leaves open, negative space that becomes an integral part of the overall design. The Quezada style typically creates a feeling of dynamism. When viewed from directly above or below, the design often resembles a balanced pinwheel of four equally spaced sections, twirling on a pivot. When these designs are represented two dimensionally on paper, they appear as galaxies spiraling outward into space.

Juan is also a teacher and has directly or indirectly affected the lives of hundreds of people. His first students were his brothers and sisters, then neighbors and friends. Juan's influence on the village and the surrounding countryside continues to be profound. It is astounding how fast his influence has spread throughout the community and how it is now spreading throughout the state of Chihuahua, Mexico, and into the United States.

Guillermina Olivas de Quezada has been Juan's lifelong partner and assistant, helping with sanding and polishing, administering the business end of selling pottery from their home, providing food and shelter for an endless stream of students, and traveling with Juan throughout the United States to exhibits and demonstrations. Today, several of their children assist in preparing clay, sanding, and polishing. They live in Barrio Central across from the old train depot.

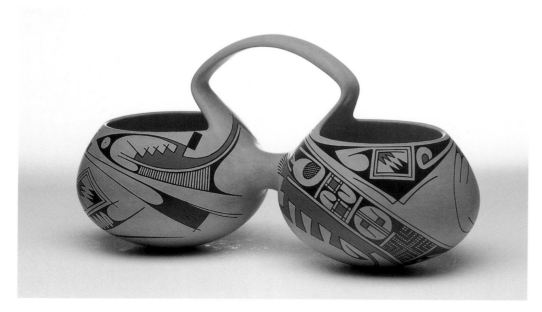

Double *olla*, 6¾ x 12¼ inches

opposite
Olla, 14½ x 13¾ inches

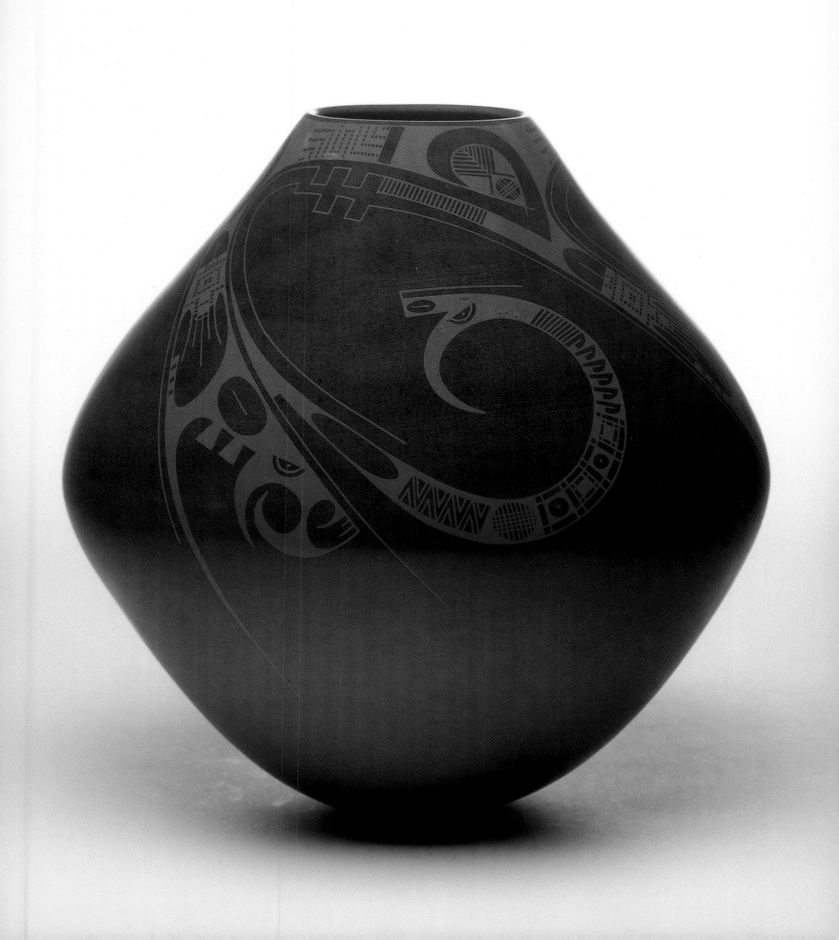

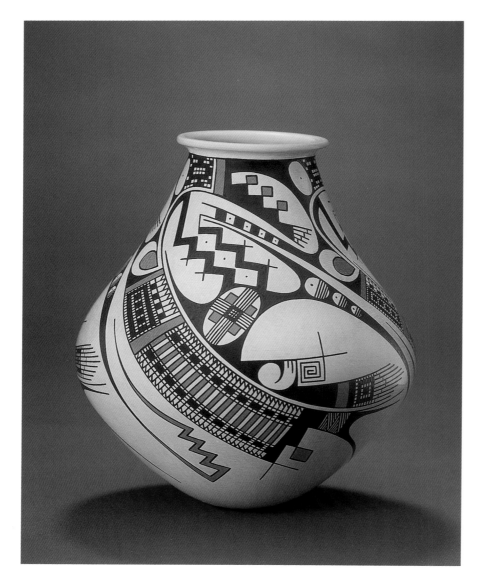

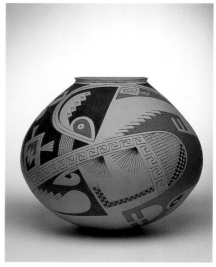

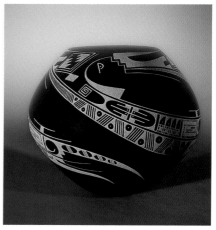

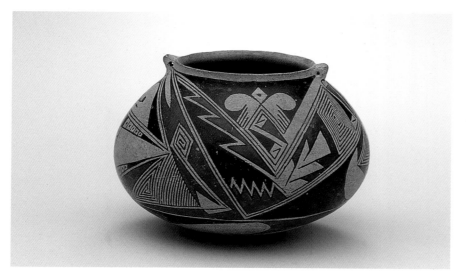

top left
Olla, 9 ¾ x 8 ¾ inches

top right
Olla, 14 x 16 inches, 1976–1979, San Diego
Museum of Man Cat. No. 1997-2-129

center right
Olla, 8 x 8 inches, 1997

bottom
Olla, 3 ½ x 5 inches, February 1977, San
Diego Museum of Man Cat. No. 1997-2-58

opposite
Olla, 8 ½ x 7 ½ inches, 1996

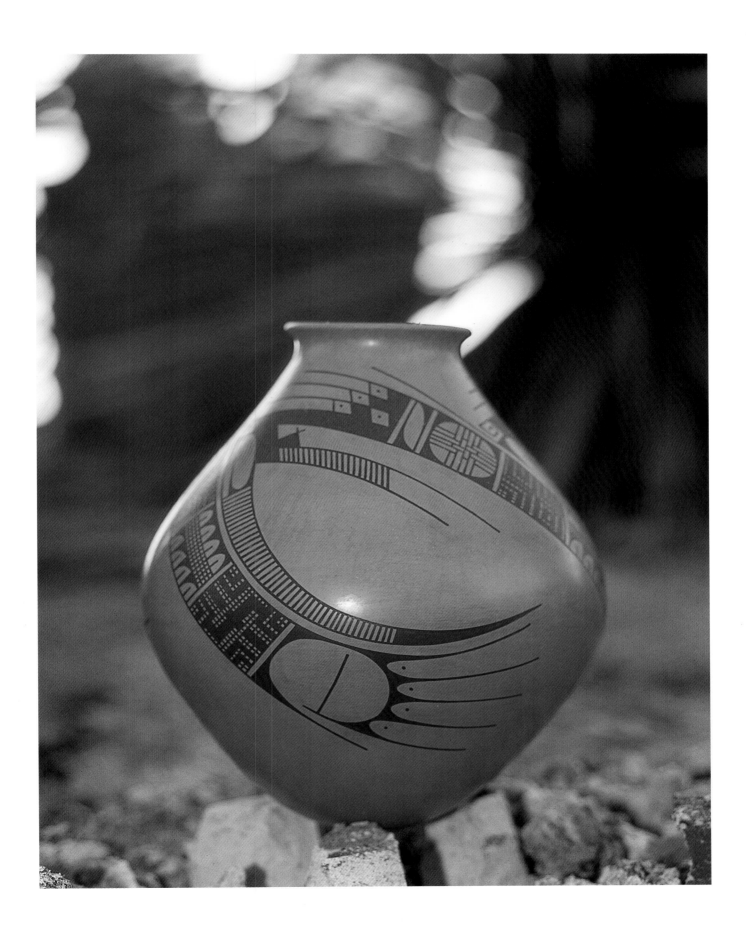

Olla, 8 ½ x 8 inches

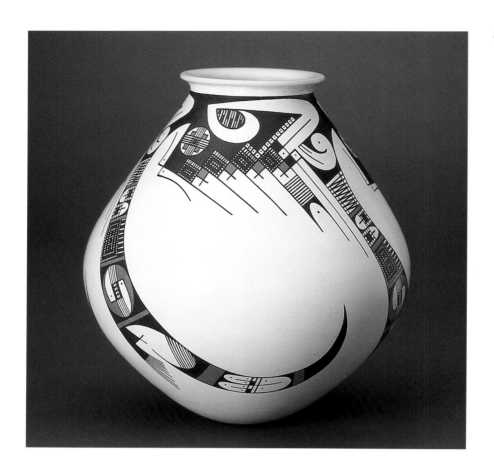

Olla, 14 ½ x 13 ½ inches, 1997

opposite
Olla, 9 ¾ x 8 ½ inches

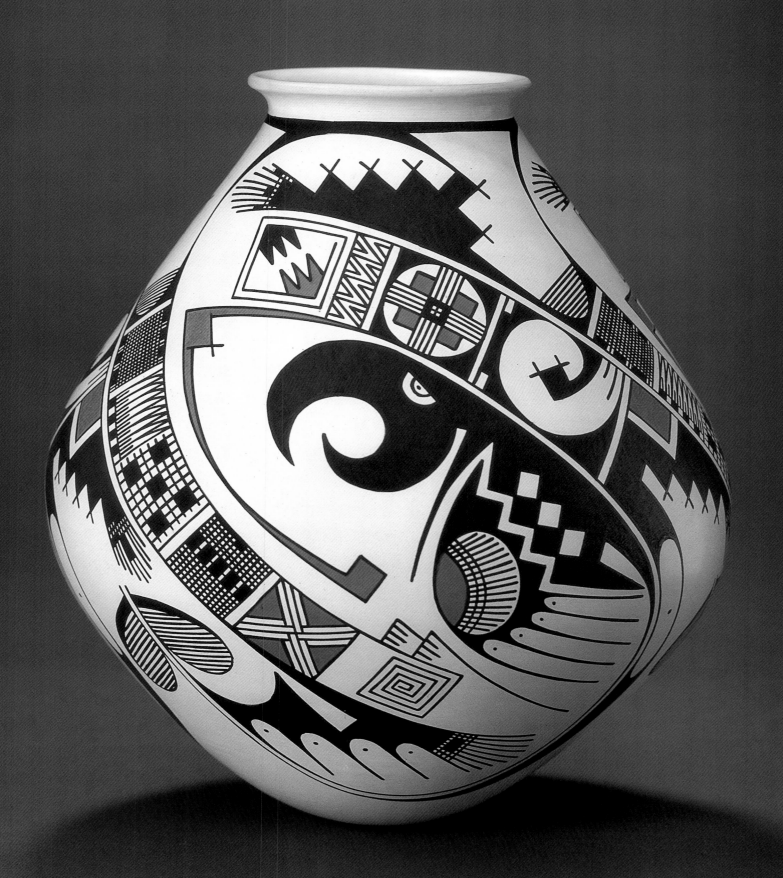

Casuela, 4¼ x 12 inches, 1985, San Diego
Museum of Man Cat. No. 1985-19-2

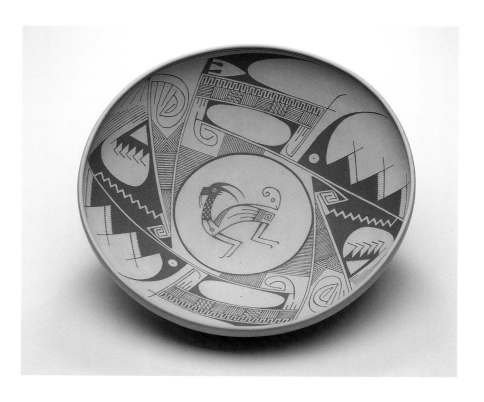

Olla, 8½ x 8 inches, June 1976, San Diego
Museum of Man Cat. No. 1997-2-11

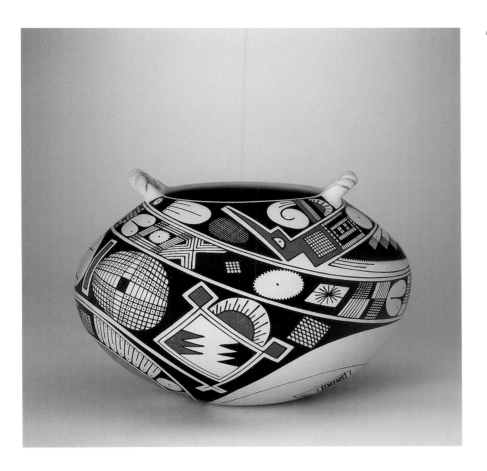

Olla, 7 x 9¾ inches

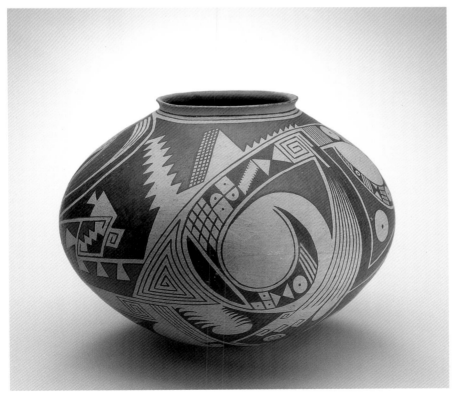

Olla, 7¼ x 9¼ inches, February 1978, San Diego Museum of Man Cat. No. 1997-2-91

Leonel Quezada

Leonel Quezada Talamontes is the second son of Nicolás Quezada and has been around pottery making all his life. He made his first bowl in November of 1988 when he was only ten years old and by the early 1990s was on his way to becoming an excellent potter. He never received official instruction from his father but learned from observation. Leonel's work is not consistent, although at times he creates works of brilliance.

Like so many younger potters, he experiments with ideas that the older, more established potters have not tried. He has experimented with commercial paints, constructed sculptural forms such as rams or owls atop the rims of pots, and tried new design elements that run counter to the "traditional" established elements. Although most of the younger potters do return to the tried and true way of doing things, sometimes that experimentation has led the whole village in a new direction. Major examples of this phenomenon would the designs of Laura Bugarini, Manolo Rodríguez, and Leonel López.

Leonel is a better painter than a potter, and his work often sells for more than that of his famous father. He lives with his family in an addition to his parents' home on the outskirts of Casas Grandes, overlooking the ruins of Paquimé.

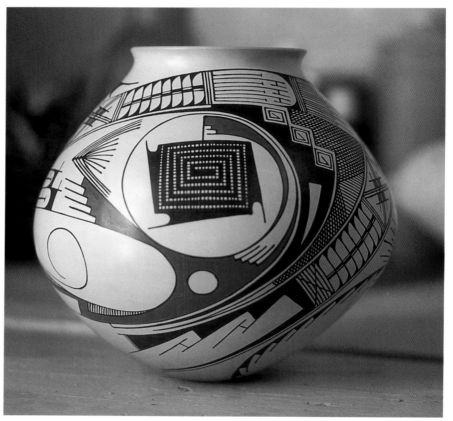

Olla, 7 ½ x 8 inches, 1999

Lydia Quezada and Rito Talavera

Lydia Quezada de Talavera is the youngest of Juan's siblings and has always loved working the clay. She learned to pot from Juan over two decades ago when she lived with her parents in Mata Ortiz. She makes all types of pottery, from brilliant white to polished blackware to mixed clay. Her *ollas* have the typical Quezada designs with dynamic long lines sweeping downward from rim to base.

Like her brothers Juan and Nicolás, Lydia has always been on the leading edge of experimentation, originally perfecting the black-on-black pottery (using the reduction-firing method so widely used today) and then experi-

menting with blackware that has both polished and matte surfaces. She is now making large, elegant *ollas* of both black and cream polychromes. The rims of these recent pots emphasize elements on the bodies that swirl up and around like propellers in the same direction as the body design, combining interesting two-dimensional flat imagery with three-dimensional sculptural imagery. Her work is precise and elegant.

Ten years ago Lydia taught her husband, Rito Talavera, how to pot and is now teaching her children. Rito's most characteristic pottery is stone-polished blackware (much like his sisters-in-law Rosa, Reynalda, and Genoveva) in which sculptural forms of snakes, lizards, and turtles decorate the rim and upper sides of the *ollas*. Lydia and Rito moved to Nuevo Casas Grandes several years ago so their children could have access to a better education in the Mormon school in Colonia Dublán, just north of Nuevo Casas Grandes.

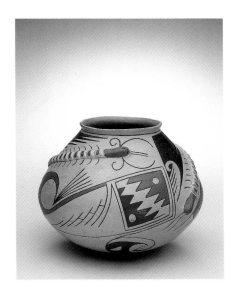

Olla, 5 ½ x 6 ¾ inches, 1978-1982, San Diego Museum of Man Cat. No. 1997-2-188

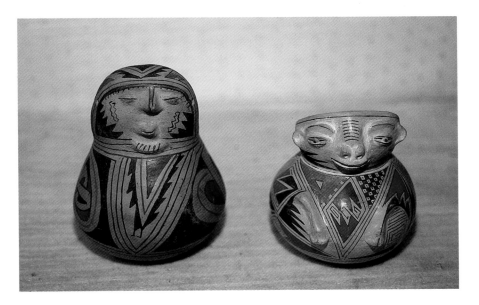

A prehistoric Casas Grandes effigy is on the left, San Diego Museum of Man Cat. No. 10856, paired with an effigy by Lydia Quezada on the right, 7 ½ x 6 inches, 1977.

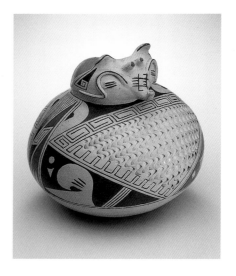

Effigy, 8 1/8 x 7 7/8 inches, 1978–1982, San Diego Museum of Man Cat. No. 1997-2-191

opposite
Olla, 9 1/2 x 8 inches, 1997

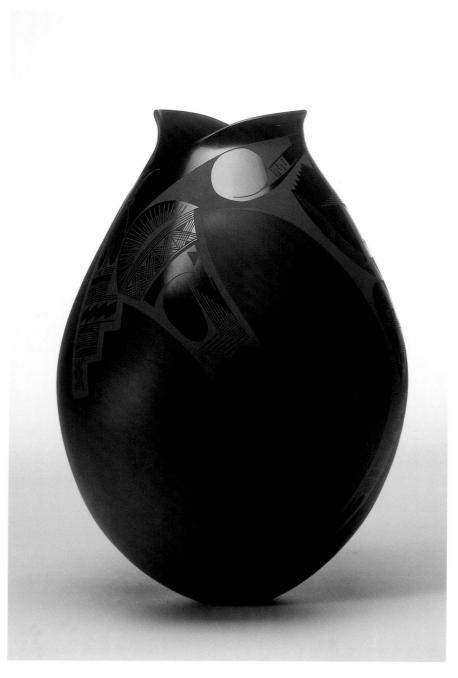

Olla, 16 x 10 inches, 1998

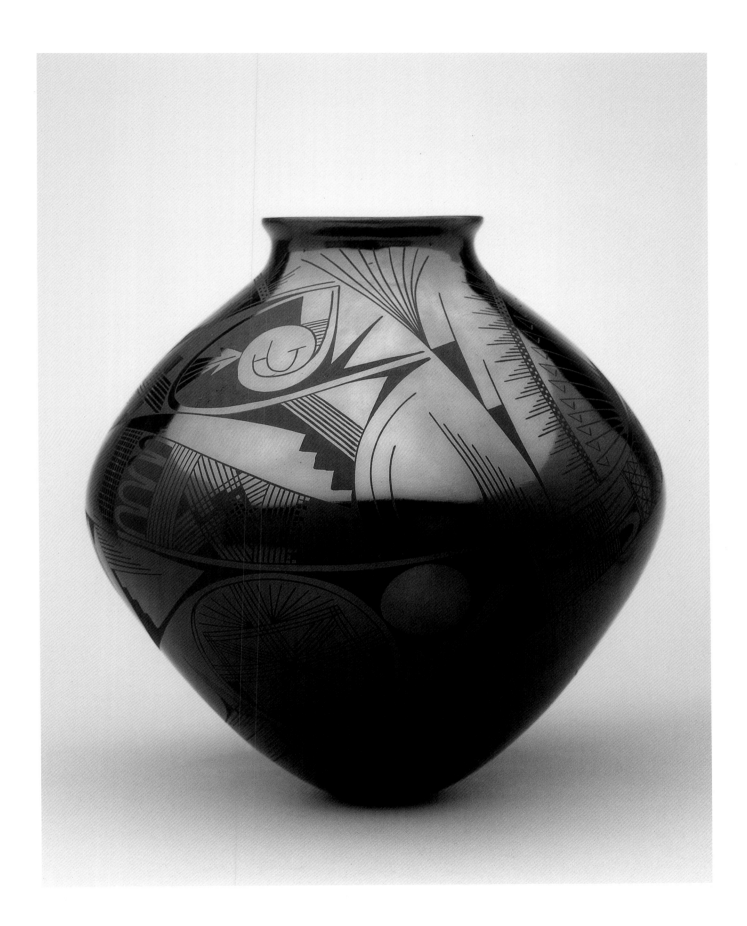

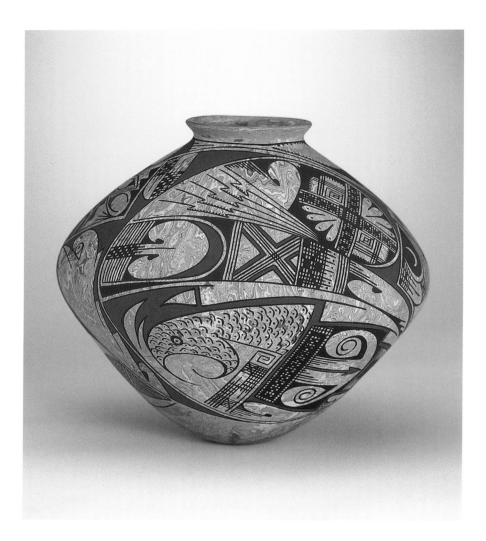

Olla, 8½ x 9½ inches

bottom left
Olla, 4¾ x 5⅝ inches, 1978–1982, San Diego Museum of Man Cat. No. 1997-2-216

below
Olla, 8 x 8 inches, Rito Talavera, 1997

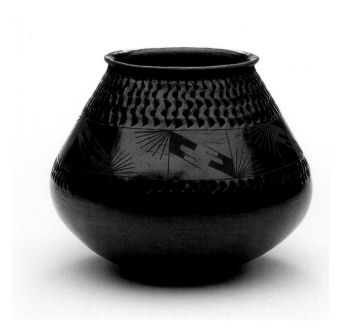

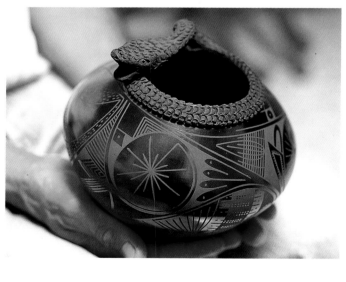

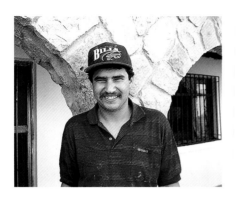

Mauro Quezada

Mauro Corona Quezada is the youngest son of Consolación Quezada. He learned to make and paint *ollas* from his mother when he was only seven or eight years of age. Now in his early thirties, Mauro, like his cousin Damián, is considered one of the best second-generation potters. He has never worked at any other job but pottery making.

He forms, sands, polishes, paints, and fires his own vessels, specializing in large white pots with detailed polychrome designs of rich red and black. His Paquimé designs "move" across the pots in a dynamic sweep similar to that of his famous uncle Juan. Until recently, however, Mauro tended to fill up the spaces between the main elements with a multitude of dots, frets, and lines.

Mauro and his wife, Marta Martínez de Quezada, participated in the show *The Masters of Mata Ortiz* in the spring of 1996 at the Arizona-Sonora Desert Museum in Tucson, Arizona. Mauro and Marta live with their children in Barrio Central in a well-appointed, three-bedroom home overlooking the Palanganas River.

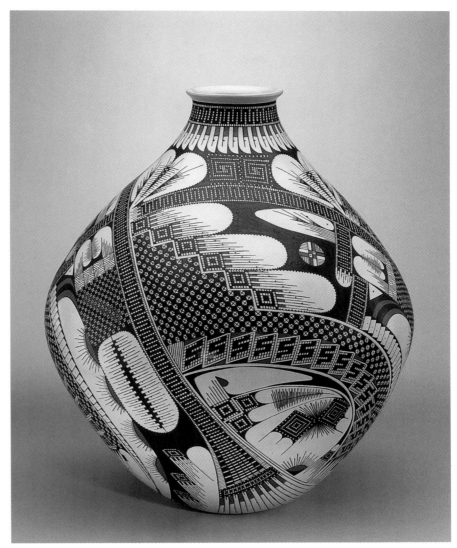

Olla, 17¼ x 13 inches

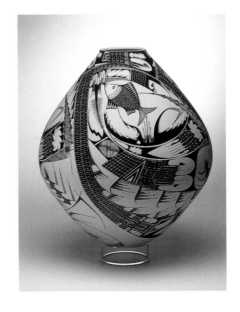

Olla, 16½ x 13 inches, 1998

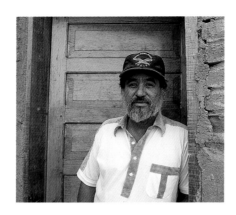

Nicolás Quezada

Nicolás Quezada Celado was the first sibling Juan taught to pot while he was learning the craft himself. Nicolás is one of the unsung heroes of the Mata Ortiz revival in that he has always worked in the shadow of his older brother. In fact, Nicolás was one of the leaders in problem solving during the late 1970s. He helped to discover new clay sources, new tempers for the clay, and new polishing techniques. Nicolás loves a challenge and has both the patience and analytical abilities to meet them creatively. In the late 1970s and early '80s, he was one of the first to build a *secador* (a drying tank) to "suck" the water out of clay suspended in solution. This technique is taken for granted today and used by all the Mata Ortiz potters.

Nicolás has always pushed the envelope of design, size, and shape for his pots. He loves working with the more tempermental white clays, the most difficult to form, fire, and paint. He has been known to lose as many as fifteen to twenty *ollas*, often completely painted, just to accomplish a specific artistic objective. Nicolás discovered that by mixing white clay with other colored clays in very pre-

cise proportions, he could achieve variations of color that a single clay cannot. He also discovered how to attain various shades of color by polishing the clay surface with a unique combination of oil and water.

His pots follow the Quezada style with long curving lines that flow from rim to base in sweeping arcs of elegance. He refers to these lines as *calles*, or roads, that one must follow to create a work of art. He seldom works with blackware, claiming that he doesn't have the patience "to polish the pot two to three times to make a beautiful *olla*."

Nicolás has traveled to the U.S. on many occasions to teach pottery making. His work was included in the University of New Mexico Art Museum exhibition in 1995 and has appeared in other exhibitions throughout the U. S. and Mexico. He and María Gloria Talamantes de Quezada live in Casas Grandes in a modern adobe overlooking the ruins of Paquimé. Their son Leonel and his family live in a large addition attached to the home.

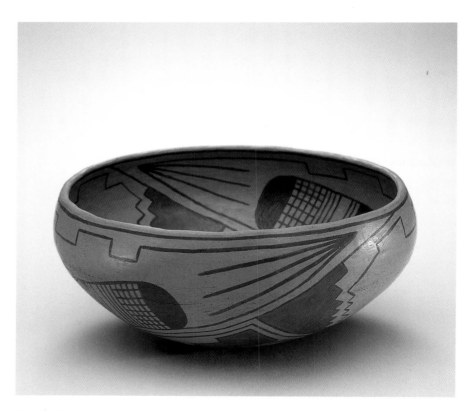

Casuela, 3 ¼ x 7 ¼ inches, July 1979,
San Diego Museum of Man Cat. No. 1997-2-242

opposite
Olla, **11 x 11 inches**

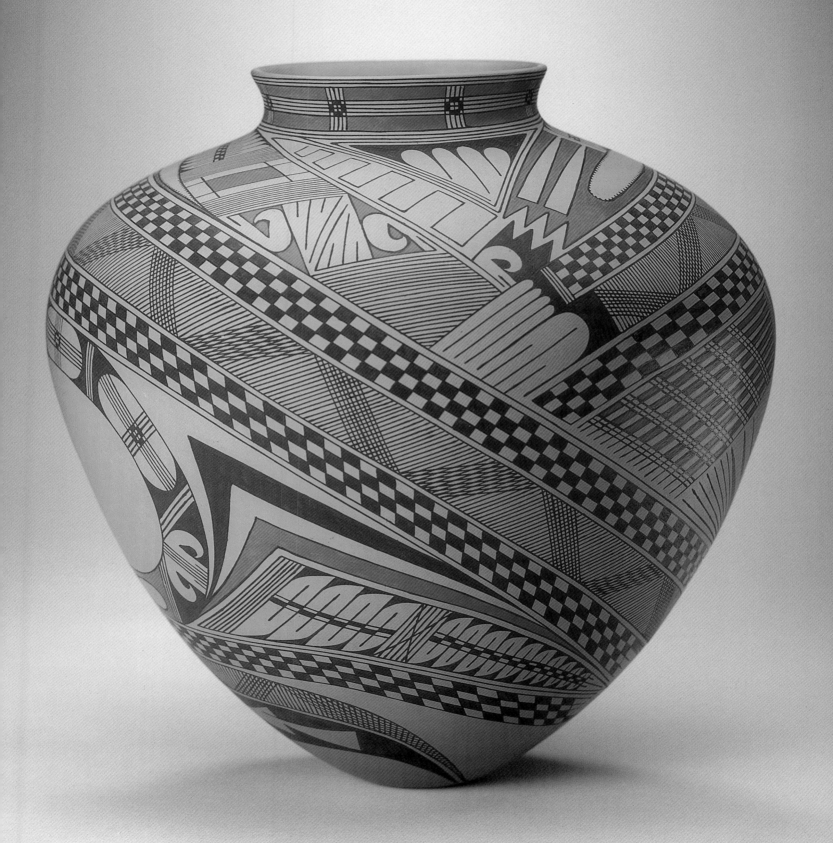

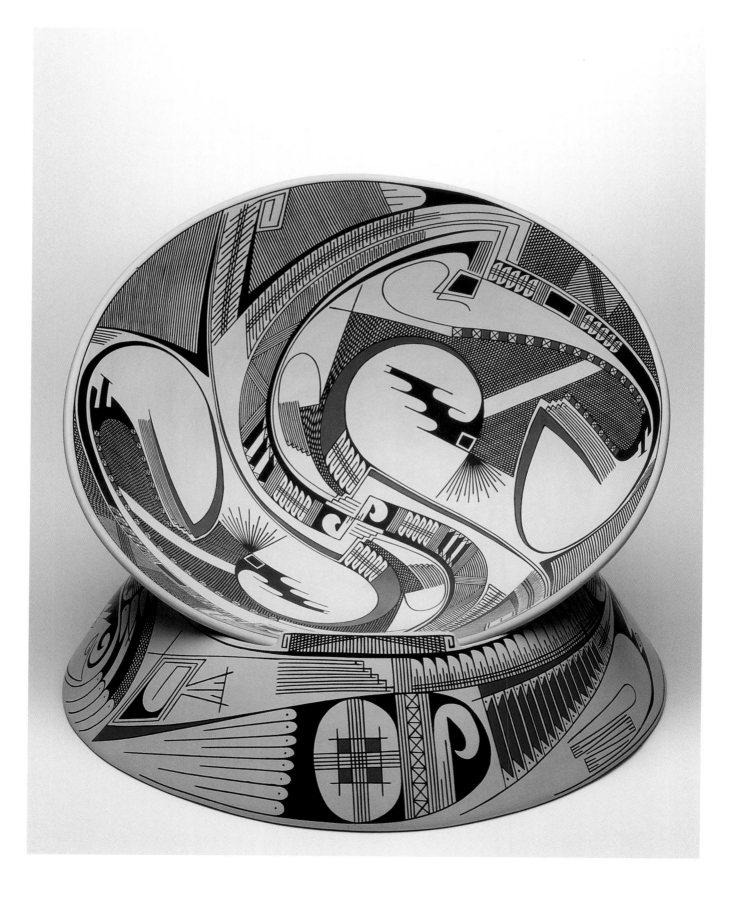

opposite
Casuela with stand, 5 x 11 inches, 1998

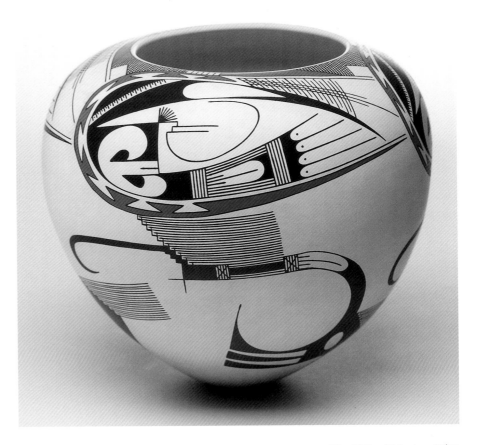

Olla, 10¼ x 10 inches, 1998

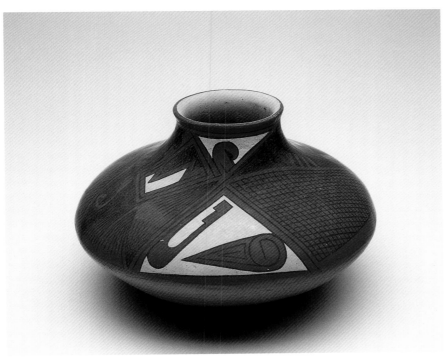

Olla, 4¾ x 7¼ inches, 1979–1982, San Diego
Museum of Man Cat. No. 1997-2-240

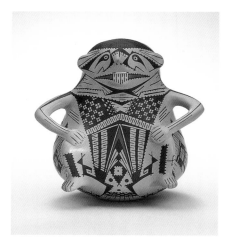

Effigy, 5⅜ x 5⅜ inches, 1987, San Diego
Museum of Man Cat. No. 1987-53-3

opposite
Olla, 11½ x 11½ inches, 1997

Noé Quezada

Noé Quezada Olivas is Juan Quezada's eldest son and, as such, is the heir apparent to his father. Of all the Quezada children, Noé is the best potter and painter of *ollas* and in the early 1990s developed a style of painting unique among the potters of Mata Ortiz. He used the same long sweeping arcs and bands as his father, but within those bands he painted tiny checks and dots that give the designs a "computer board" look. Noé used to enjoy making fish, frogs, owls, and human effigy pots with his distinct painting emblazoned across their surfaces, but he seldom makes them today. His recent work looks more like his father's, utilizing the minimalist style of painting with more open space on the pottery surface.

Noé and his wife, Betty Quintana de Quezada, live along the Palanganas River in Barrio Central.

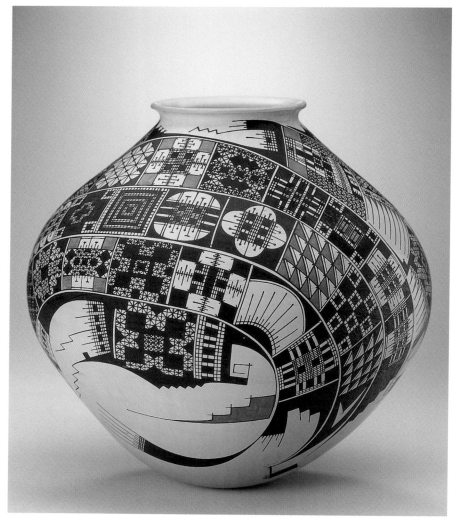

Olla, 12 x 11½ inches

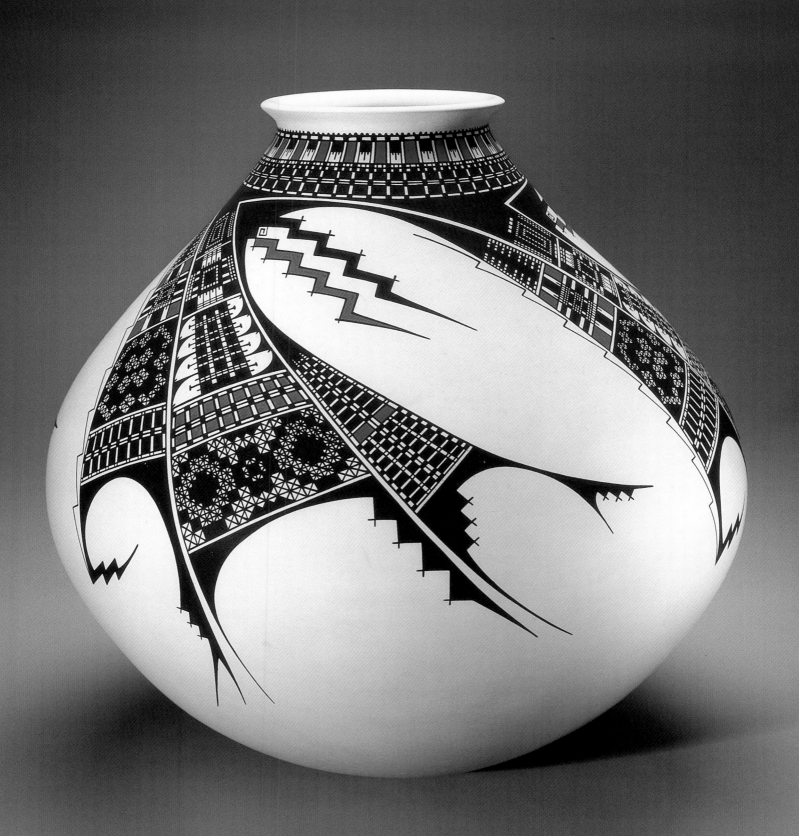

Olga Quezada and Humberto Ledezma

Olga Quezada de Ledezma, like Blanca Quezada, is another potter with the same last name as Juan but is not related. (The name of Quezada is common throughout the state of Chihuahua, much as Smith is in the United States.) Although Olga is not related to Juan or any of his siblings, that hasn't stopped her and her husband, Humberto "Beto" Ledezma Jacques, from becoming one of the best potting teams in the village. Olga was the first to learn how to pot from Gerardo Cota and Angela Bañuelos López, both neighbors. Olga then taught the basic techniques to Beto, who then perfected his talent with the assistance of his friend Gerardo Cota.

Their pottery is in demand from

both tourists and commercial traders for the delicacy of line work and their distinctive delicacy of structure. The pots are made by Beto of sienna-red clay and are the thinnest being made

today in Mata Ortiz. After forming, he sands the *ollas* eggshell thin until they feel like balloons. He has become a master at firing them without explosions. Olga does all the painting and hence signs the pots. All of their pots have a checkerboard design of alternating squares of black paint on the red clay, with thin blue-gray lines sweeping through the center of each square. Rim shapes vary, from round to fluted to square to double-necked in the case of the wedding vases. Yet each *olla* is a miracle of construction.

Their work was featured in the University of New Mexico exhibition in 1995, and they have won awards in exhibitions at the local museum of anthropology in Casas Grandes. Olga and Beto live with their children in Barrio Iglesia.

Olla, **7 x 9 ½ inches**

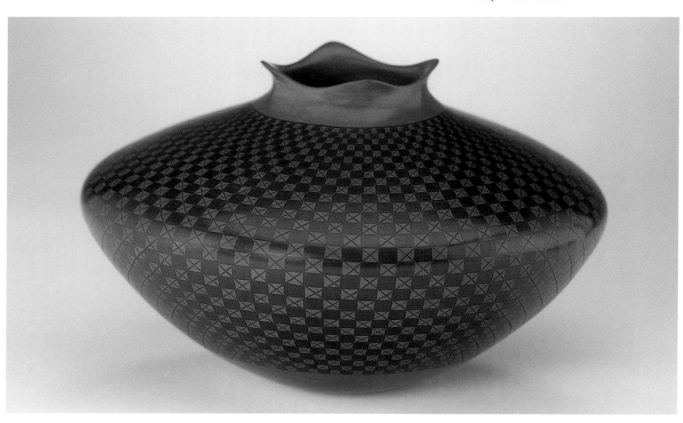

Oscar Quezada

Oscar Gonzáles Quezada, the eldest son of Consolación Quezada, was the first of the second-generation potters to begin the craft, probably when he was about fourteen. When I met him in 1979, Oscar was already an established potter, indicating that he probably began to make pots just a couple of years after his mother, who began potting in the mid 1970s. During the late 1970s Oscar worked with his uncles Nicolás and Reynaldo Quezada and often assisted his mother with the forming and painting of her *ollas*.

Oscar has traveled extensively in the U.S., with and without documents, working or demonstrating pottery. He is vivacious and gregarious with a quick tongue, which usually puts him in middle of the action. He lives in Nuevo Casas Grandes with his wife, Concha Camacho de Gonzáles, who helps him polish his *ollas*, and their small daughter and second son, Oscar Jr., who also makes pots.

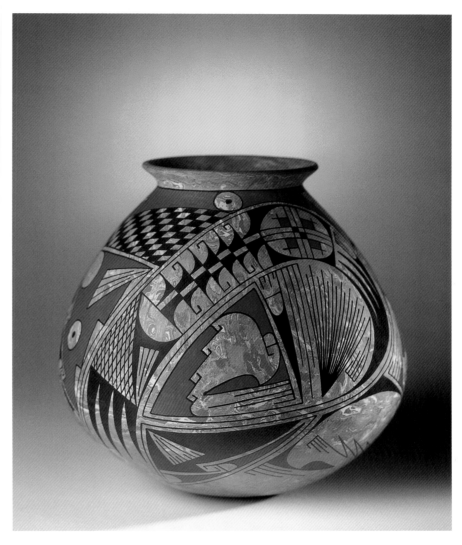

Olla, 10 ½ x 10 ½ inches

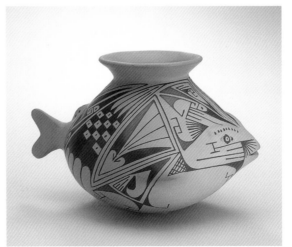

Effigy, 5 x 7 ½ inches, 1987, San Diego
Museum of Man Cat. No. 1987-53-2

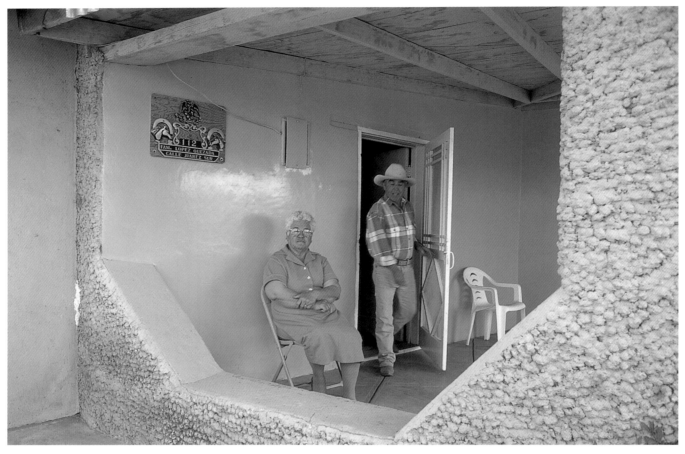

Reynalda and her brother Juan

Reynalda Quezada

Reynalda Quezada de López is one of Juan's sisters, who from the first day she began making pottery twenty years ago has stuck exclusively to blackware. She sculpts her pieces in the shapes of turtles or frogs and sometimes decorates the rims with circling lizards and snakes. Others in the village, including her sisters Rosa and Genoveva, have copied her style.

Her son, Samuel López Quezada, is now an accomplished second-generation potter and her two daughters, Yolanda and Olivia, are also copying Reynalda's style. Reynalda and her husband, Simón López, live in Barrio Central.

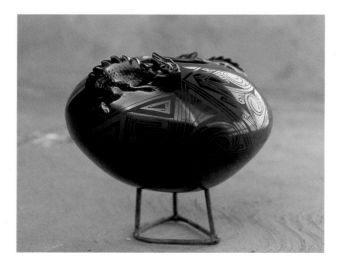

Olla, 6½ x 9½ inches, 1999

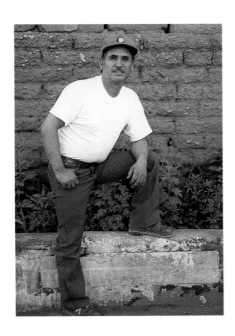

Reynaldo Quezada

Reynaldo Quezada Celado is one of the most innovative of all the Quezada potters—and in the village at large. Reynaldo is Juan's youngest brother and learned to pot over twenty years ago from Juan and Nicolás. He then perfected his natural talents working with his sister Consolación. He is credited with the mixing of clays called *mezclado* that give a marbleized appearance to the finished olla. He also pioneered the use of textured, or *tejido*, indentations in the damp clay that give the finished piece a "braided" look. He has become famous for black, unpainted, textured bowls called *cazuelas* and for pots in the shape of flying saucers with textured elements adorning the surface. His innovative work is elegant and modern in appearance.

Reynaldo has spent a lot of time in the U.S. teaching and demonstrating the making of pottery. He was born in Mata Ortiz and lives in the family home in Barrio Central.

Olla, 4 x 11¾ inches

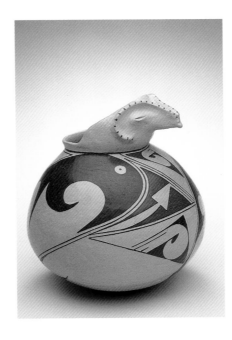

Effigy, 8½ x 7½ inches, 1979–1982, San Diego Museum of Man Cat. No. 1997-2-283

169

Jorge Quintana

Jorge Quintana Rodríguez learned to pot from a multitude of capable potters. His aunt Luz Gallegos de Almeida, the mother of Blanca Ponce and Gaby Domínguez, first exposed him to the craft in 1974. During this same time he had the opportunity to watch Juan Quezada work, which impressed him for the rest of his life. It wasn't until 1993 that Pilo Mora convinced him to work in clay. Jorge makes and paints all of his own pots and uses a checkerboard technique of complex designs, often including Mimbres animals, as his main design themes. He prefers polychrome painting on the difficult white clay and is one of the better potters working today in Mata Ortiz.

For the past several years, Jorge has worked part time as a buyer for trader Jerry Boyd and through that work has seen and evaluated pottery from the entire pottery community. Jorge's first profession and love, however, is carpentry. He recently completed construction of a *posada* in Barrio Americano with Jerry Boyd.

He and his wife, Leticia Cota de Quintana, have been to the U.S. on numerous trips for sales exhibitions as well as to participate in shows. Leticia and their daughter Rocío Quintana Cota make fine small pots. The family lives in Nuevo Casas Grandes.

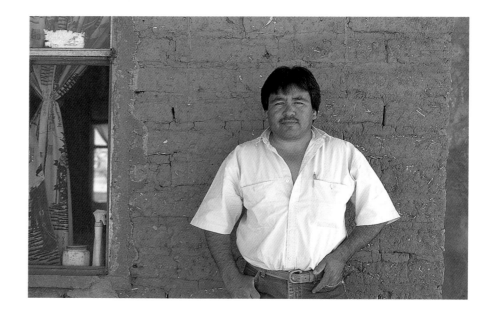

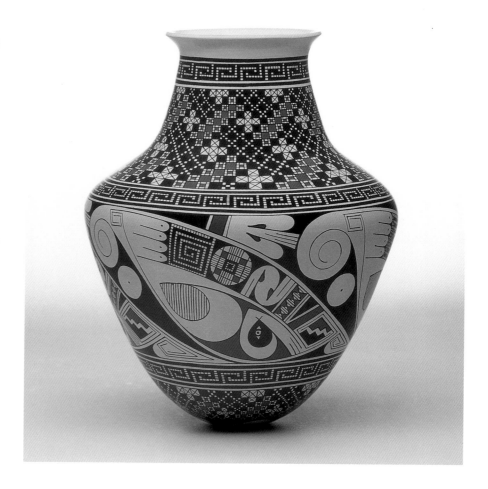

Olla, 9¾ x 6½ inches, 1998

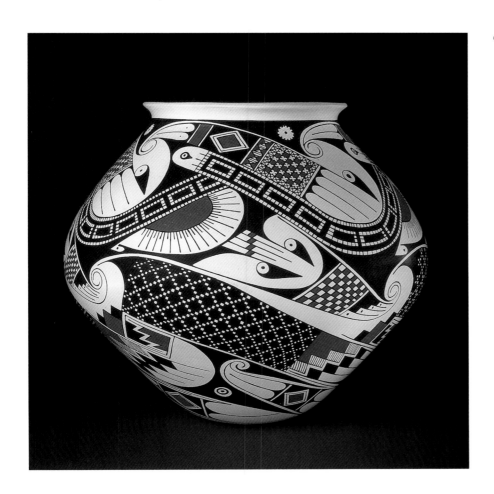

Olla, 8 x 8½ inches, 1996

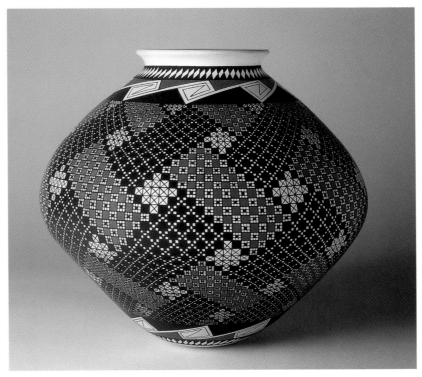

Olla, 8¼ x 9 inches, 1996

Armando Rodríguez

Armando Rodríguez Guillén learned to pot from his younger brother, Manolo Rodríguez, about ten years ago. Like so many of the older male potters, Armando would rather be tending his cattle than laboring over earthen vessels. Working with clay, however, has allowed him to expand his herd and buy quality horses. His wife, Olivia Mora de Rodríguez, helps by making the medium-sized *ollas*, usually of red clay, and then Armando paints detailed designs of small black squares that cover the pots.

Olivia also makes and paints pots utilizing a similar design motif and has been teaching their teenage children, Leticia and Luis Armando, the craft. They live in Barrio Americano near Armando's old family home.

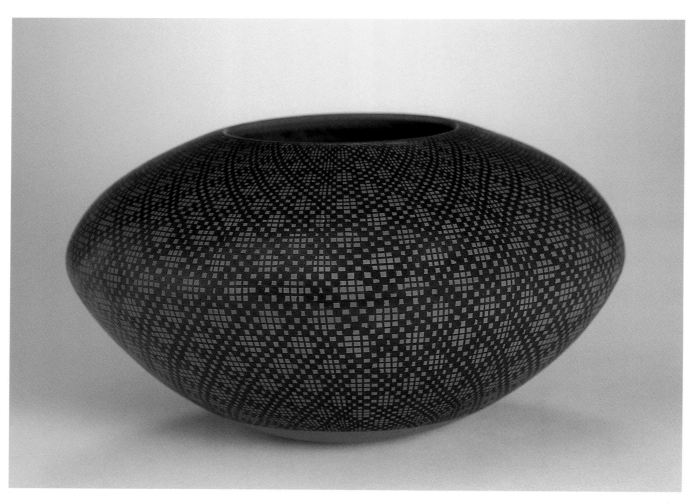

Olla, 4 x 7 ½ inches

Manuel Rodríguez

Manuel "Manolo" Rodríguez Guillén is one of the most innovative of all the younger second-generation potters. Although Manolo is only in his twenties, he has either taught or directly influenced more new potters than most of the other potters twice his age. He has taught his older brothers, Armando, Rubén, and Oscar, as well as his sisters, Tere and Elena, and has worked directly with Arturo, Efrén, and Gerardo Ledezma (he also taught them how to make red paint), and dozens of others.

Manolo began potting a dozen years ago after watching Juan Quezada and says he learned to pot from his old friend Juan Quezada Jr. His original ceramic work consisted of whimsical Paquimé figures in human and animal form. His current work is largely *ollas* of medium size, of white, red, or yellow clay with unique designs that dance across the surface much like Escher paintings. They have a supernatural feel and incorporate reptiles, birds, and fish growing out of complex geometric designs.

A number of Manolo's pieces were featured in the University of New Mexico Art Museum exhibition in 1995 and are actively acquired by avid collectors. He lives in Barrio Americano near his parents with his wife and family.

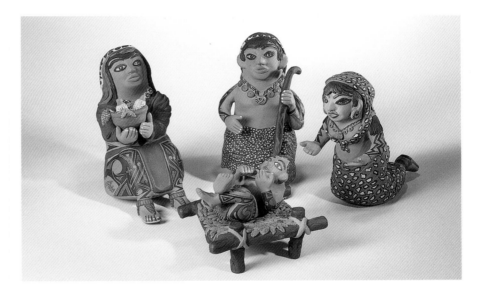

Nativity, each figure approximately 5 inches tall

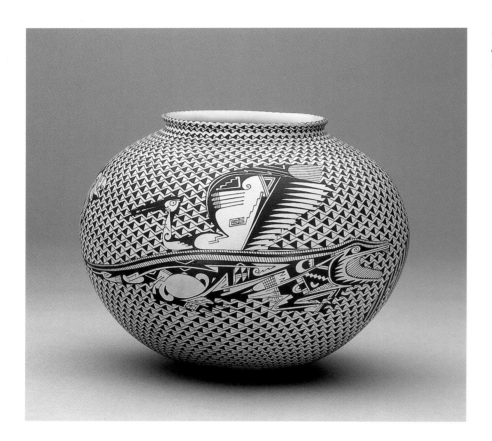

Olla, 7 x 8 inches

opposite

Olla, 9 x 7 inches, 1998

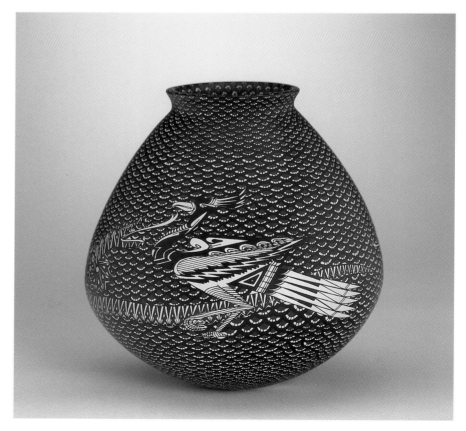

Olla, 8¾ x 7½ inches

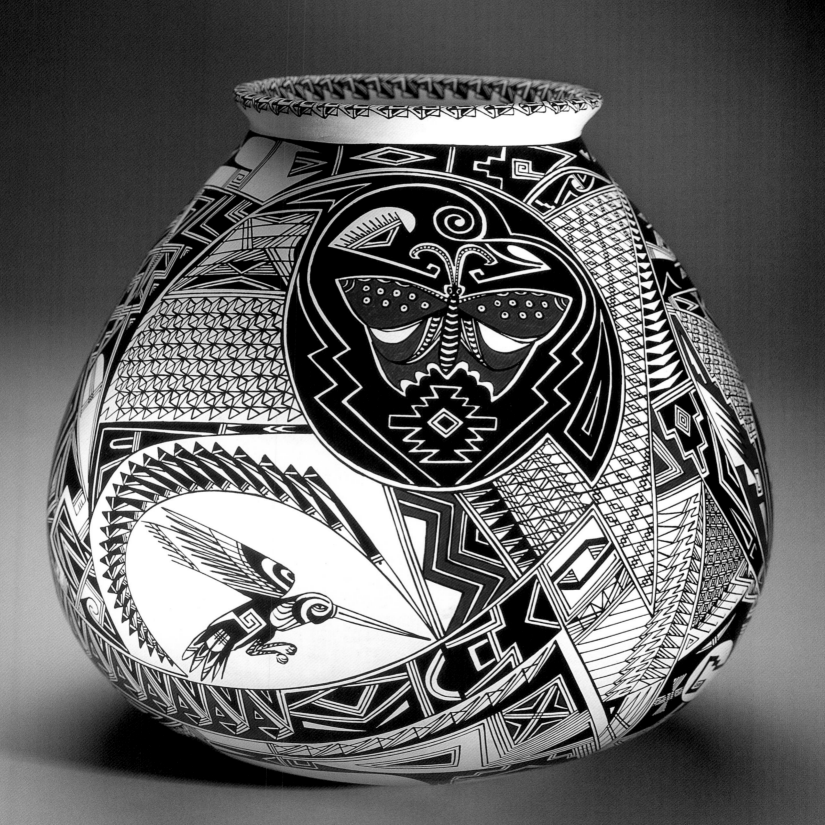

Rubén Rodríguez

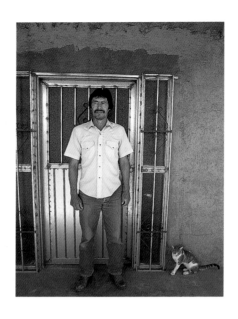

Rubén Rodríguez Guillén is the oldest of the Rodríguez brothers. He learned to pot from his younger brother Manolo in the early 1990s. Gerardo Cota taught him how to put the amazing stone polish on his blackware, which constitutes over 95% of everything he makes. Rubén is now known as the best maker of reduction-fired blackware pots.

His *ollas* are painstakingly stone polished up to five times, so that the surface of his work appears as a black mirror. His line work is highly geometric with all angles terminating at precise points. The openings of his larger pots (six inches in diameter), are often square or rectangular in shape, cut into a flat surface that extends from a wide shoulder, much as one would expect to see in the water jar shapes of Hopi-Tewa potter Nampeyo.

Rubén and his wife, accomplished potter Marta Ponce de Rodríguez, live in Barrio Iglesia.

Olla, 3 x 6½ inches

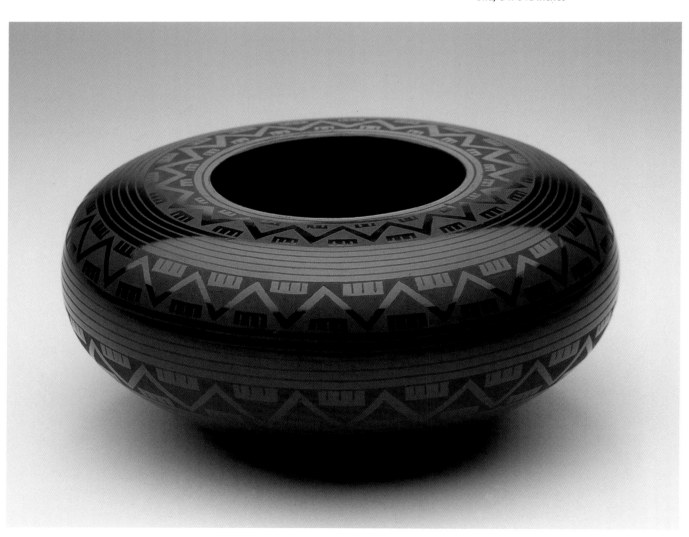

José Silveira, Socorro and Trini Silveira
Sandóval

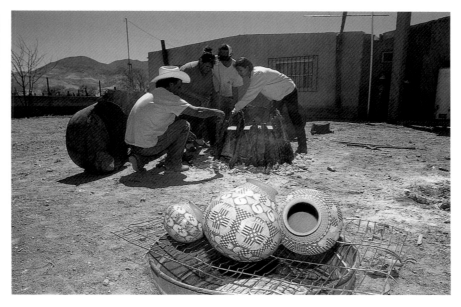

Socorro Sandóval

Socorro Sandóval de Silveira is known for her large, red-slipped *ollas* that sometimes reach eighteen inches in height and are formed with an incised, unslipped rim. Her pottery is similar to that of her husband, José Silveira Ortiz, and their daughter Trini Silveira Sandóval but is distinguished by larger size and more complicated design elements. Their son Saul Silveira Sandóval helps with the pots and makes elaborate rings for holding their work. Socorro learned potting some fifteen years ago from her sister-in-law Gloria Hernández.

Socorro and José live with their children in Barrio Porvenir near Félix Ortiz.

above

José, Socorro, Saul, and Trini prepare to fire while three pots by Socorro and Trini cool in the foreground.

Olla, 8 x 8 inches, Trini Silveira Sandóval, 1997

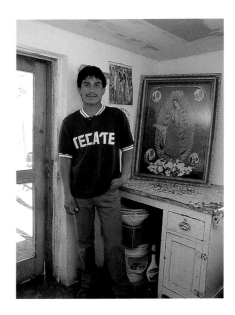

Octavio Silveira

Octavio "Tavo" Silveira Sandóval learned to pot in the early 1990s from his father, Nicolás Silveira Ortiz. His style of painting is unusual in Barrio Porvenir in that it blends the Porvenir style with the Quezada style. His *ollas* are medium in size, usually red-slipped with the distinctive incised unslipped rim well known in Porvenir. His designs, however, are likely to be symmetrical, like the Quezada style, and to include Mimbres and Paquimé symbols.

Tavo has been an active participant in the *matachine* dances and lives with his family on the eastern side of Barrio Porvenir.

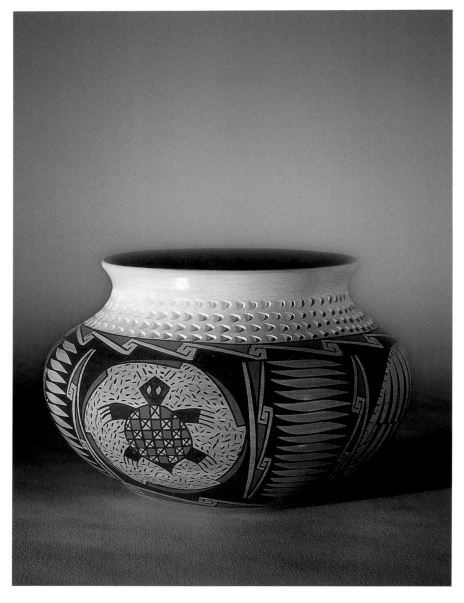

Olla, 5 x 7 inches, 1997

Gerardo Tena

Gerardo Tena Sandóval has lived all his life in Barrio Porvenir. He learned potting from his mother, Sofia Sandóval de Tena, a decade ago. His wife, Nora Hernández de Tena, helps him polish and sand *ollas* in all sizes and colors. He has built a solid reputation as an outstanding potter for white miniature *ollas* with long necks and fine line painting in red and black. His attention to detail is extraordinary, as exemplified in a desert bighorn sheep on an *olla*, built by Félix Ortiz, that brought Gerardo first place in the zoomorph category in a 1998 exhibition at the Museo de las Culturas del Norte in Casas Grandes. Ever since the public presentation of that piece, he has had a steady flow of orders.

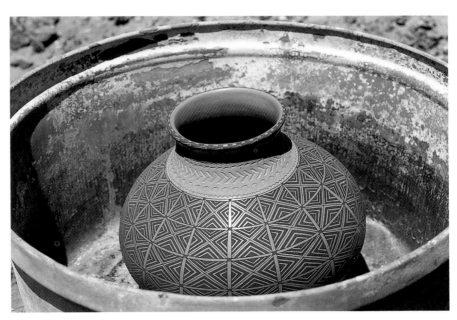

Olla, 11½ x 11 inches, 1996

Ana Trillo

Ana Trillo de Corona usually makes pots of red clay with combinations of intricate Paquimé, Mimbres, and contemporary elements rendered in black paint with graphic detail. The same pots are sometimes fired black by the reduction process. Her pieces tend to be small, with the exception of larger wedding vases.

Ana is vivacious, outgoing, and eager to learn new techniques, constantly striving to improve her work. She learned to pot nine years ago from Elvira Guillén de Escarsega, the wife of Damián Quezada. Her husband, rancher Monico Corona, helps her with the sanding and polishing. Ana has influenced many of her in-laws, particularly Sara Corona, who lives nearby.

Ana and Monico live in Barrio Americano just behind the school.

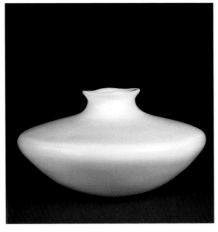

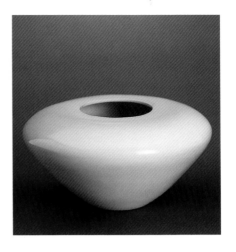

Carmen Veloz
and Jesús Veloz

After learning to pot from Gloria Losoya de Veloz (a distant relative of her husband), Carmela "Carmen" Ledezma de Veloz developed her own white miniature seedpots, which measure only two inches in diameter. She covers the white clay with small red and black squares exposing a small white unpainted square in the middle, giving the illusion of a three-colored polychrome pot. Carmen also makes wedding jars and small, wide-shouldered pots up to six inches in diameter with no painting on the surface.

She signs all of her work on the bottom with a painted turtle and her name scratched with a sharpened nail.

Carmen taught her husband, Jesús Veloz, the basics of pottery making so that he could assist in the polishing, sanding, and firing. They have made a number of trips to the United States to do demonstrations and now conduct classes for U.S. students in their home. Their daughter Rosario has become her mother's apprentice, helping with the painting. The family lives near the Catholic church in Barrio Iglesia.

left
Olla, 4 x 7 inches, 1996

right
Olla, 3 x 6 inches

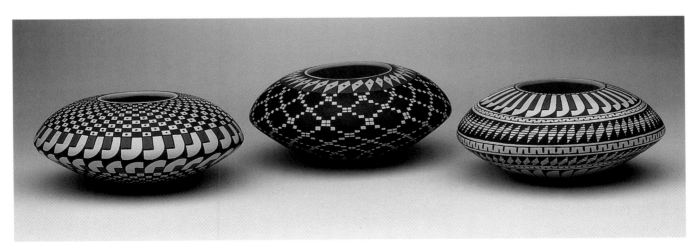

Miniature *ollas*, each about 2 x 4 inches

Ramiro Veloz Jr. and Ramiro Veloz Sr.

Ramiro Veloz Casas Jr. took up pottery making out of necessity in 1991 after the death of his mother, who had painted all her husband's pots. Ramiro Jr. took over the task and developed a complicated monochrome design in an orange paint that turns red after firing. After Ramiro Veloz Gutiérrez Sr. suffered a stroke in 1998, Ramiro Jr. also took over the task of forming the delicate plates and pots made of yellow clay, for which the family has become famous.

Ramiro Sr. had learned to pot from his brother Saul Veloz Gutiérrez (as well as being influenced by his neighbor Juan Quezada) and was one of the best potters in the village. His unusual teenage son has also turned out to be an accomplished potter. Soon after the stroke, Ramiro Sr. asked his son to sign all the pieces with his own name, Ramiro Veloz Casas. This young man is now providing all the family's income from their home next door to Juan in Barrio Central.

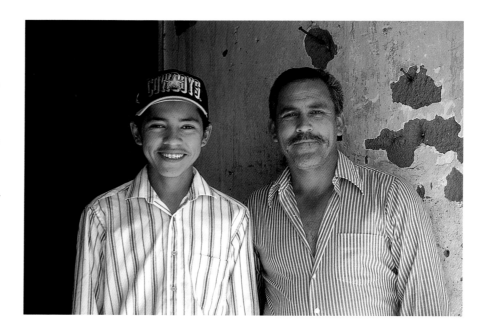

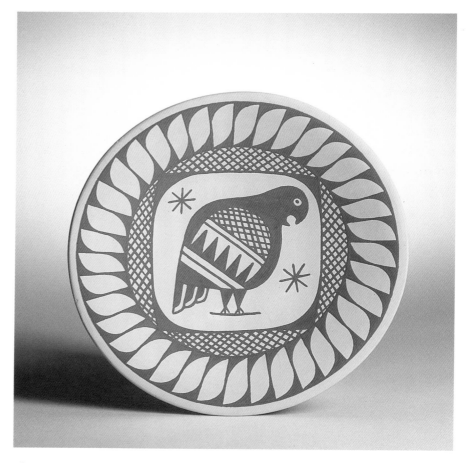

Plato, ½ x 4¾ inches, 1996

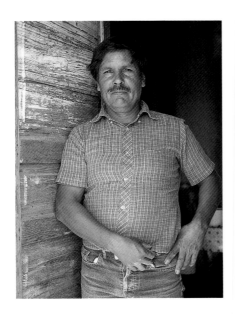

Andrés Villalba

Andrés Villalba Pérez is best known for effigy pots of human figures painted in the Ramos Polychrome style of pottery that American archaeologist Charles Di Peso uncovered in Casas Grandes in the late 1950s. Andrés was born in Colonia El Rusio south of Mata Ortiz in 1945 but has lived in Mata Ortiz for many years. He learned to pot from his son Sabino Villalba Hernández.

Andrés is devoted to following the traditions of the ancient Paquimé potters and to honoring "those ancient people." He is so emphatic about perpetuating those traditional designs and shapes that he maintains a library of two to three dozen books on the prehistory of the area for constant reference and inspiration. Andrés also greatly admires Juan Quezada and, as such, is always striving to improve not only his painting but the building of his pots as well.

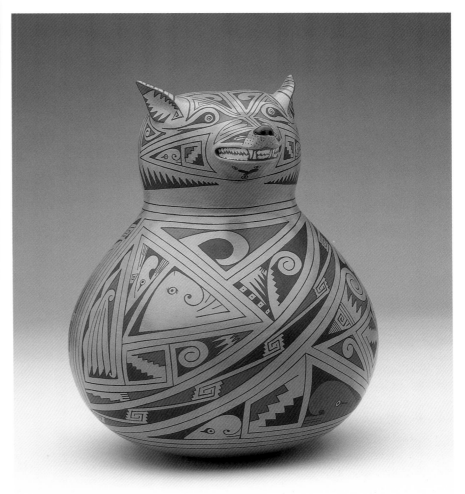

Effigy, 10¾ x 9 inches, 1998

He lives in Barrio Porvenir with his wife, Bacilia Hernández de Villalba, and their six children, including potters Lourdes, Juan Carlos, and Sabino, just a few doors south of Félix Ortiz.

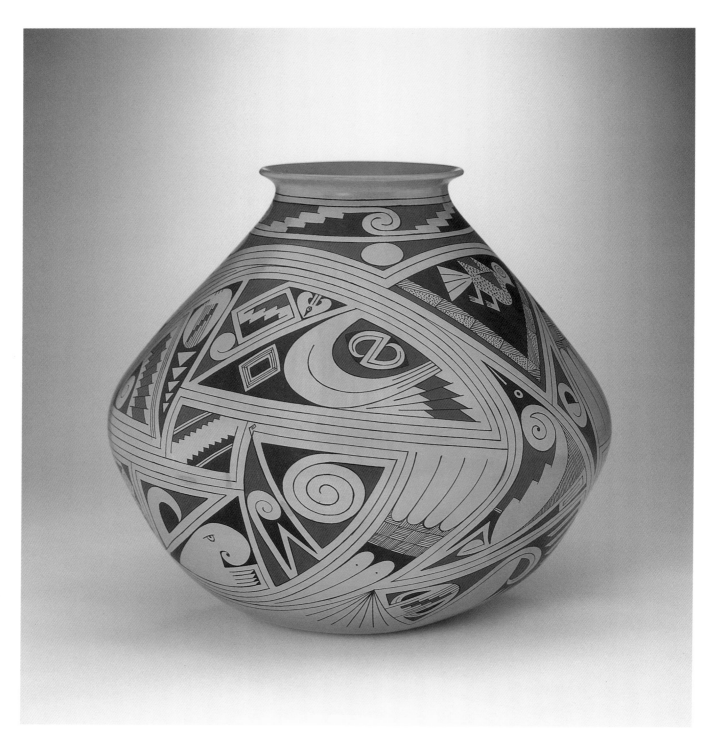

Olla, 13 ½ x 12 ½ inches

Sabino Villalba and Carlos Villalba

Sabino "Cabi" Villalba Hernández is the eldest of the six children of Andrés Villalba and Bacilia Hernández de Villalba. Cabi and his wife, Veronica Silveira de Villalba, work together— she sanding and polishing and he painting and firing. His plates with bat designs are particularly popular with a number of traders. Cabi sometimes presses the back of his *platos* into a mold he built to create a raised maze design on the convex side, opposite the painted side. He has been potting for over fifteen years, learning the craft by watching other potters in the Porvenir area.

Juan Carlos Villalba Hernández, Cabi's younger brother, has been potting for almost three years, since learning the process from his father, Andrés, and his brother. He enjoys the work and doesn't want to do anything else.

The Villalba family lives close together next door to the Catholic church in Barrio Porvenir.

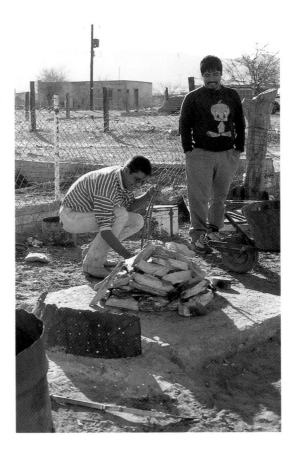

Carlos and Sabino preparing to fire

Sabino with a spider *plato*

Over the past ten years, I have had the good fortune to study intensively with Juan Quezada and other artists in Mata Ortiz. Juan Quezada's genius for working with raw materials and his generosity in sharing his knowledge are unique personal attributes. One of my close friends and fellow artists, Tom Fresh, has said that had Juan Quezada been formally educated, "he would naturally have become a rocket scientist or genetic engineer." Indeed, Juan's analytical and deductive abilities are truly astonishing. His willingness to share his achievements with his own community and with other artists such as myself is having a tremendous impact on the development of the art of ceramics in both Mexico and the United States.

The Ceramic Technology of Mata Ortiz

by Michael Wisner

Sources for Clay

During one of my many trips to work with Juan Quezada, we headed into the *sierra* to gather clays. After several hours of walking, we reached a site that looked as if a bomb had exploded, leaving an enormous crater in its wake. It was a hand-excavated hole containing the highly prized white clay for which Juan is famous. He had discovered the site in the early 1990s after a twenty-five-year search.

"I was walking alone one day scanning the ground for traces of clay or minerals to make paint when I paused here a moment to watch some ants busily working on their anthill," he told me. "They were bringing tiny balls of a white substance to the surface and discarding it about the periphery of their mound. Upon closer inspection, I realized it was clay. I eagerly began digging off to the side of the anthill, and about a foot below the surface I found this white vein."

Juan Quezada examining a vein of yellow clay

Juan in the manganese mine. Note the rope he used to lower himself.

From top to bottom, first, second, and third filtration buckets are for preparation of paints from native minerals.

This white clay now supplies virtually all of Mata Ortiz. When I asked Juan if he ever tried to hide the site and keep this discovery to himself, he smiled. "Michael," he said, "here in Mexico we have a saying that goes like this: Everywhere the sun shines is for everyone. I welcome the town to come here on my land and gather the clay. This freedom to roam is one of the beautiful things we have as a community here in Mata Ortiz. Recently there has been some talk by landowners who want to charge potters for the clay they gather on their property. I intend to continue letting the town use this clay, and I hope that it serves as a reminder to everyone of the beautiful things that we share."

It is a treat to go on digs with Juan, particularly when he finds a new material. I once watched Juan locate a clay vein several hundred yards from its source from a mere stain on a rock. After examining the bright red stain, he peered carefully uphill and reasoned that rain water had transported the trace from its origin. He began zigzagging back and forth over the ground, searching for clues like a bird dog on the trail of a quarry. Once he located the vein, he struck his pick into the strata, looking for a layer that contained just the right mixture of clay and temper. (Temper is crucial in giving the clay strength to withstand the brutal firing it will be subjected to later.) He broke open each piece of clay and stared into it as if he were reading its chemical makeup. Suddenly he tossed a piece to me and said, "Look here! This has too much caliche. It will fire okay, but months from now small pieces will flake off." Later he discarded another chunk of clay and said, "Now look at this one. This has too much clay. It is like stone and will need to be pulverized, and volcanic ash will have to be added, so it won't crack while drying." Finally, he wet another piece and handed it to me. "Feel this. It's very plastic and will hold its shape well when handbuilding the pot. And it has the right balance of clay and volcanic ash to fire with strength." Juan often performs test fires for color right at the site. "Why carry the mountain to Mata Ortiz when we can experiment right here?" he says. If the result is a new color or new shade of clay, he will carry thirty to forty pounds home for further testing.

Back at the house, the new clay is immediately washed to remove rocks and large particles. Juan has invented a unique filtration process to yield clay that polishes with the stroke of a fingernail. Juan sometimes gets so excited about new clays that he can't sleep through the night. He will catnap, waking up every couple of hours to work with the clay. He invests as much time in an experimental pot as any other he creates, in spite of the fact that many end in sherds. Juan explains that he uses these time-consuming methods because there is more on the line, and with each risk his senses sharpen and he learns more about the possibilities of the new clay. Juan says, "Risk a little, learn a little. Risk a lot, learn a lot."

Handbuilding

Juan Quezada has always had a gift for innovation. This gift was greatly nurtured by his relationship with Spencer McCallum. Spencer's agreement with Juan was a dream come true for any artist. He told Juan that he wanted him to leave his work on the railroad and focus all of his energies on art. Spencer didn't even specify that Juan make pots, just that he make art. This generous agreement allowed Juan to explore without boundaries. This transmitted spirit of creation that was seized and expanded upon by Juan molded the mindset of all subsequent generations.

Their tradition based on innovation contrasts sharply with that of the American Indians, where pottery traditions are based on ancestry and techniques and designs are used over and over again. In Mata Ortiz, innovation has become their tradition. Artists are prized for their creativeness in all aspects of the pottery process, including their handbuilding. Mata Ortiz potters use a tremendously refined pinching technique of handbuilding that constructs the pot walls from one or two very large coils. By comparison, American Indians use many small coils joined together with a rib tool, usually made from a gourd. The advantage of the Mata Ortiz technique is that fewer coils mean fewer joints in the clay wall, which ultimately makes a stronger wall. (Breaks in the drying and firing process often occur in joints between coils.) Additionally, the rigorous pinching done to flatten the large coils compresses the clay particles, giving strength to the pot wall. Hence Mata Ortiz pottery has become known for an amazingly thin wall construction, where an $1/8$-inch wall is not uncommon.

The clay of Mata Ortiz possesses three outstanding characteristics that lend themselves perfectly to the handbuilding and firing process. First, the clays are very plastic (with the exception of the white clay) and handbuild like no store-bought clay can. They hold their form, allowing potters to make radical curves in the clay wall without danger of collapse.

Second, the clays of Mata Ortiz possess a great capacity to withstand thermal shock without breaking, due to what Juan Quezada calls "having the right stuff." Juan's most difficult struggle was discovering clay that worked. Many of his early trials broke because he mistakenly sought out the purest clay, and pure clay cracks during drying and firing. After breaking numerous pots, he returned to studying the prehistoric pot sherds and realized that the prehistoric potters had added temper or grog (small bits of inert material like sand, volcanic ash, or prefired clay) to their wares. Temper helps open the clay body, so it can endure the expansion and contraction of the drying and firing process. Juan experimented with many tempers and discovered that volcanic ash worked best: its fineness allowed him to polish the clay

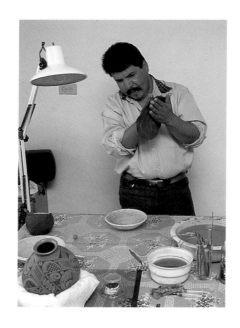

smoothly without the lumps that larger grog left in the surface. Today Juan digs clays in areas known to contain volcanic ash, so that the temper occurs naturally.

Finally, the majority of clays located around Mata Ortiz are earthenware clays that fire at very low temperatures. This allows the pottery to fire to a significant strength at bonfire temperatures between 1000°F and 1450°F. Juan has also discovered kaolin clays to the south of the village that barely mature at the temperatures used in Mata Ortiz. (Kaolins mature at temperatures around 2400°F, a full 1000°F hotter than the Mata Ortiz firings.)

The potters of Mata Ortiz have developed several variations of the coil and pinch technique. All processes share the same basic principles. Following is one commonly used technique employed throughout the village.

The potter forms the base of the pot by taking a handful of clay and rolling it out on a table with the aid of a rolling pin or pounding it by hand. This step is modeled after the way the villagers make their tortillas. In fact, they call this flat pancake of clay the "tortilla." The potter then places the clay tortilla in a rounded plaster mold that will support the wet clay and ultimately give the bottom of the pot its shape. Plaster is the mold of choice because it slowly wicks moisture from the clay and will release the pot from the mold without sticking. In the early days, Juan experimented with anything he could find for a mold. He used his mother's dishes for some of his first successful molds, but the pots sometimes stuck to the nonporous glass. Later, Juan and Nicolás discovered a clay mold used by the Indians and realized a porous mold worked much better than glass, because it allowed the pot to dry and release without sticking.

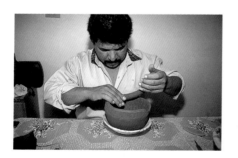

After the clay tortilla is centered in the plaster mold, the clay is vigorously pressed against the mold to remove air bubbles and repair wrinkles made in the tortilla while placing it in the mold. Next, the tortilla is trimmed level with the top of the mold. A large coil of clay, called a *chorizo*, is rolled out and attached to the edge of the tortilla. Special care is taken to ensure that the clay coil is completely attached to the tortilla both inside and out. Coils measuring one to two inches in diameter are not uncommon. One coil this size can be pinched into a wall four to six inches high.

Now that the coil is securely attached to the tortilla, the potter systematically pinches the coil while slowly spinning the mold to ensure that equal time is spent pinching each part of the coil. The coil is first pinched from the bottom near the joint. As the coil compresses to the desired thickness, the potter's hands move upwards, repeating the pinching process until the entire coil is flattened. Depending on the size of the pot, more coils may be necessary. I have seen many small pots formed with the use of only one coil. The Mata Ortiz technique is very similar to the wheel-throwing technique. The walls of the vessel are first pulled straight up to form a cylinder, then later manipulated to produce the final shape.

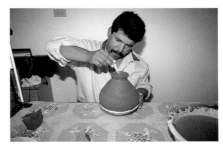

Once the coils are added and the walls are pinched straight up, the clay begins to stiffen a bit, and the potter can safely begin to manipulate the clay without collapsing the walls. With one hand placed inside the pot and the other slowly turning the plaster mold, the potter gently begins pushing the walls outwards to achieve the desired form. Working from the bottom up, the potter usually chooses to flare out the bottom and close in the mouth. To form the mouth, the potter pinches together the clay around the top edge of the wall sequentially, reducing the size of the mouth. Once the mouth is sufficiently reduced, another very small coil of clay is often added to complete the mouth. The mouth of the pot is usually made slightly thicker than the walls, to make it stronger.

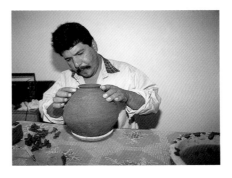

The completed pot is allowed to harden for ten minutes or so, at which point the potter smoothes the entire surface of the clay with the aid of a hacksaw blade. The serrated side is used first to remove high spots and fill small depressions. Next the smooth backside of the blade erases the lines left from the previous step. This leaves the pot very smooth and greatly helps in the next phase of sanding.

Pots are left to air-dry in a room with little draft and no direct sunlight for two to four days. This reduces cracking caused by uneven drying. On the second day, the potter removes the pots from the mold and smoothes the bottoms with a hacksaw blade. The pots are turned upside down and rotated to ensure that all sides dry evenly. When the clay is bone-dry, the potter takes the pot outdoors and sands it with sandpaper, usually starting with a rough grit of #100 and finishing with paper as fine as #200. This sanding further refines the surface and prepares it for polishing.

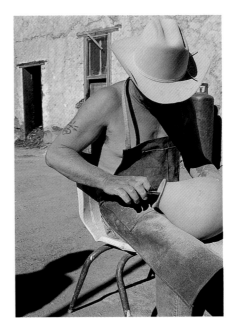

Juan sanding the surface of a pot

Polishing the Clay

To polish, the sanded pot is covered with oil (vegetable, saddle, castor, or baby—Juan's oil of choice). The oil slightly softens the clay and provides a protective barrier to the water that is applied next. Putting water on a pot without oil will rehydrate the clay and cause cracking. The potter applies the water conservatively to the entire pot using a soft cotton cloth, often a T-shirt. This further smoothes the surface and fills pinholes in the clay. The air and water restore the clay to a slightly damp "leather-hard" condition. Now the clay can be polished to a mirrorlike sheen with minimal effort.

People use many different polishing tools: tumbled stones, the backside of a spoon, deer bones, valve push rods, seeds, silk cloth, and leather. Every clay responds differently to each tool, prompting Juan to say that polishing in itself is an art that you can spend a lifetime perfecting. It is helpful to think of the polished surface of the pot as a canvas prepared for a painting. A well-polished pot makes a beautiful canvas that will allow the artist's designs to literally flow over its surface.

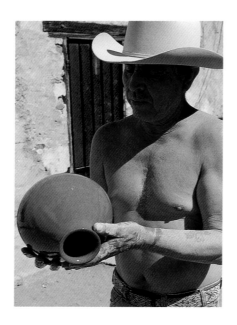

Oil softens the clay slightly and provides a protective barrier to the water that is applied next.

Painting

The paints used in Mata Ortiz are of exceptional quality. Juan found quality paints that fired brilliant red and black early in his explorations, and he continues to experiment with new clays and minerals, searching for richer blacks and more vibrant reds. Here I would like to honor the terms used in modern ceramics, where "slips" or "pigments" are the accepted words for paints. In Mata Ortiz, however, "paint" is the usual term.

Many minerals undergo surprising color transformations when subjected to heat. It is essential to do color tests on new minerals before adding them to the clay or paint.

Once a nice color is found, it must then be milled into a fine powder and added to a similarly colored clay to make paint. (See photograph of grinding minerals on facing page.)

When viewed within the various handbuilding traditions of the Southwest, the paints of Mata Ortiz are outstanding. Their clay bases fire so strongly onto the pots that they cannot be removed by water or rubbing. The black manganese paint of Mata Ortiz comes from an old manganese mine in the mountains above the village. Manganese alone will not adhere to the pot. A good paint needs a mixture of mineral and liquid clay to attach the mineral to the pot when it is fired. Fortunately, clay is naturally present in the manganese vein, so if the potter is skillful in selecting his manganese, nothing else is necessary to make the paint adhere. The clay paints of Mata

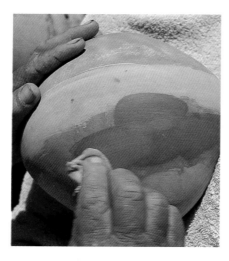

The potter applies water with a damp cloth before polishing to fill in any holes and smooth the clay for polishing.

Ortiz are also saturated with minerals and so finely filtered that they polish with the stroke of a fingernail. To achieve purity, the paints undergo a filtration process. The clay and minerals are dissolved in a bucket of water. The contents are stirred vigorously and are then allowed to settle several minutes so that the larger, heavier particles fall to the bottom. At this point, the "cream," or finest particles floating near the surface, is ladled off the top and poured through the fine mesh into a second bucket. The same process is then repeated from the second to third bucket. The final product is a paint that not only has a sufficient clay base to adhere the mineral colorant and fire permanently onto the pot, it is of exceptional clarity and flows like cream onto pottery surfaces.

Pueblo Indian potters of the American Southwest make a black paint in a very different manner. They grind and mix black iron oxide and beeweed extract on a *metate*. Beeweed is an iron-rich wild spinach used to bind the black iron oxide to the pottery. This beeweed binder is essential, because without it the mineral oxide will rub off. The potter mixing the paint must have a good eye for proportions. A paint mixed with too much oxide and too little beeweed rubs off the fired pot; but a paint with an overabundance of beeweed and lack of oxide fires a light black. Properly mixed paints are a sign of craftsmanship, so it behooves any buyer to check the paint quality by gently rubbing the pot before purchasing. The beeweed binder of the Pueblo paint is equivalent to the clay component of the Mata Ortiz paint.

Mata Ortiz paintbrushes are made by hand from human hair. Juan experimented with many animal samples before deciding on human hair. Today each extended family usually has one child who has just the right hair to produce the prized brushes for long straight lines. In the Quezada family, it is Juan's granddaughter Judy. Juan claims that she has the best hair he has ever found for paintbrushes. Judy is now supplying about fifteen artists with paintbrushes.

These human-hair brushes appear very different from conventional paintbrushes. They are designed specifically to paint long straight lines. A typical brush is 1 to 1¹/₂ inches long and contains an average of twenty strands of hair. In application, these homemade brushes are used differently than a standard brush. To produce a line, the brush is dipped in paint and its entire bristle is laid down on the surface of the clay and pulled to create the line. This human hairbrush is perhaps one of Juan's most significant inventions. It enables an artist to paint incredibly fine and intricate designs. The old saying "You are only as good as your tools" rings true with this key innovation. It is one of the important reasons why Mata Ortiz pottery has developed so quickly. Using a more primitive paintbrush made of yucca, a potter may keep a brush only a week or two before it dries out and becomes ineffec-

Paint colorant test. Samples on the center brick represent the fired minerals, while samples next to the brick on the ground represent their unfired counterparts. Note that some minerals radically change, such as the green stone turning black and the tan and yellow rocks turning bright red.

Grinding minerals on a metate for a test fire

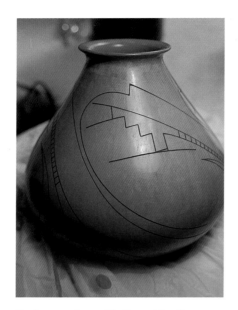

Designs are framed in first with a fine brush. Broad patterns are later filled in with a larger brush.

tive. I know potters in Mata Ortiz who have had the same brush for ten years. This has enabled them to intimately learn the nuances of their tools and create even finer designs.

The fine lines allowed by this innovative brush create the stunning geometric patterns so characteristic of Mata Ortiz pottery. Large solid areas of paint are first framed by outlining with the human-hair brush. These outlines create a "corral," according to Juan, for the large pool of paint that will fill the solid area. A separate brush, similar to a conventional paintbrush, is heavily saturated and then applied to the corralled area so that the paint "floats" onto the clay instead of being brushed. This ensures the thick coverage that will fire opaque and entirely obscure the clay beneath.

Once the pot is completely painted, the potter applies a thin layer of oil to the entire pot and gently polishes each line of the design with a bean or small stone to give a beautiful sheen. In the case of blackware, the paint is not polished, so that a matte contrast sets off the design work from the polished clay background. At this point the "greenware," or unfired pottery, is ready to be fired.

Firing

Firing is the final step that permanently hardens the clay particles through a series of physical and molecular transformations. At temperatures below 1000°F organic material burns out of the clay body, reducing the space between particles and making the clay stronger. At temperatures between 1000°F and 1500°F, some clay begins to "sinter." This is where clay begins to melt and become glasslike. Many Mata Ortiz clays fall into this category. They contain natural fluxes (organic material) that lower the melting temperature giving them incredible strength at low temperatures. This is another trademark of Mata Ortiz pottery. It is incredibly strong and does not break down in water. Some Pueblo traditions have lost this concern for quality and consequently underfire their clay, yielding pots that lack structural integrity.

The potter's worst enemy is moisture in the clay body, the cause of the majority of breakage in the fire. Residual water must be slowly driven out before firing. Slow extraction is the key. Just as water expands rapidly into a vapor when it boils, rapid expansion of water within the wall of a pot will result in a crack or flake popping out of the pot. Many potters prevent this nightmare by "candeling" pots in an oven overnight at temperatures below boiling or placing them in the strong desert sun prior to firing.

The firing process is itself an art form. A skilled potter watches for visual clues in the colors of the flames and smoke to adjust the heat of the fire. An

underfired pot will often have a grayish or smoky appearance and lack the brilliant, crisp colors and strength of a properly fired pot. When tapped with a fingernail, it will sound "plunky." Overfired pieces become toasted, almost burnt looking. They often lose their burnished brilliance, and the black paint often turns to brown. A perfectly fired pot will possess a very consistent clay color all around the pot and have no firing stains or clouds. The paint will be deep black or blood red, and when plucked with a fingernail, it rings like a bell. According to Juan, "She sings."

One windy afternoon, Juan was firing a large red pot. When he removed the *quemador* (a clay or metal cover that protects the pot during the fire), the wind precariously rocked the pot back and forth on its firing stand. As Juan jumped to rescue the pot from falling to the ground, he shouted out laughing, "Most of my pots sing! This one wants to dance!"

Two very different firing techniques are routinely used in Mata Ortiz: oxidation and reduction firing. Oxidation yields pottery of colors—white, red, tan, etc. Reduction fires are responsible for the blackware. These terms refer to the oxygen in the atmosphere during the fire. A reduction fire has a reduced amount of oxygen, so subsequently an elevated level of carbon dioxide circulates around the pottery. This causes the pottery to impregnate with the carbon and turn black. Any clay can be fired black by placing the pottery under a sealed container, such as a metal bucket or a clay flowerpot with the drain hole covered. Several handfuls of dry horse manure or sawdust is placed under the pot. Once ignited this liberates more carbon, helping to turn the pot black. An interesting technical note, as I briefly mentioned above, is that much clay in Mata Ortiz contains an abundance of organic matter. During the fire, as this organic matter burns, it turns into carbon which turns the pot black. Because of this, sawdust or manure is not essential for black firing. After a bonfire is built around the container, the inside oxygen is quickly consumed by the heat of the fire, leaving an atmosphere rich in carbon dioxide. Once the hot clay body is open and susceptible, the carbon can penetrate it in a process termed "carbon trapping." And once the pot has cooled, the rich black surface remains as a permanent feature.

Oxidation firings are responsible for all the beautiful colors of Mata Otriz pottery. In an oxidation fire, the potter elevates the *quemador* several inches off the ground with bricks to allow ample air to circulate inside the fire chamber. Here an oxygen-rich environment predominates, and the carbon found in reduction atmospheres never has the opportunity to build up and mask the colors. The oxygen then brings out all the amazing color ranges of clay and paint. It is fascinating to see an oxidation and reduction firing done sequentially on the same pot. An intense red pot with black paint placed in

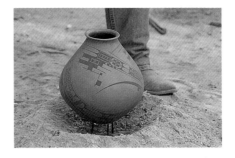

A preheated pot is placed on the firing stand. Soil has been gathered around the base to seal the *quemador*. Note that the color of the unfired pot is the same as the unfired oxidation pot on the next page.

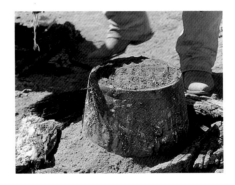

The *quemador* is placed over the pot. The drain hole and base of the *quemador* are sealed with dirt and ash to limit infiltration of air.

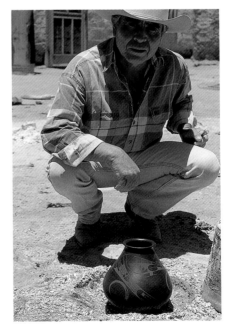

Juan and his *olla* after reduction firing

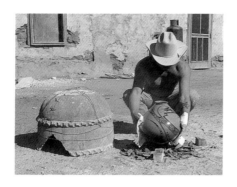

A preheated unfired pot is placed on the fire stand. Note the pot's color and the small wood chips underneath for combustion.

The wood is doused with kerosene and systematically lit from all sides to create symmetrical heat.

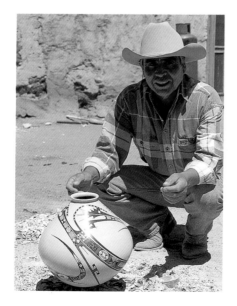

Oxidation firing produced a white *olla* for Juan.

an oxidation fire with the elevated *quemador* will fire out a beautiful red form with rich black designs. If the potter then removes the bricks that elevate the *quemador*, seals it to the ground, and refires in a heavy reduction atmosphere, the pot will emerge with a shiny black where the clay used to be red and the once-black design will be a smoky gray.

In the oxidation fire, the potter takes great care to preheat the pottery in an oven or in the sun. This ensures the elimination of any residual water in the clay body and greatly reduces the possibility of cracking or explosions in the first few minutes of the fire. Pots are elevated off the ground to allow heat and air flow to circulate evenly around the pot. This ensures proper clay "maturation" and evenness of color. (A pot sitting on the ground during firing will usually have a gray smoky underside.) Once the preheated pot is secure on the firing stand, the potter quickly covers it with the *quemador* to protect it from drafts that may crack the delicate clay. The potter then arranges the cowpies systematically around it, interlocking them like brickwork to ensure stability throughout firing. When I first studied with Juan, he used to laugh at my selection of cowpies and tell me that I was a bad cowpie picker. I am proud to say that he inspired me to become a connoisseur of the subject. (Now that he has switched to cottonwood bark, I am being forced to learn yet another new skill.)

Juan has experimented with many fuels, including grasses, lumber, palm trees, and yucca, and has found cottonwood bark and cowpies to be the most reliable. He loves to experiment with firing techniques and laughs when he recounts a technique he tried long ago. Watching blacksmiths blowing air across coals to increase the forge temperature inspired Juan to consider that a similar technique might work for firing pots. He placed a pot in a metal bucket with charcoal and lit the charcoal. He had no bellows to force air across the embers, so he swung the bucket on a rope above his head over and over. After burning his shoes with falling embers, he decided there had to be a better way to fire pottery. This is merely one example of how Juan has always been eager to experiment, innovate, and gain knowledge.

To continue the most usual method of firing, once the cow dung is sufficiently stacked, the potter drizzles kerosene around the base of the dung and lights it in three or four spots at the base to ensure slow, even heating of the pot. The fire will burn for twenty minutes and reach a temperature around between 1000°F and 1450°F. (I have verified these temperatures through the use of cones and a pyrometer.) This radical firing process shocks any formally trained potter. It breaks all the rules learned in school governing kiln firing. The same firing in a kiln would take twenty-four hours to fire and cool. After the climax of the fire has been reached and the flames are subsiding, it is

critical to rake away the smoldering coals to maintain a "clean fire," because smoldering coals can produce smoke that stain pottery. Pots are then left to cool over the next half hour, at which point they may be removed from the *quemador*. Some potters choose to cool their pots more quickly. Reynaldo Quezada often takes out pots at 500°F–600°F and ducks them into a barrel of cold water, producing a cloud of steam. He loves to hear the hysterical cries of spectators as they expect the sight of a pot in pieces. Of course, they never do because the clay has outstanding thermal shock resistance.

My ten-year apprenticeship with Juan has radically changed the way I work in clay. Since my first trip to Mata Ortiz in 1989, Juan and Guille took me into their home as if I was their ninth child. This is the same generosity Juan brings into his teaching. Once while teaching at the Idyllwild School of Music and the Arts in Californina, Juan was pulled aside by Pueblo potters and admonished to save some of his secrets for his family. Juan respectfully replied, "If someone comes to me and wants to learn, I am going to teach them. I have no secrets." Juan has encouraged me to explore and use his techniques in my own work, in which I use these beautiful polishing and painting techniques on contemporary forms. Juan invited me to join his family in the Exhibits USA show. When asked by Bill Gilbert, the show's curator, if he was concerned about a North American being included in an all-Mata Ortiz show, Juan replied, "It doesn't matter where Michael is from. He has the soul of an artist." Juan Quezada is truly a master artist by the standards of any tradition.

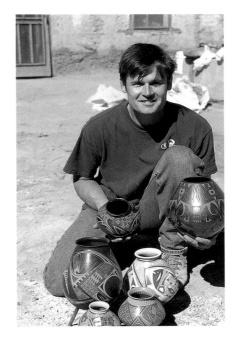

Michael Wisner with a few of the pots he made on a study-visit with Juan Quezada

Potters Index

All potters known to the authors as of January, 1999

Lorta, Alejandro
Losoya de Baca, Virginia
Losoya de Veloz, Gloria
Loya, Andrés
Loya, José
Loya de Flores, María
Loya de Ledezma, Rosa
Loya Jaquez, Ismael
Lozano Lucero, Jesús
Lozano Lucero, Rubén
Lucero, Lidia
Lucero Andrew, César
Lucero Andrew, Efraín Jr.
Lucero de Mora, Elida
Lucero Juarez, Efraín
Luchuca Rios, Mary
Marín González, Carolina
Marín Olveda, José "Pepe"
Martínez, Araceli
Martínez, David
Martínez, Edgar
Martínez, Eduardo
Martínez, Luz Elva
Martínez, María
Martínez de Domínguez, Martha
Martínez de Quezada, Marta
Martínez de Tena, Amelia
Martínez López, José Manuel
Martínez López, Luis
Martínez Rentería, Jesús Jr.
Meleros, Dulces Nombres
Meras, Benito
Meras, María
Molina, Maupel
Mora, Anastasio
Mora, Armando
Mora, María
Mora de Bugarini, Lucia "Lucy"
Mora de Rodríguez, Olivia
Mora de Silveira, Tomasa
Mora Sandóval, Juan Jr.
Mora Sandóval, Julio
Mora Tena, Bonifacio
Mora Villalba, Jesús Manuel
 "Manuel"
Mora Villalba, Porfirio "Pilo"

Moreno, Amelia
Navarrete Ortiz, César "Chester"
Navarrete Ortiz, Elí
Núñez, José
Núñez de Ledezma, Moncerrey
Núñez de Soto, Cruz
Núñez González, Luisa
Olivas, Blanca
Olivas, Manuel
Olivas, María de Jesús
Olivas, Martín
Olivas Hernández, Candelaria
Olivas Hernández, Cipriano
Olivas Hernández, Ines
Olivas Hernández, Maricela
Ortega, Ernesto
Ortega, Héctor
Ortiz, Alonzo
Ortiz, David
Ortiz, Emeterio "Telo"
Ortiz, Rosa
Ortiz Chacón, Isídro
Ortiz de Pedregón, Teodora
Ortiz de Santillán, Paty
Ortiz Estrada, Eduardo "Chevo"
Ortiz Estrada, Macario
Ortiz Estrada, Nicolás
Ortiz Estrada, Salvador
Ortiz Estrada, Santos
Ortiz López, Julio César
Ortiz Ortiz, Osbaldo
Ortiz Rodríguez, Emeterio
Ortiz Rodríguez, Félix
Ortiz Sandóval, Luis Armando
Ortiz Sandóval, Raquel
Ortiz Villa, Anastasia
Osuna, Tomás
Payan, Lissette
Pedregón, Jesús Manuel
Pedregón Lujan, Reynaldo
Pedregón Ortiz, Enrique
Pedregón Ortiz, Gerardo
Pedregón Ortiz, René
Peña, Ana
Peña, Ernesto
Pérez, Bety

Pérez, Rodrigo
Pérez Davila, Elias Javier
Pérez de Zuniga, María "Mary"
Pérez Olivas, Javier
Ponce, Blanca Noelia
 (Almeida de Ponce)
Ponce, Luis
Ponce, Maribél
Ponce, Mayra
Ponce, Jorge
Ponce Avalos, Humberto
Ponce Avalos, Lazaro
Ponce de Ledezma, Rosa Elena
Ponce de Rodríguez, Marta
Ponce de Veloz, Lidia
Quezada, Betty
 (Quintana de Quezada)
Quezada, Damián
 (Escarsega Quezada)
Quezada, Elvira
 (Antillón de Escarsega)
Quezada, Hilario "Lalo"
 (Corona Quezada)
Quezada, Imelda
Quezada, Jaime
Quezada, Jorge
Quezada, Manuel
 (González Quezada)
Quezada, Matilde "Matilde de
 Quezada" (Olivas de Quezada)
Quezada, Mauro (Corona Quezada)
Quezada, Nolberto "Nolbie" (Olivas)
Quezada, Octavio (Gonzáles
 Camacho)
Quezada, Olga (Quezada de
 Ledezma)
Quezada, Oscar (Gonzáles Quezada)
Quezada, Oscar Javier Jr.
 (Gonzáles Camacho)
Quezada, Samuel (López Quezada)
Quezada Camacho, José Luis
Quezada Celado, Jesús
Quezada Celado, Juan
Quezada Celado, Nicolás
Quezada Celado, Reynaldo
Quezada de Corona, Consolación

Quezada de Escarsega, Genoveva
Quezada de Hernández, Rosa
Quezada de López, Reynalda
Quezada de Lujan, María Elena
 "Nena"
Quezada de Rentería, Blanca
Quezada de Talavera, Lydia
Quezada de Valenzuela, Dora
Quezada Olivas, Adrino
Quezada Olivas, Alvaro
Quezada Olivas, Arturo
Quezada Olivas, Efrén "Pollo"
Quezada Olivas, Juan Jr.
Quezada Olivas, Mireya
Quezada Olivas, Noe
Quezada Talamontes, Dora
Quezada Talamontes, Elida
Quezada Talamontes, José Armando
Quezada Talamontes, Leonel
Quintana Cota, Rocío
Quintana de Quezada, Lourdes
 "Luli"
Quintana Rodríguez, Eduardo
Quintana Rodríguez, Jorge
Ramírez, Jesús
Ramírez, Luz Elva
 (Ramírez de López)
Rentería, Cruz
Rentería de Cota, Lidia
Reyes, Manuel Jr.
Reyes, Yolanda
Reyes B., Manuel
Reyes de Villalpando, Socorro
Reyes Roque, Reydesel
Rios, Martín
Rios Lechuca, Mary
Rodríguez, Alfredo "Freddy"
Rodríguez, Jesús
Rodríguez, Reydesel
Rodríguez, Yolanda "Yoli"

Rodríguez de Arrieta, Flora
Rodríguez de González, Marta
Rodríguez de López, Elena
Rodríguez González, José Antonio
 "Tonio"
Rodríguez González, Silvia
Rodríguez Guillén, Armando
Rodríguez Guillén, Manuel
 "Manolo"
Rodríguez Guillén, Oscar
Rodríguez Guillén, Rubén
Rodríguez Guillén, Teresa "Tere"
Rodríguez Mora, Leticia "Lety"
Rojas, Adrian
Sandóval, Eusebio "Chevo"
Sandóval, Lucio
Sandóval, Socorro
 (Sandóval de Silveira)
Sandóval de Ortiz, Otila
Sandóval de Silveira, Genoveva
Sandóval de Soto, Chela
Sandóval de Tena, Sofía
Sandóval Ortega, Ernesto
Sandóval Tena, Israel
Silveira, Rafael
Silveira de Olivas, Arminda
Silveira de Osuna, Silvia
Silveira de Villalba, Veronica
Silveira, Juan
Silveira Ortiz, Gregorio "Gollo"
Silveira Ortiz, José
Silveira Ortiz, Nicolás
Silveira Ortiz, Rogelio
Silveira Sandóval, Armando
Silveira Sandóval, Lilia "Lila"
Silveira Sandóval, Octavio "Tavo"
Silveira Sandóval, Trini
Soto, Benjamín "Chamín"
Soto, Lupe
Soto de Bugarini, Yolanda

Soto de Mora, Alma Delia "Delia"
Soto de Mora, Guadalupe
Talavera, Rito
Tena, Ernesto
Tena de Mora, Antonia
Tena de Sandóval, Esperanza
Tena López, José Luis
Tena López, Roberto "Beto"
Tena Sandóval, Adolpho "Fito"
Tena Sandóval, Gerardo
Trillo de Corona, Ana
Valenzuela Quezada, Pedro
Valenzuela Quezada, Zulema
Veloz, Carmela "Carmen"
 (Ledezma de Veloz)
Veloz, Fabiola
Veloz, Jesús
Veloz Casas, Ramiro Jr.
Veloz de Jacquez, Teresa
Veloz Gutiérrez, Ramiro
Veloz Gutiérrez, Saul
Veloz Ponce, Carlos
Villa, Rito
Villa Corona, Deonicio
Villa de Camacho, Cruz Celia
Villa de Lozano, María Ana
Villa López, Benjamín
Villa López, Ramón
Villa López, Tomás
Villa Ortiz, Benjamín
Villalba de Andrew, Adriana
Villalba de Arrieta, Petra
Villalba Hernández, Juan Carlos
 "Carlos"
Villalba Hernández, Lourdes
Villalba Hernández, Sabino "Cabi"
Villalba Pérez, Andrés
Villalpando, Gerónimo
Villalpando, Socorro

A Traveler's Guide to Mata Ortiz

Getting There

The three nearest major airports to Mata Ortiz are located in Tucson, Arizona, El Paso, Texas, and Chihuahua City, Chihuahua. Special car arrangements must be made to drive from the U.S. into Mexico, including Mexican auto insurance and, if it's a rental car, written permission to take the car across the line. To obtain a Mexican permit at the border, all drivers also must present the registration papers of their vehicles, along with a driver's license, proof of citizenship—either a passport, a birth certificate, or a notarized copy of a birth certificate—and an international credit card in the same name as the other documents. Proof of citizenship is required for a tourist card that permits a person, as opposed to a car, to travel in Mexico. Fees for tourist cards and car permits can be paid with the credit card. It's important to know, too, that before it expires, the vehicle permit must be surrendered at the border when leaving Mexico. The processes of getting and surrendering the permit take a variable amount of time, depending on the particular border crossing, the season, the day of the week, and the time of day. (Also, regulations may change, so current requirements should be checked before setting out on any trip.) From Tucson, the drive to the village takes approximately six hours; from El Paso, about five; from Chihuahua City, about four.

Planning Ahead

Since all routes to Mata Ortiz involve long drives through thinly populated areas, it's wise to start out with a full tank of gas, a supply of bottled water, and a spare tire. Later on, refills and repairs are readily available in Mexican

towns and cities, but not in the middle of the Sierra Madre. It is inadvisable to travel in remote areas at night. The altitude of Nuevo Casas Grandes and Mata Ortiz is close to 5,000 feet, and winters can be cold and windy. Summers are hot, and thunderstorms may cause roads to wash out. Sturdy walking shoes are a must.

Money

American dollars (but not checks) are accepted currency in Mata Ortiz. Pesos can be obtained from automatic teller machines in Nuevo Casas Grandes, and credit cards work at motels and gas stations.

Accommodations

Several comfortable motels and many excellent restaurants are available in Nuevo Casas Grandes. More informal food and lodging can be arranged in the village itself. Since rates and management of these businesses are subject to change, a travel agent, recent guidebook, or internet search will probably give the most current information.

U.S. Customs

Pottery bought in Mexico must be declared at the American border. Customs regulations are complex; a copy of these regulations may be obtained through the U.S. Customs web site or from regional offices. Modest amounts of pottery bought for a tourist's own use are duty free, and fine art is duty free. Moreover, Mexican ceramics in general are considered duty free under the North American Free Trade Agreement. But customs inspectors may make subjective judgments, so customs officials recommend obtaining receipts from potters, particularly for highly valuable purchases.

Glossary of Spanish terms used in the Mata Ortiz area

ahorita: right now, pretty soon

alfarero, alfarera: a potter (m., f.)

amarillo: yellow (in clay, covers a range of colors from cream to tan)

aro, arito: a display ring for pots

barrio: neighborhood

barro: clay

baya: all colored pots except black and white

bonito, bonita: pretty (m., f.)

braceros: farm workers

bruñido: burnished

buñigas: cow manure

cantímplora: a canteen

cáscara de alamo: cottonwood bark (used for firing)

cazuela: a rimless bowl, "casserole"

charola: a tray, platter

chico: small

chiste: a joke, punch line, or, by extension, the point of something

chorizo: a sausage (a thick coil of clay)

comerciante: a trader

¿Compran ollas?: Are you buying pots?

comprar: to buy

correa: a coil of clay

cruda: green or unfired (pot)

cuadritos: little squares or checks in a checkerboard

cuates: double or twin pots connected by a handle (also called *gemelos*)

curioso: remarkable, quaint

dibujo: a drawing

diseño: a design

ejido: communal land divided into individual plots

figura: an effigy pot

fondo: bottom or base of pot; also a display ring

fuego: fire

gancha: a hook for removing pots from kiln

grafito: graphite finish

grande: big

horno: an oven or kiln

jarra: a jar or jug

jarrón: a tall jar, vase

jarroncito: a miniature vase

labor: a plot of land allocated to a farmer under the *ejido* program

lizar: to sand

mano: the hand, also a hand-held grinding stone

matachines: costumed dancers in religious festivities

mestizo: of mixed Spanish and Indian heritage

metate: a stone mortar or grinding basin

mezcla, mezclado: marbled clay, made by mixing colored clays

moctezuma: pre-Columbian ruins or archaeological site

mojados: literally "wetbacks," undocumented Mexicans in the U.S.

mono: literally, a monkey and, by extension, a grotesque or humorous effigy pot

movimiento: movement, a lively design

negro: black, produced as body color of a pot either by graphite slip or oxygen-reduction firing

olla: a clay pot (inclusive term for all Mata Ortiz ceramics)

olla cuadrada: a square pot

olla gemela: a "twin" pot, a double pot with connecting handle (also called *cuates*)

olla matrimonial: a double or wedding vase

olla turbante: a pot with a swirled shape

ollita: a small pot

ollita mini: a miniature pot

¡Pásale!: Come in!

pico: a spout

pintura: paint

plato: a plate or shallow bowl

Por favor: Please

posada: an inn

pueblo (in lower case): a town or village

pulido: polished

pulir: to polish

¡Que le vaya bien!: Literally, May things go well for you, or Good wishes! A pleasant goodbye.

quemador: a kiln (a tub, bucket, or flowerpot used in firing pots)

quemar ollas: to fire pots

¿Quiere comprar ollas?: Do you want to buy pots?

raya: a thin painted line

rellenar: to fill in portions of the design

rojo: red

rosa: pink (in clay, a blend of red and white)

secador: a dryer, plaster trough for desiccating clay

sequeta: a hacksaw blade used in pottery making

¡Siéntese!: Sit down!

tejido: textured or indented clay that has a braided look

turbinos: swirls

vender: to sell

Bibliography

Cahill, Rick. *The Story of Casas Grandes Pottery.* Tucson, AZ: Boojum Books, 1991.

Di Peso, Charles C. *Casas Grandes: A Fallen Trading Center of the Grand Chichimeca.* 8 vols. Dragoon and Flagstaff, AZ: The Amerind Foundation and Northland Press, 1974.

Di Peso, Charles C., and Spencer Heath MacCallum. *Juan Quezada and the New Tradition.* Fullerton, CA: The Art Gallery, California State University, 1979.

Gilbert, Bill, ed. *The Potters of Mata Ortiz/Los Ceramistas de Mata Ortiz: Transforming a Tradition.* Albuquerque: University of New Mexico Art Museum, 1995.

Hancock, Richard. *Chihuahua: A Guide to the Wonderful Country.* Norman, OK: University of Oklahoma Press, 1978.

Hatch, Nelle Spilsbury. *Colonia Juarez: An Intimate Account of a Mormon Village.* Salt Lake City: Desert Book Company, 1954.

Hatch, Nelle Spilsbury, and B. Carmon Hardy, eds. *Stalwarts South of the Border.* [n.p.]: Privately published, 1985.

Kiva: The Journal of Southwestern Anthropology and History 60, no. 1 (1994). Entire issue devoted to Mata Ortiz pottery.

Lozano Kasten, Guillermo. *Paquimé Grupo Pearson: artesanía viva 52 mujeres.* Ciudad Juárez, Chihuahua, México: Fonaes Sedesol, 1997.

Parks, Walter. *The Miracle of Mata Ortiz: Juan Quezada and the Potters of Northern Chihuahua.* Riverside, CA: The Coulter Press, 1993.

Paz, Octavio. *Selected Poems.* Edited by Eliot Weinberger; translated by Muriel Rukeyser. New York: New Directions, 1984.

————. *The Labyrinth of Solitude.* Translated by Lysander Kemp. New York: Grove Press, 1961.

Sahagún, Bernardino de. *Historia general de las cosas de Nueva España. General history of the things of New Spain: Florentine Codex.* Edited and translated by Arthur J. O. Anderson and Charles E. Dibble. Santa Fe, NM, and Salt Lake City: School of American Research and University of Utah, 1950-1982.

Smith, Sandra S. *Portraits of Clay: Potters of Mata Ortiz.* Tucson, AZ: Privately published, 1997.

Acknowledgments

On behalf of all of the contributors, many thanks to the potters and their families for their cooperation, hospitality, and the kindness they have extended to each of us during our visits and interviews.

A number of people have generously provided research information, photographs, and have led us by hand through the village and into hundreds of homes. To Mark Bahti, Debi Bishop Flanagan, Nick Brown, Adriel Heisey, Grace Johnson, Spencer MacCallum, Dick O'Connor, Jorge Quintana, Blanca Ponce, Steve Rose, Diego Samper, and Marta Turok—thank you for your special help and guidance.

We would also like to thank each of the other contributors—Jim Hills, Walter Parks, Jorge Quintana, Robin Stancliff, and Michael Wisner—for volunteering their talent and wisdom to make this book. And special thanks to Jim Hills, who introduced us to the pottery of Mata Ortiz, charmed us with the magic of village, and then contributed more time than he had available to develop biographical profiles and review each step of the book over the past three years. It has been a delightful collaboration.

—ROSS HUMPHREYS AND SUSAN LOWELL

Credits and Exhibitions

Pottery featured in this book was loaned by José Alicea and Alicia Jorgenson, Jerry Boyd, Tito Carrillo (Casa Molina Curio Shop), Kevin Henderson, Pamela and Walter Henderson, Amelia Hernandez and Jim Hills (Native and Nature), Ross and Susan Humphreys, Richard and Cindi Humphries (Rancho Mata Ortiz), Barry and Maria King, Dick and Joan O'Connor, Adalberto Pérez Meillon (Galería de Pérez Meillon), Steve Rose, Ron Schneider (Galería de Ollas) and the San Diego Museum of Man. Pieces loaned by the San Diego Museum of Man are identified throughout the book by the museum's catalog numbers.

Forty-six of the same pieces have been loaned by their owners to three major exhibitions of Mata Ortiz pottery traveling throughout Mexico and the United States. The exhibitions and pots from this book included in these shows are listed here.

The Magic of Mata Ortiz
San Diego Museum of Man
San Diego, California
October 30, 1999 through
September 4, 2000

An exhibition highlighting the museum's Spencer MacCallum Collection of Mata Ortiz Pottery. The exhibit compares and contrasts pottery revivals inspired by three separate artists in indigenous Southwestern communities—Nampeyo and Hopi, Maria Martinez and San Ildefonso, and Juan Quezada and Mata Ortiz.

Pottery from this exhibition appears on pages 18, 48, 138, 139, 141, 142, 146, 147, 148, 152, 153, 155, 156, 158, 160, 162, 163, 164, 167, and 169.

Pottery of Mata Ortiz
Franz Mayer Museum
Mexico City, Mexico
May 1999 through December 2000

A traveling exhibition of pre-hispanic pottery from northern Mexico from the collection of the Franz Mayer Museum and contemporary pottery from Mata Ortiz. The exhibition will travel to several cities in Mexico and the United States in 1999 and 2000.

Pottery from this exhibition appears on pages 14, 16, 20, 43, 62, 66, 87, 91, 96, 97, 108, 111, 122, 130, 134, 137, 144, 150, 159, 164, 174, 175, and 183.

The Potters of Mata Ortiz: Transforming a Tradition
Exhibits USA Tour
September 1999 through August 2002

A traveling exhibition of 50 fine pots from Mata Ortiz scheduled to travel throughout the United States for three years. Updated schedule available from Exhibits USA, 912 Baltimore Avenue, Suite 700, Kansas City, Missouri 64105.

Pottery from this exhibition is featured on pages 22, 88, 128, 113, and 159.

September 1, 1999–October 14, 1999
Southwest School of Arts & Crafts
San Antonio, Texas

November 4, 1999–December 26, 1999
Riverside Art Museum
Riverside, California

January 21, 2000–March 16, 2000
J. Wayne Stark University Center Gallery
College Station, Texas

April 4, 2000–May 19, 2000
Perspective Gallery
Blacksburg, Virginia

June 9, 2000–August 11, 2000
Plains Art Museum
Fargo, North Dakota

November 4, 2000–January 7, 2001
Lakeview Museum of Arts & Science
Peoria, Illinois

April 6, 2001–May 19, 2001
Clark County Heritage Museum
Henderson, Nevada

June 9, 2001–August 11, 2001
Canton Museum of Art
Canton, Ohio